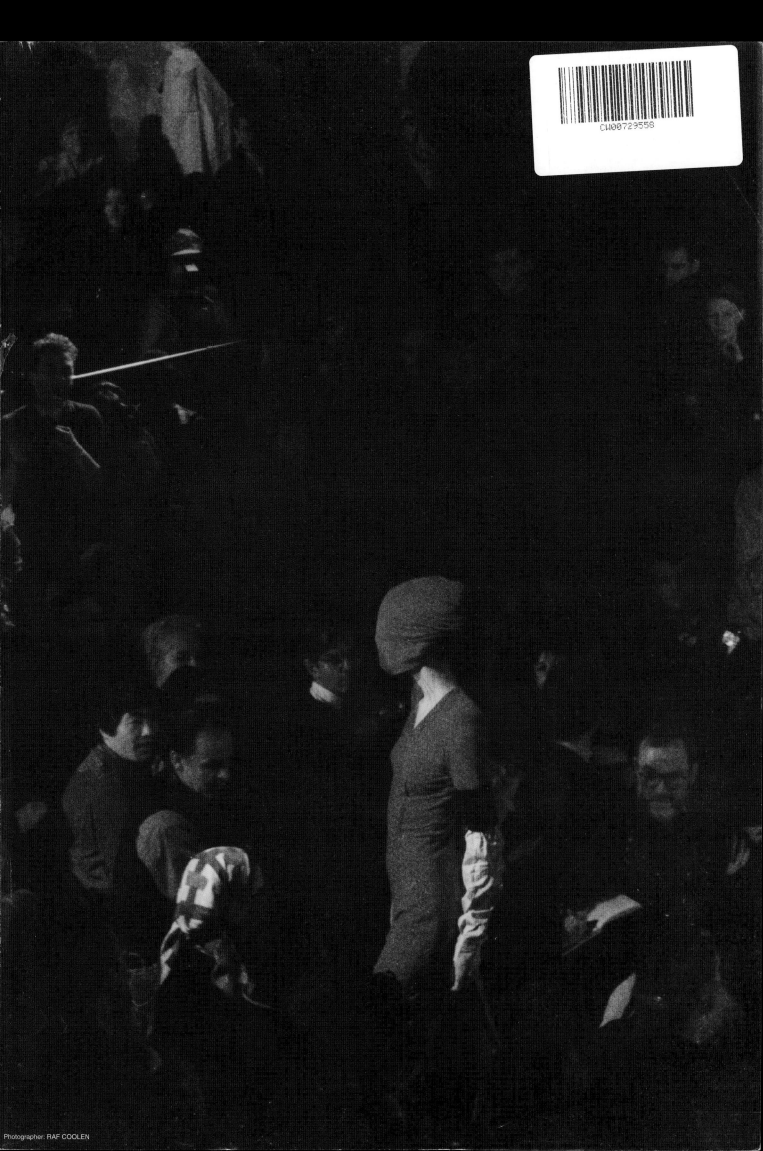

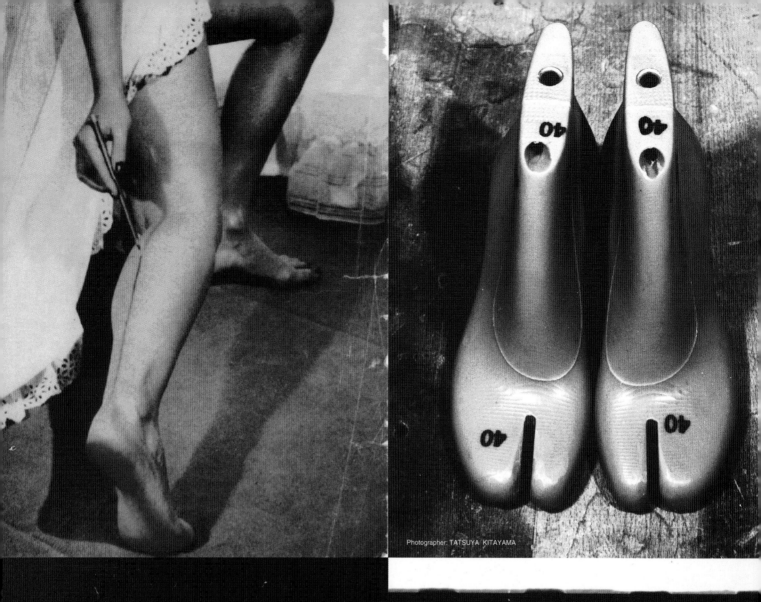

Photographer: TATSUYA KITAYAMA

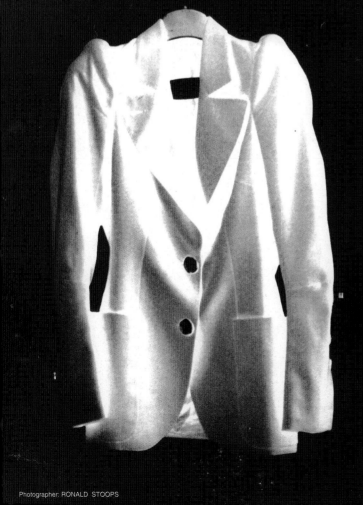

Photographer: RONALD STOOPS

Photographer: RONALD STOOPS

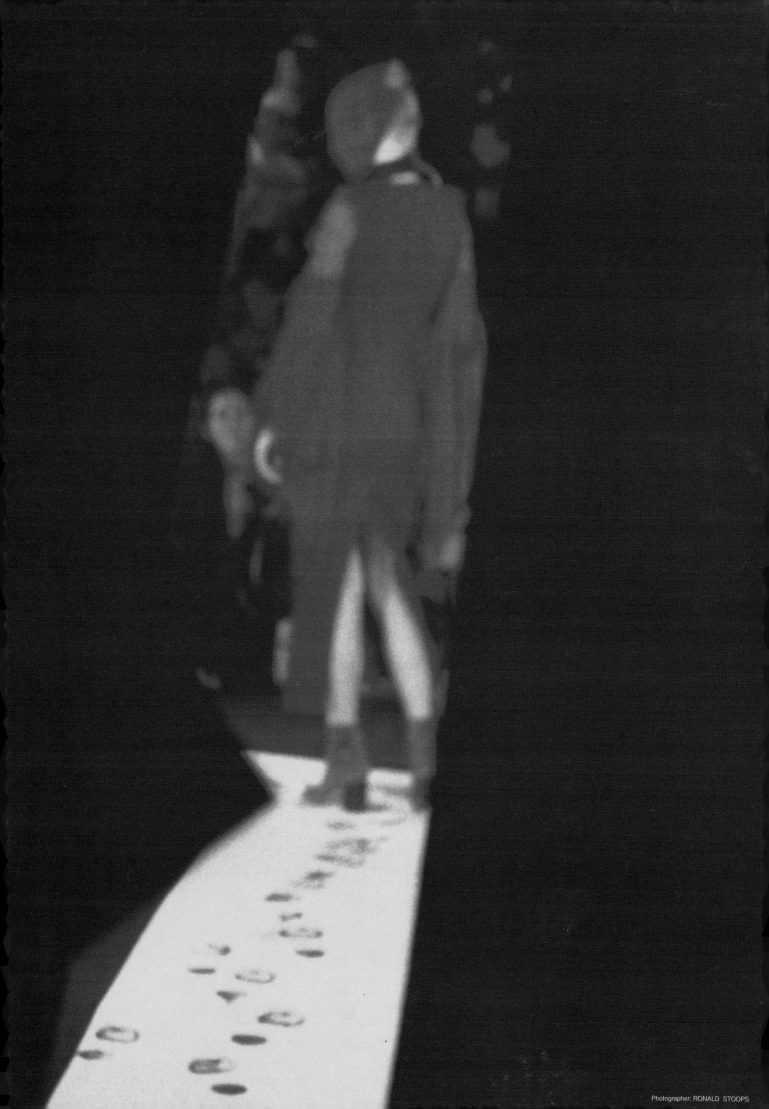

WARNING!
IT IS AGAINST THE LAW FOR ANYONE UNDER THE AGE OF 18 YRS. TO OBTAIN A TATTOO.

Please Co-operate!

OF TATTOOED SKIN

ARTIST KNOWS HIS JOB.....
DO YOU KNOW YOURS?

NT HALF OF A GOOD JOB IS UP TO YOU

TATTOO COVERED FOR AT LEAST FOUR
SENTLY WASH WITH WARM WATER.
S YOU WILL GET A SLIGHT SCAB ON
OU MUST NOT PICK OR SCRATCH THIS.
& FINGER NAILS AWAY FROM AREA
IT HAS COMPLETELY HEALED.
OED AREA 3 TIMES A DAY WITH
SOAP AT DRY WITH CLEAN
RUB

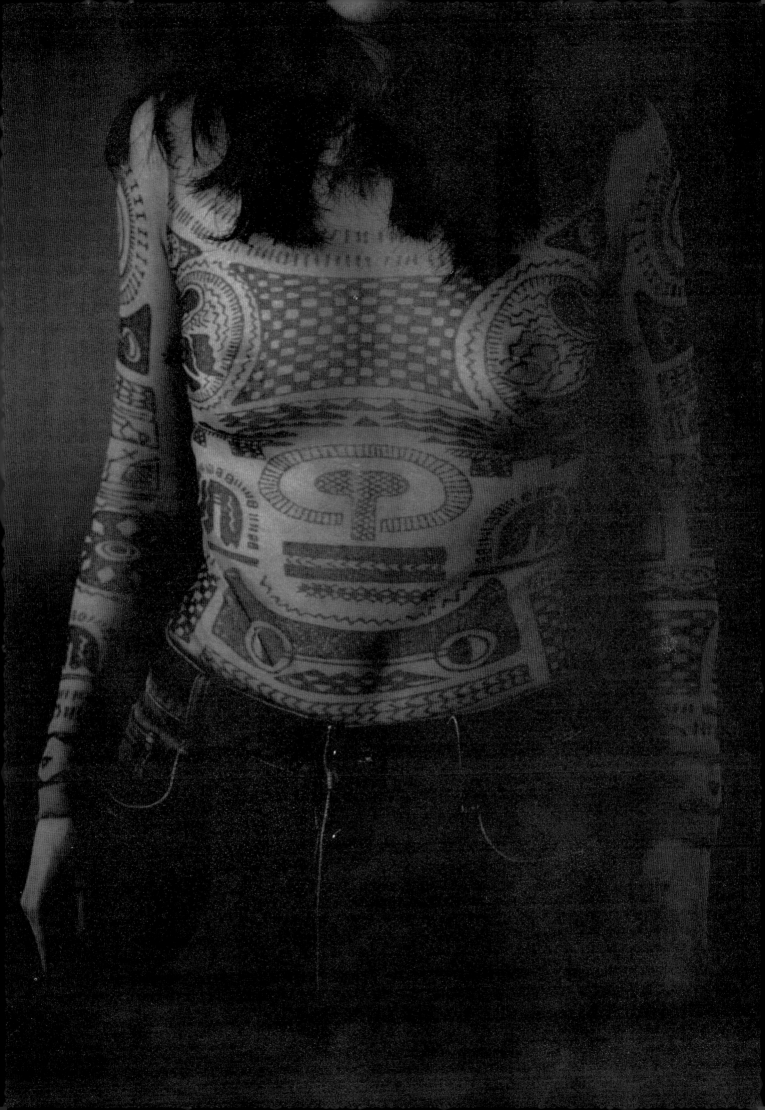

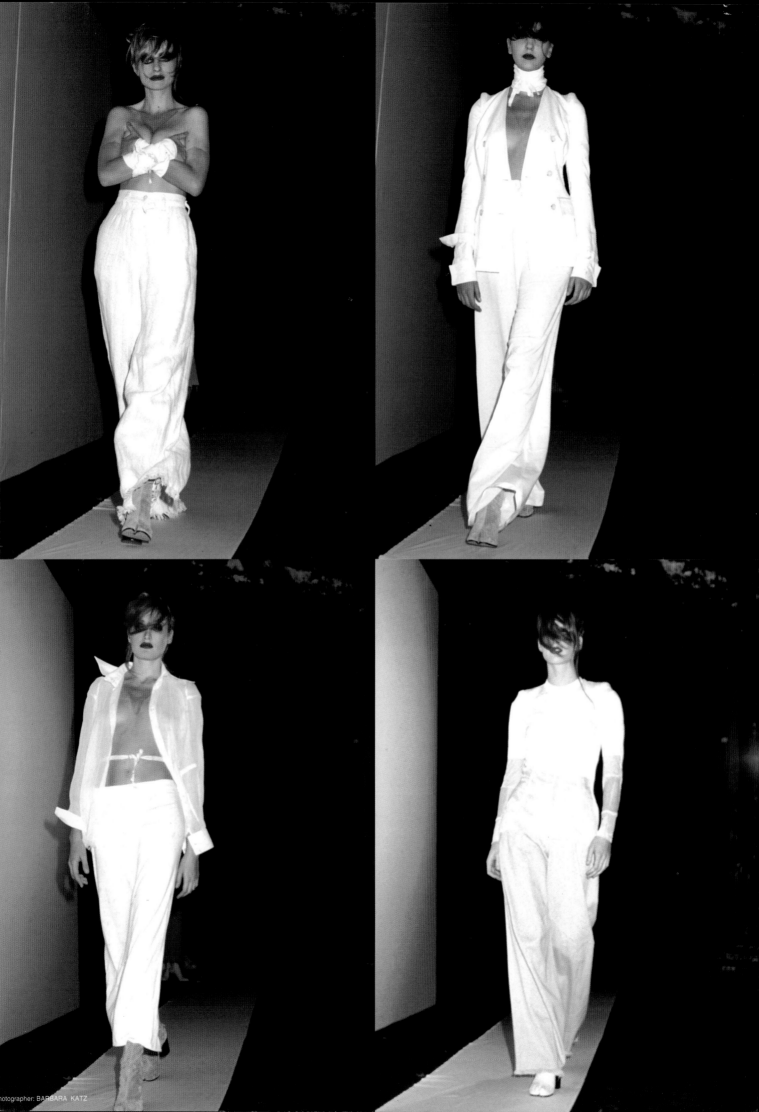

WINTER'89'90

ショールーム

Rue Réaumur Paris 75002

プレゼンテーション

1989年3月

パリのフリーペーパー"Paris Boum Boum"にインビテーションの広告を出す。"EL GLOBO"という地下にあるディスコで行う。音楽はロックグループがライブで70年代の映画音楽を演奏。モデル達は舞台で演奏しているミュージシャンの中から現われ、金色の席にすわった観客に向かって下る。空間はプラスティックで縁どられている。メイクは汚れた感じにし、黒のアイライナーで太く目の輪郭を強調する。口紅はこげ茶を塗り、そして、指には黒のリボンを巻きつけ、鏡の様なつけ爪をつける。そしてヘアーにはパウダーをふりかけ、リボンで束ね、ハイネックの衿の中に隠す。

コレクション

いろんな茶系、炎の様な青、そしてグレーに黒にミックスする。トラディショナルなメンズ素材を一度洗ったり、いろんな素材でベスト（ジレ）を作る。例えば最初のコレクションでモデル達が赤ペンキの靴跡を残したコットンだったり、こわれた食器だったり。この、コレクションでは以前に増して、足首丈のものを揃え、そのシルエットの中にニットもの、ベスト、シャツ、セーターなどをプラスし、それらにウエストベルトとして茶のスコッチテープを巻く。フィナーレにはモデル達全員、オートクチュールの白衣で、ネックラインをシルバーのスパンコールでデコレイトする。

Showroom

102 Rue Reaumur, Paris 75002.

Presentation

March 1989

An advertisement is placed in 'PARIS BOUM BOUM ', a free newspaper, inviting people to the show at 'EI Globo', a basement discothéque. Music from 1970's movies plays along with a live rock band. The models appear amid the musicians on stage and move amongst the crowd seated on gold chairs . The space is lined with plastic . Model's faces are blemished, a thick line of black eye make-up elongates their eyes, their lips are painted dark brown. A black ribbon is interwoven through the model's fingers, their nails are mirrored, powdered hair is tied to the neck with ribbon which is hidden by high collars.

Collection

A range of browns is mixed with petrol blues, greys and blacks. Washed man's suiting fabrics, felted knits and four piece suits with cropped jackets, waistcoats and mini-skirts worn over trousers. Waistcoats are in many forms, some made from the red paint stained runway cotton from the first show, others, made from broken dishes and wire. A series of garments lengthened to the ankle: waistcoats, shirts and sweaters. Waists belted with brown scotch tape. All models pass as a finale in white 'Haute couture' work coats, their neckline decorated with silver glitter.

PARIS 23 OCTOBRE 1990

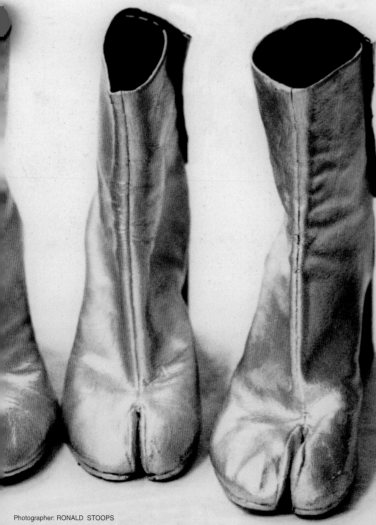

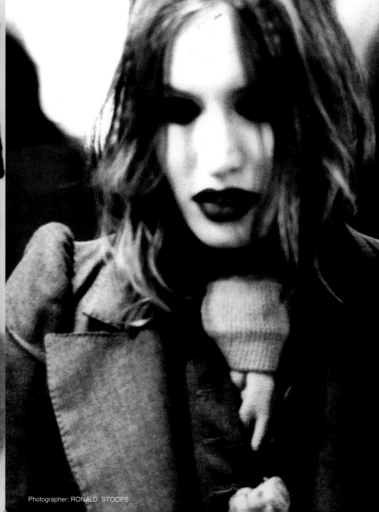

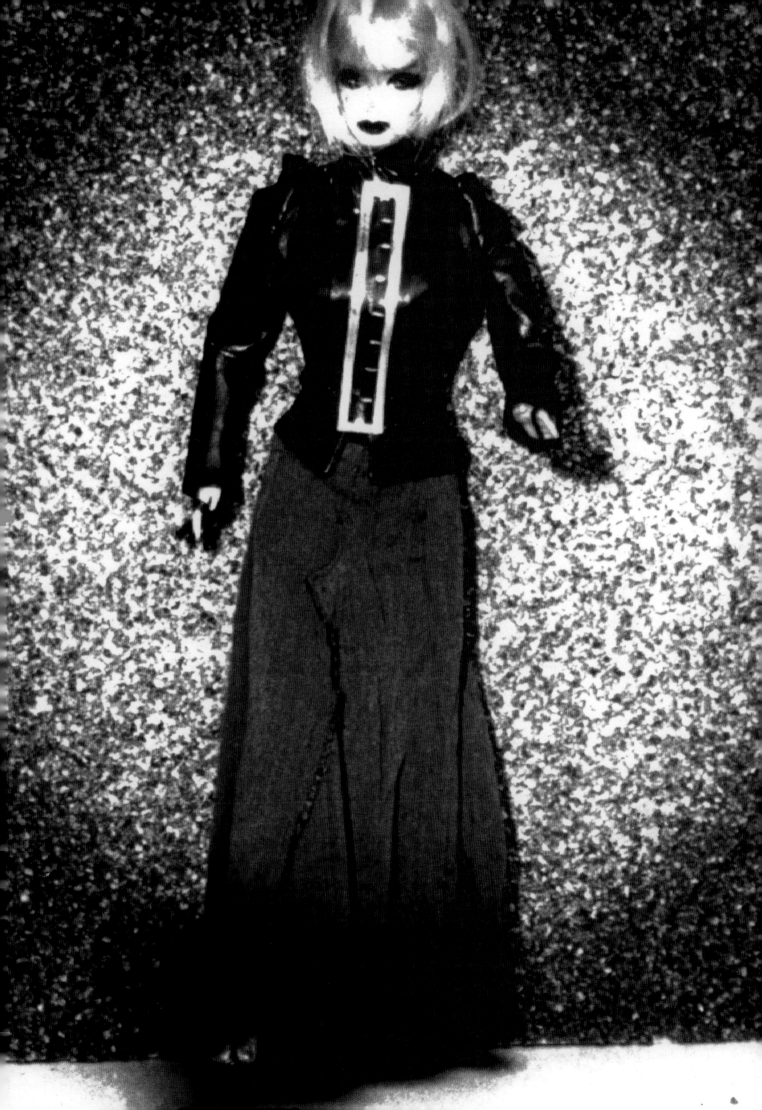

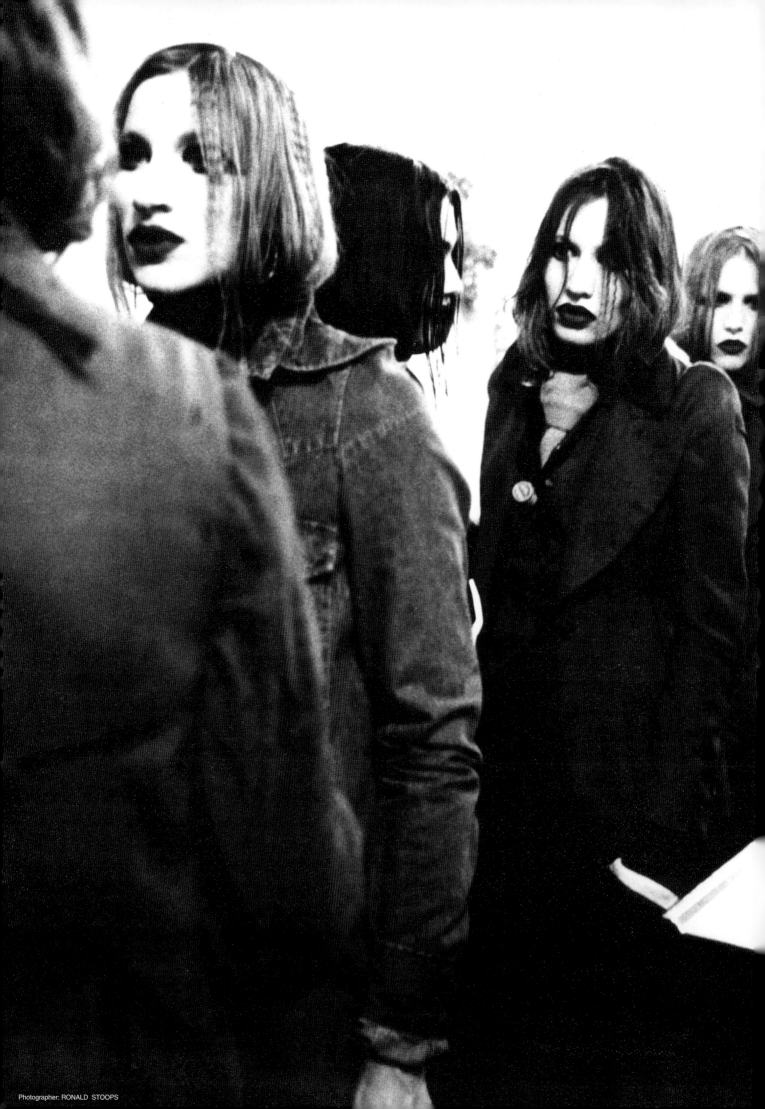

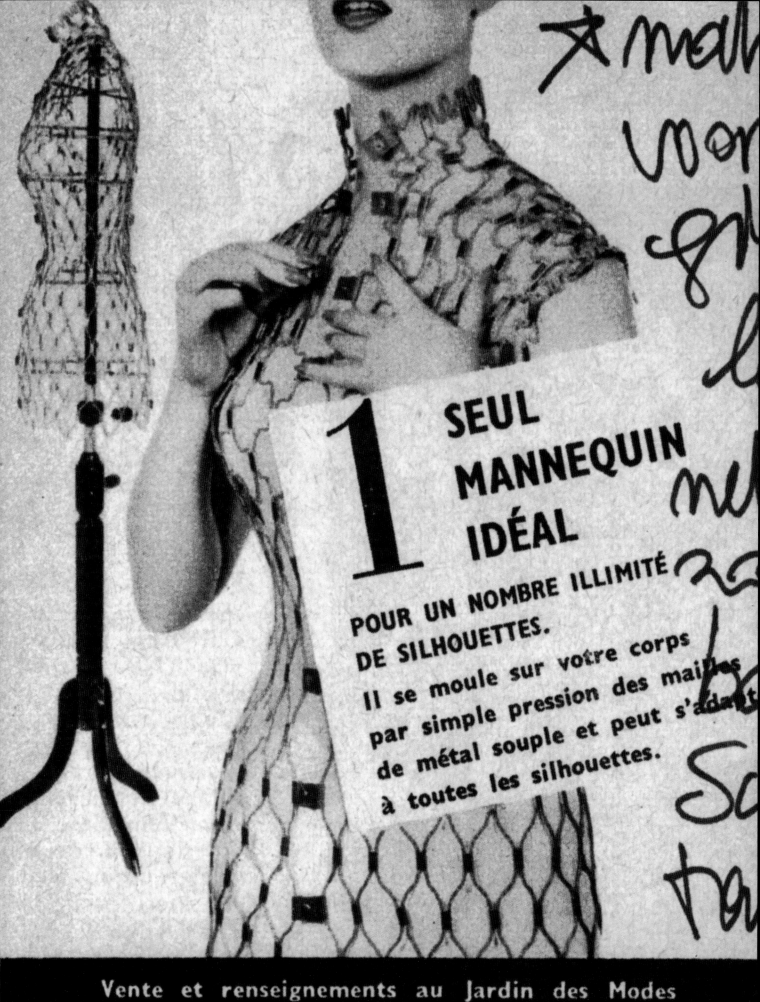

1 SEUL MANNEQUIN IDÉAL

POUR UN NOMBRE ILLIMITÉ DE SILHOUETTES.

Il se moule sur votre corps par simple pression des mailles de métal souple et peut s'adapter à toutes les silhouettes.

Vente et renseignements au Jardin des Modes
13, rue St-Florentin-Paris 8ᵉ.
Prix : sans pied 12.000 frs, avec pied 13.900 frs.
Port en plus. Demandez conditions de vente à crédit.

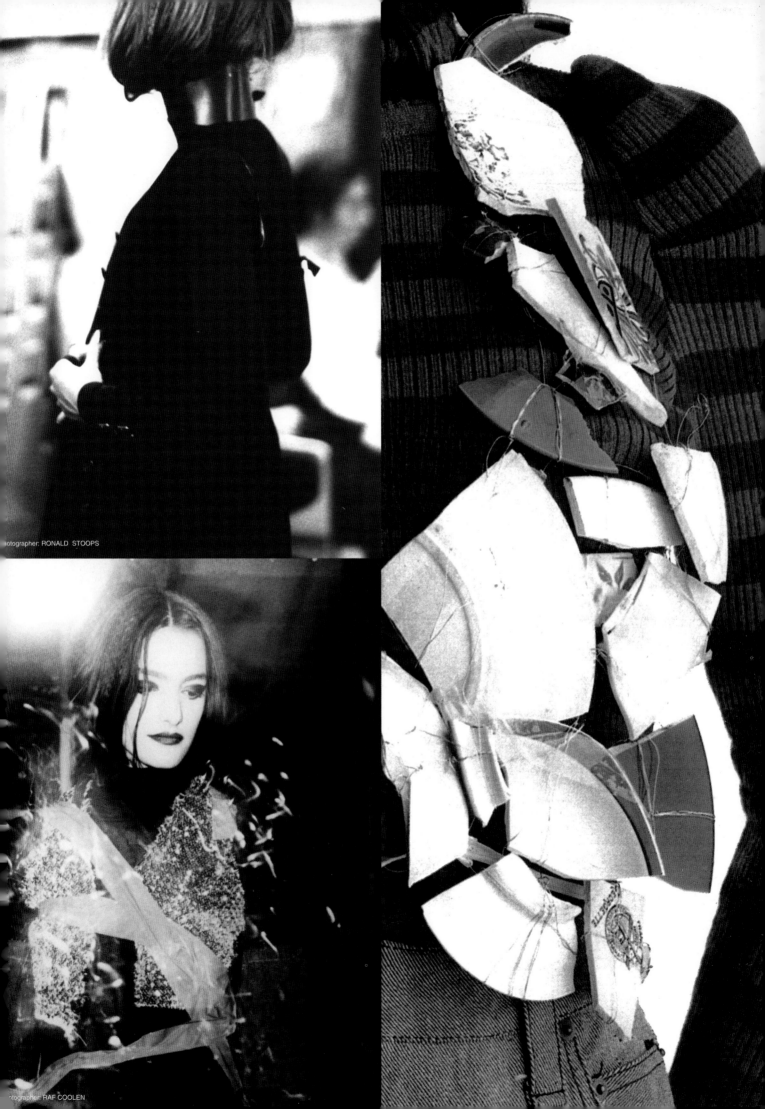

SUMMER'90

ショールーム

Rue Rumur Paris 75002

プレゼンテーション

1989年10月

場所は20区にあり、インビテーションカードは地元の子供達に書いてもらう。モデル達はロックミュージックの中を観客達と同じ高さを歩く。ヘアーは、シニヨンを乱したものに長いつけ毛を加える。目のラインを白に入れ、口紅に光りを与える。その地区の子供達を招待し、ショーに参加してもらう。

コレクション

全て白系、生成りからグレー系まで。レディスもののコンビネゾンを200％に拡大しスカートとして着用、ウエストをベルトで締めたり、フィットするTシャツの下にドレープをつけて着る。肩幅を切り詰めたジャケットの袖を切り落とし、大きなスナップボタンをつける。オブジェを使ったシリーズ、例えばメタル、紙、透明なビニールや、スーパーマーケットの袋をTシャツとして着る。多くの服をヒップで締め、上半身はアンダーサイズのトップ、シルバーのスパンコールをネックラインにデコレイトする。（18世紀のハープシコードの音楽がスピーカーから流され）フィナーレは全員オートクチュールの白衣を着て、紙吹雪をまき散らす。

Showroom

102, rue Réaumur, Paris 75002.

Presentation

October 1989

In an area of wasteland in Paris' 20th arrondissement. Invitations are handpainted by local children. The women walk along the ground. Rock music plays. Hair is in undone chignons with long hair pieces. Eyes are surrounded with white paint, lips are glossed. Children from the area, invited to come and see, join the models in their procession.

Collection

All is either white, flesh coloured or grey. Women's slips twice their normal size are worn as long skirts belted at the waist or draped under fitted T-Shirts. Fitted jackets with their sleeves cut-off, left frayed and closed with snappers. A series of garments made from metal, paper or transparent plastic and plastic shopping bags worn as T-Shirts. Most garments are tied around the hips, torsos are almost bare or with undersized tops. Silver glitter decorates the neckline. For the finale the women wear white 'Haute Couture' workcoats and scatter white confetti. Eighteenth century harpsichord music plays over loudspeakers.

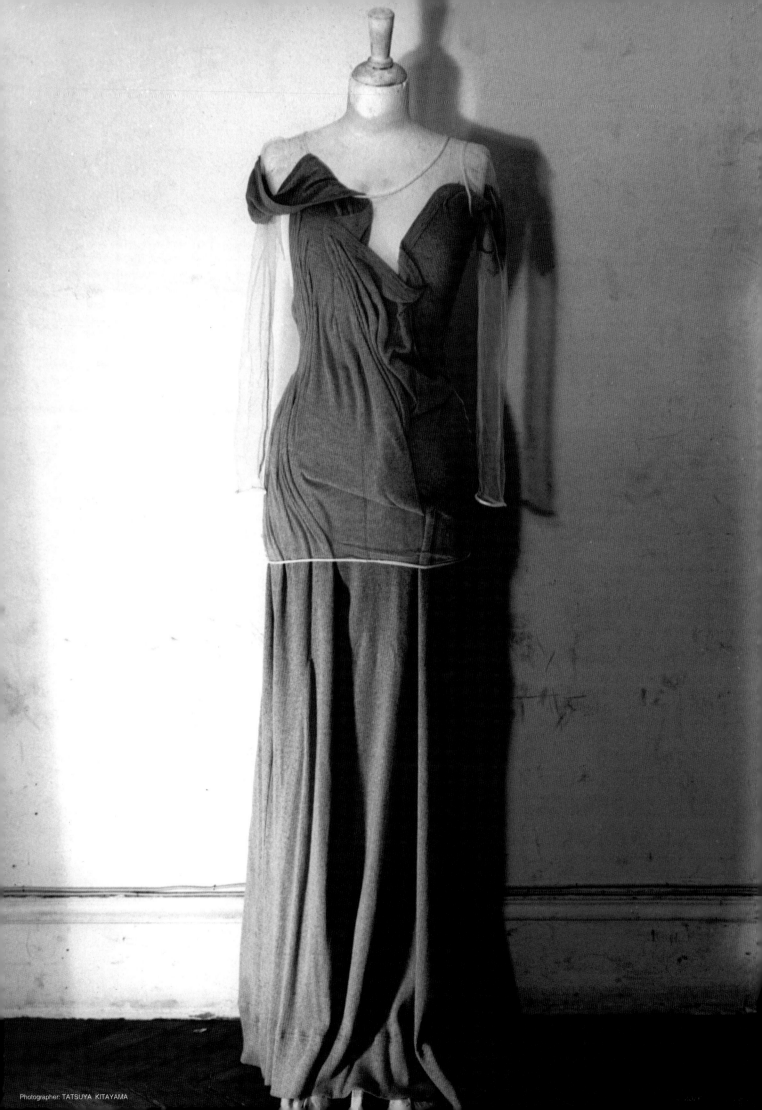

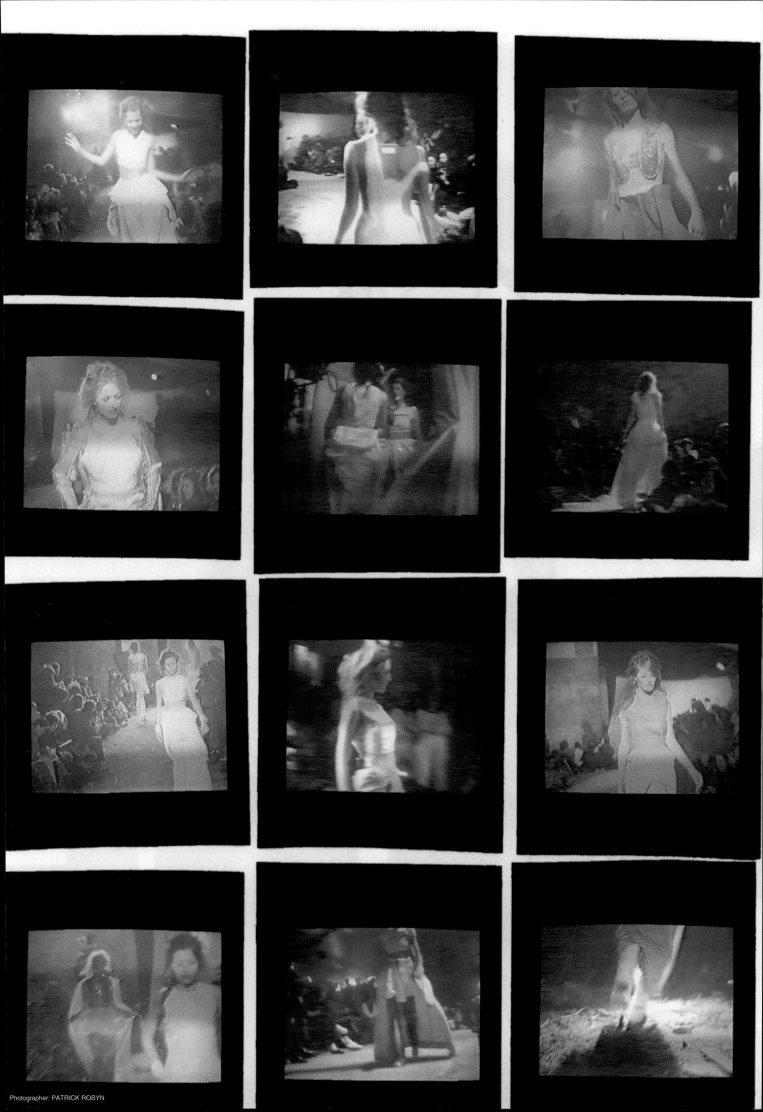

Photographer: PATRICK ROBYN

MARTIN MARGIELA ÉTÉ 90

martin margiela été 90

INVITATION

INVITATION

MARTIN

INVITATION

Martin
Margiela
été 90

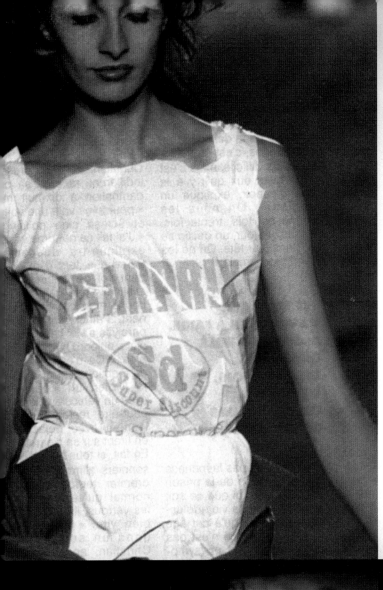
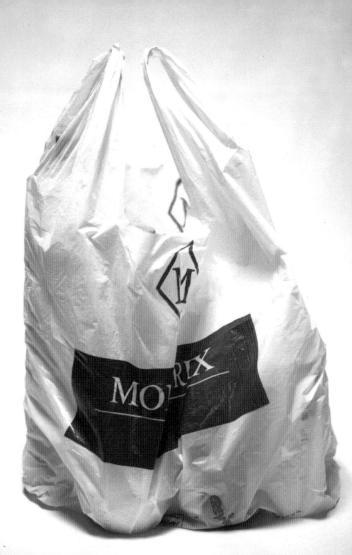
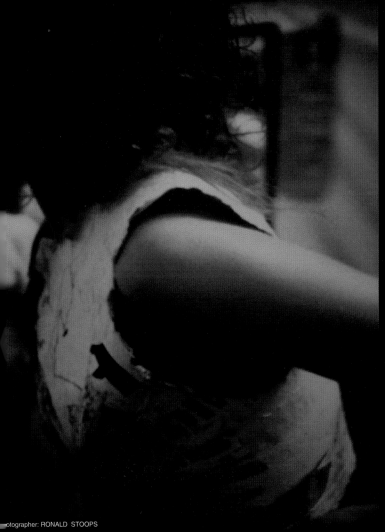
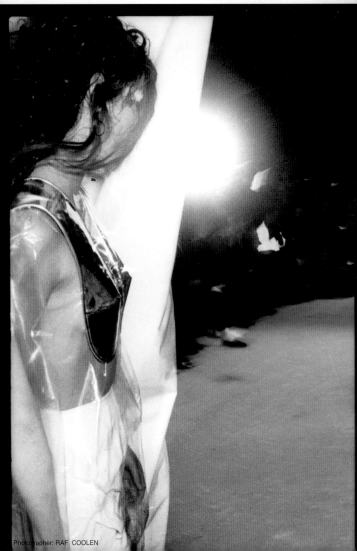

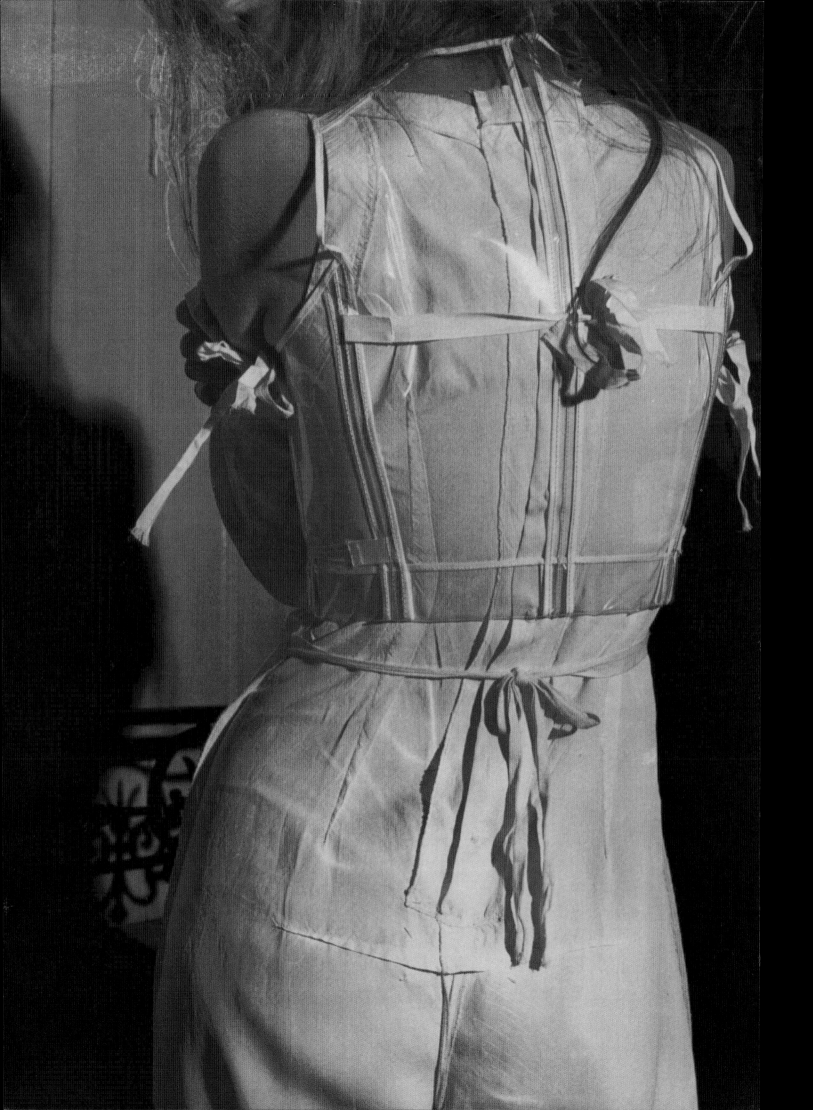

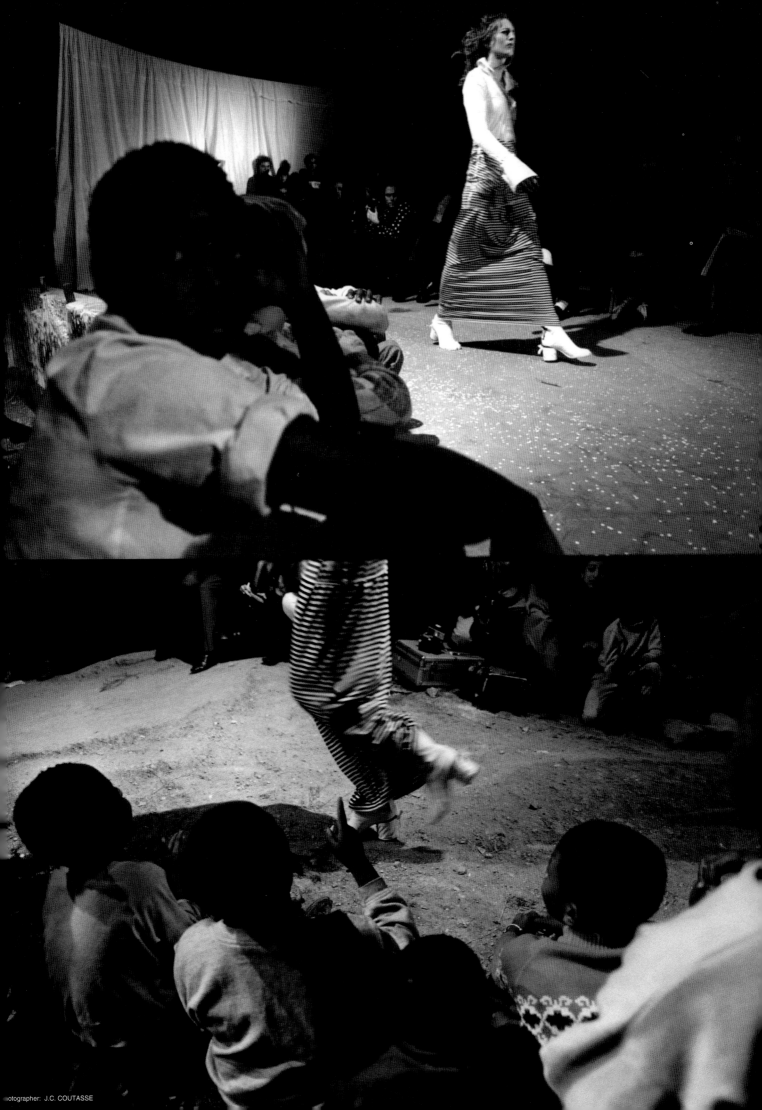

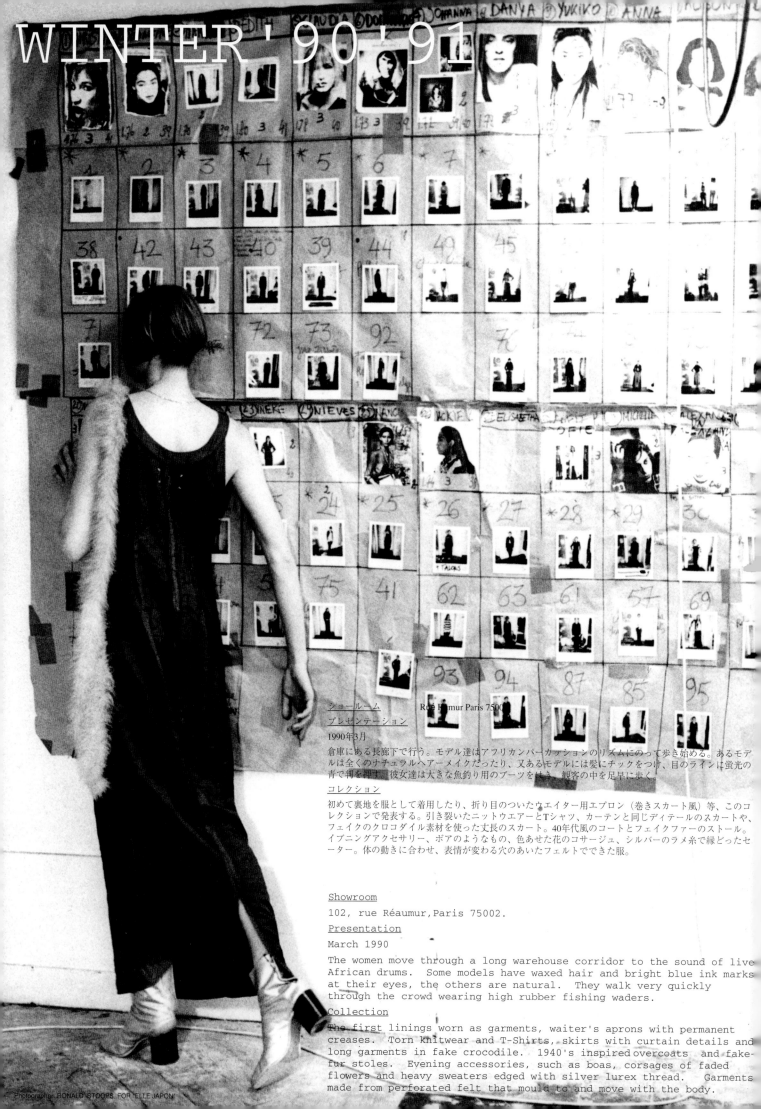

WINTER '90 '91

ショールーム　　　　　Rue Réamur Paris 75002

プレゼンテーション

1990年3月

倉庫にある長廊下で行う。モデル達はアフリカンパーカッションのリズムにのって歩き始める。あるモデルは全くのナチュラルヘアーメイクだったり、又あるモデルには髪にチックをつけ、目のラインに蛍光の青で判を押す。彼女達は大きな魚釣り用のブーツをはき、観客の中を足早に歩く。

コレクション

初めて裏地を服として着用したり、折り目のついたウエイター用エプロン（巻きスカート風）等、このコレクションで発表する。引き裂いたニットウエアーとTシャツ、カーテンと同じディテールのスカートや、フェイクのクロコダイル素材を使った丈長のスカート。40年代風のコートとフェイクファーのストール。イブニングアクセサリー、ボアのようなもの、色あせた花のコサージュ、シルバーのラメ糸で縁どったセーター。体の動きに合わせ、表情が変わる穴のあいたフェルトでできた服。

Showroom

102, rue Réaumur, Paris 75002.

Presentation

March 1990

The women move through a long warehouse corridor to the sound of live African drums. Some models have waxed hair and bright blue ink marks at their eyes, the others are natural. They walk very quickly through the crowd wearing high rubber fishing waders.

Collection

The first linings worn as garments, waiter's aprons with permanent creases. Torn knitwear and T-Shirts, skirts with curtain details and long garments in fake crocodile. 1940's inspired overcoats and fake-fur stoles. Evening accessories, such as boas, corsages of faded flowers and heavy sweaters edged with silver lurex thread. Garments made from perforated felt that mould to and move with the body.

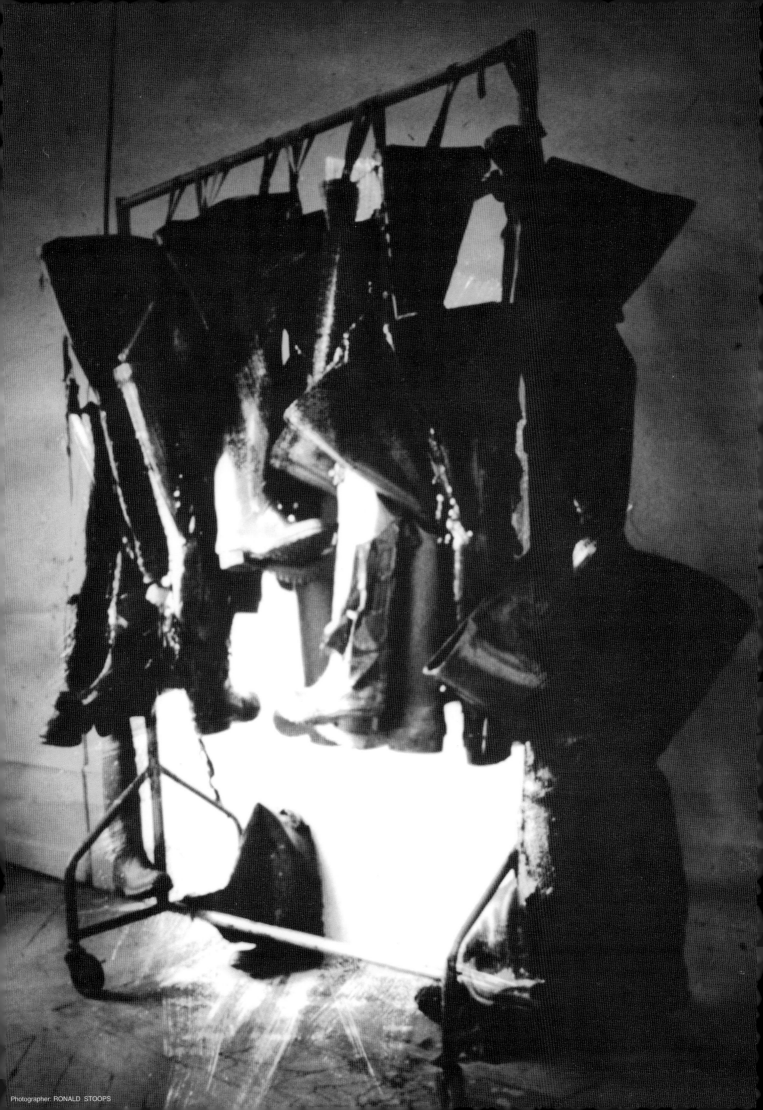

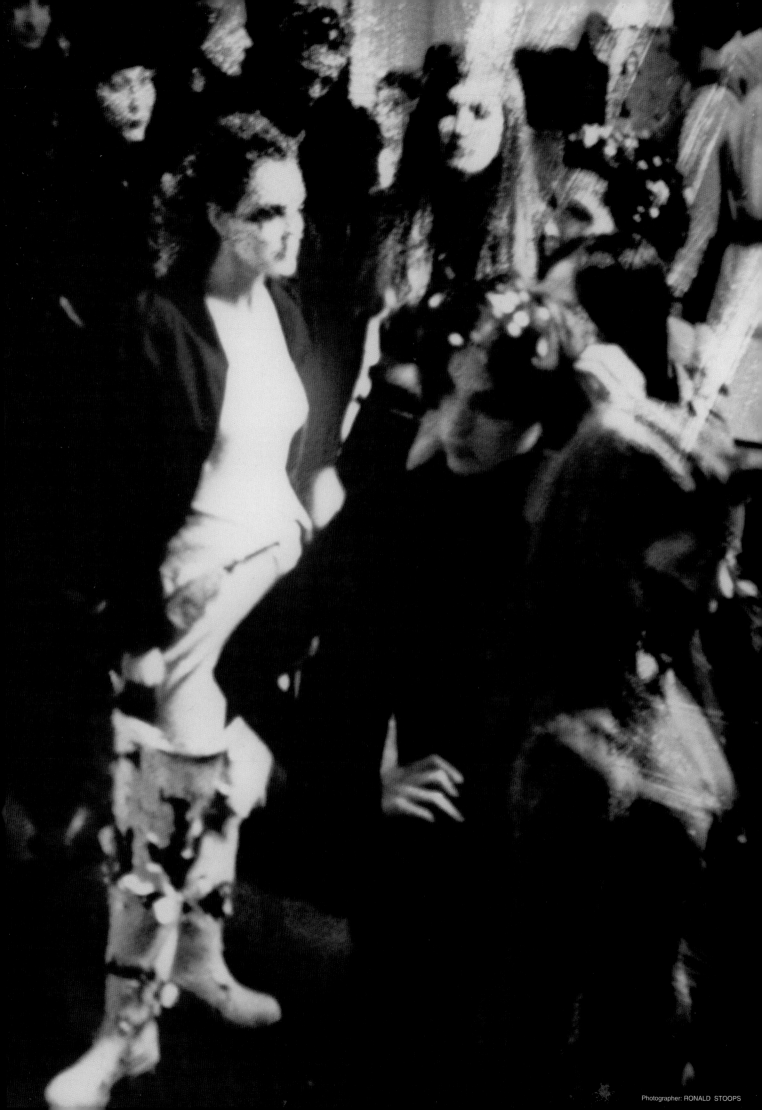

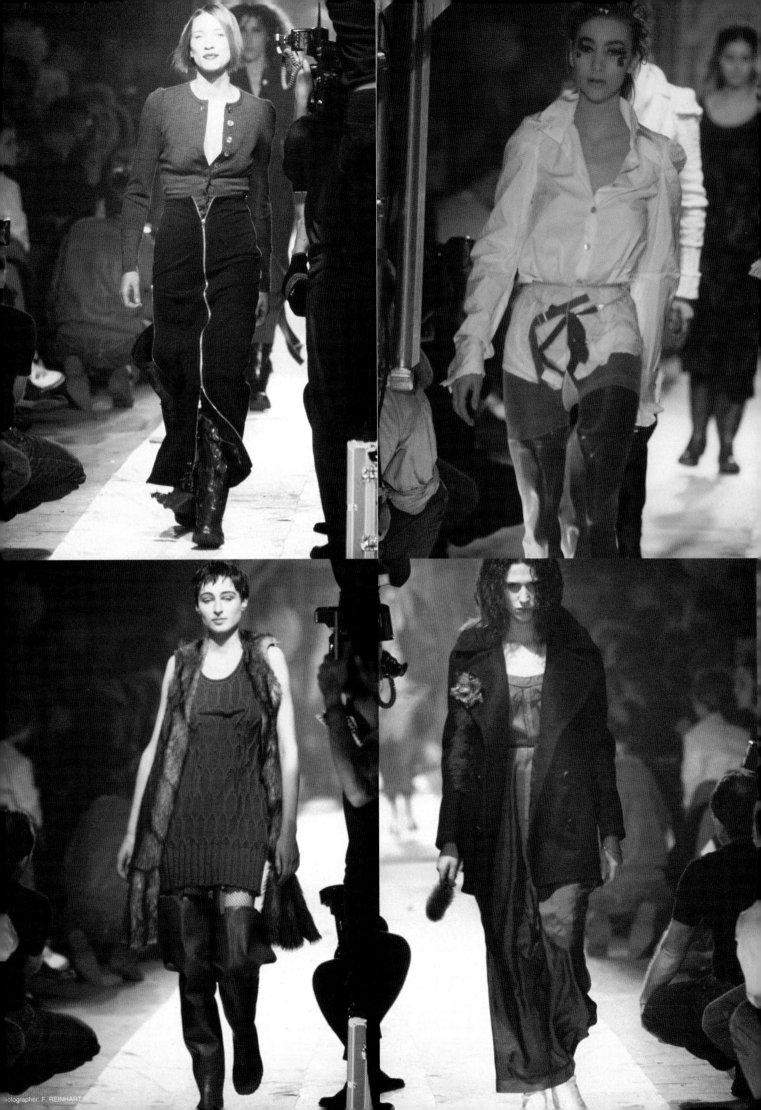

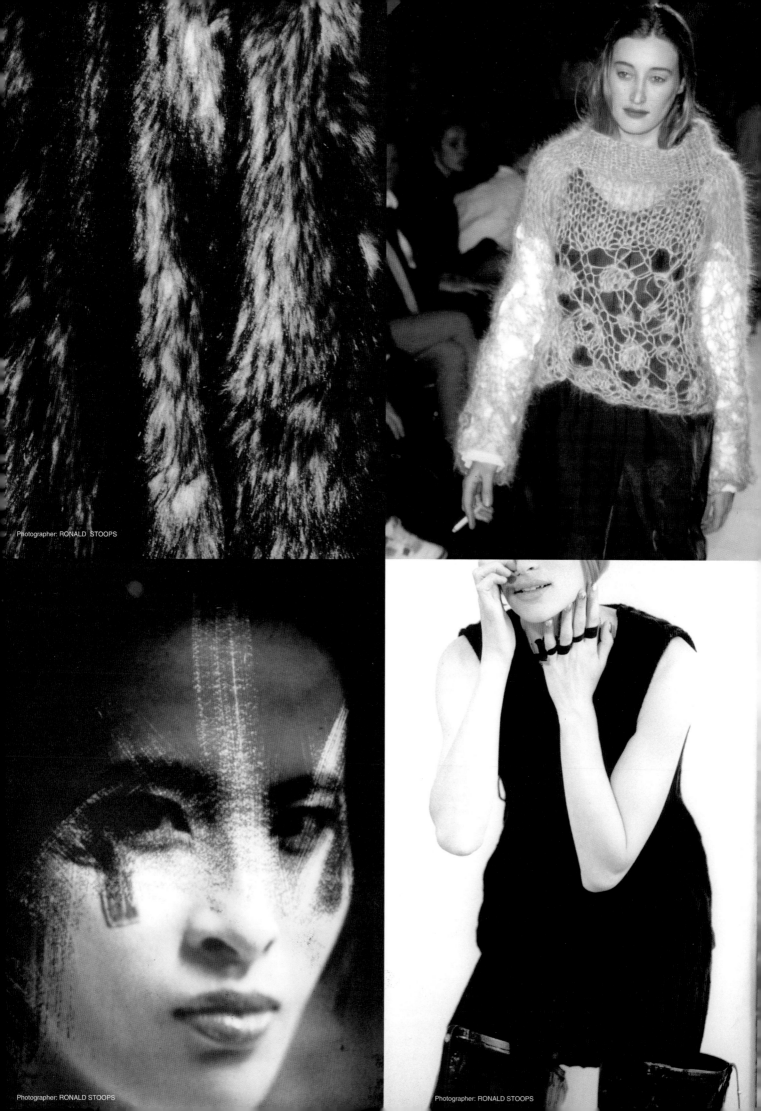

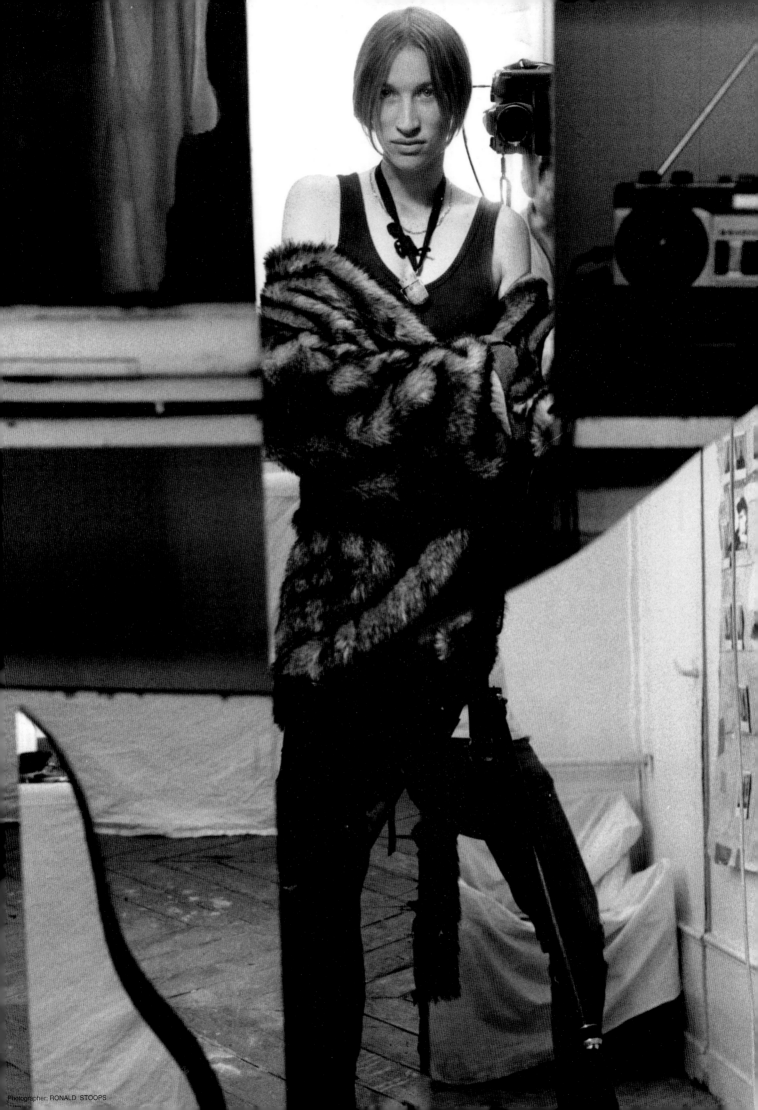

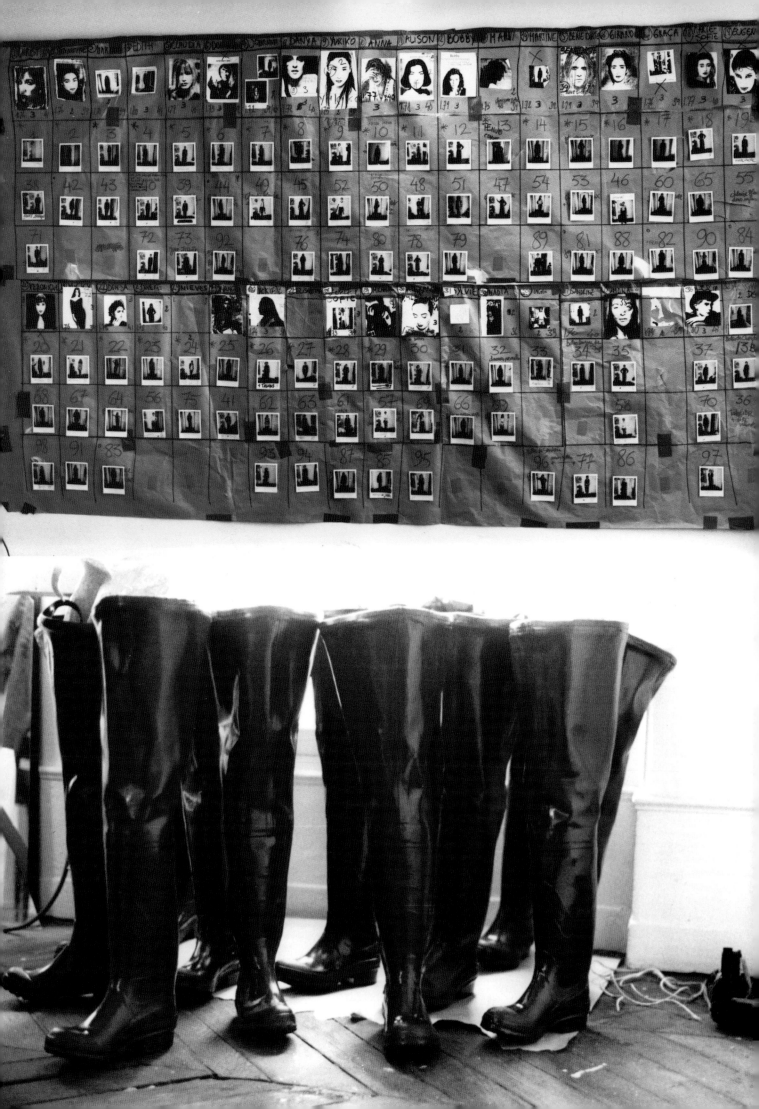

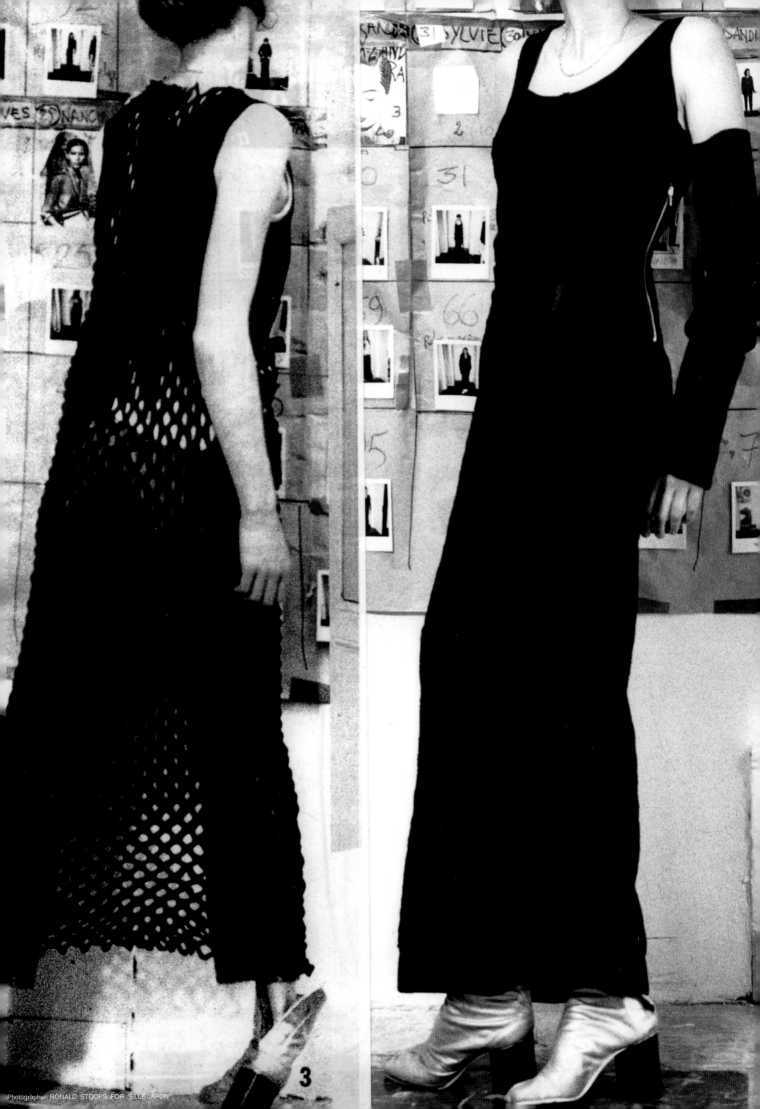

ショールーム

引っ越しをする。13, bouleverd St-Denis Paris 75003の3階、6部屋からなるこのアパートメントも無頓着なやり方で白に仕上げ、白い布で覆ったシャンデリアでライティングをする。そこに始めてアーティザナル（職人的製作）の、古着や古物の作り変えの、アトリエを設置する。

プレゼンテーション

1990年10月

バルベス地区にある広い空の駐車場で行う。赤ワインがテーブルにセットされる。モデルのためのステージはない。空間と観客が真っ暗闇に置かれる。やがて強いスポットライトが観客達に向けられ、観客はそのライトを避ける様に動く、そして自然とモデルのための通路が、作り出されていく。60人の様々な年齢のモデル達は、全員パッチョウリの香りに包まれ、観客達の間を行きかう。髪にはバラの花びらを散らせる。

コレクション

50年代ビンテージのロングドレスをグレーに後染めし、前中心を切り開き、古いジーンズに合わせる。色々なスタイルのイブニングドレスが、洗いざらしにされたり、始末をしていないコットンチュールが、普通のTシャツの上に組み合わされる。又、古着のGジャンとジーンズをロングコートに作り替える。そして彼女達は木のプラットフォームを付けた足袋を履く。

Showroom

Change of address to 13, Boulevard Saint Denis, Paris 75003.

A six room apartment where all is painted white in a carefree fashion, lit by white muslin covered chandeliers and where, our first workshop for the 'Artisanal' production (reworking of used clothing and objects) is set-

Presentation

October 1990

Held in a vast, empty, enclosed car-park near Barbés, Paris. Red wine is set out on tables. There is no podium for the models. The space and invited crowd are plunged in darkness. Strong spotlights are trained on the crowd who then part to make way for the women wearing the collection to pass. Sixty women of varying ages, heavily scented with patchouili oil, coil their way through the crowd, rose petals in their hair.

Collection

Vintage 1950's ball gowns, overdyed in grey, cut as waistcoats and worn with old jeans. Many pieces of evening clothes of various styles washed and unfinished cotton tulle are worn over basic T-shirts. Second hand jeans and jeans jackets are reworked into long coats. Wooden platform clogs with 'Tabi' toes are worn on their feet.

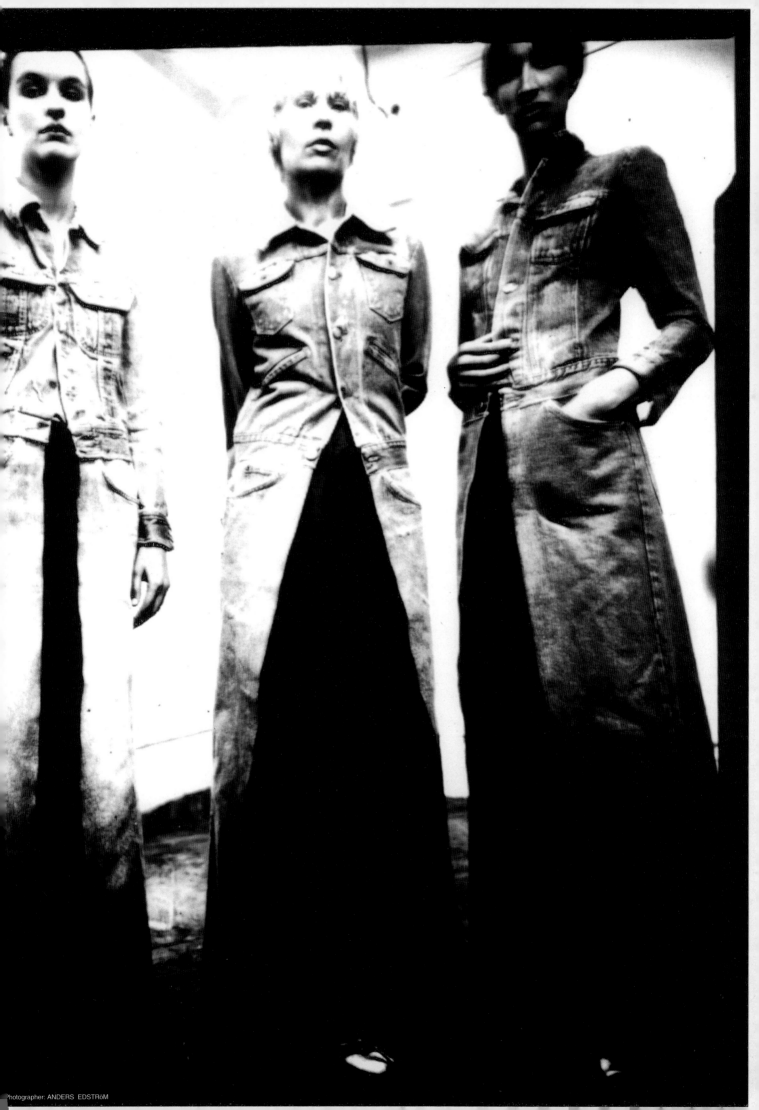

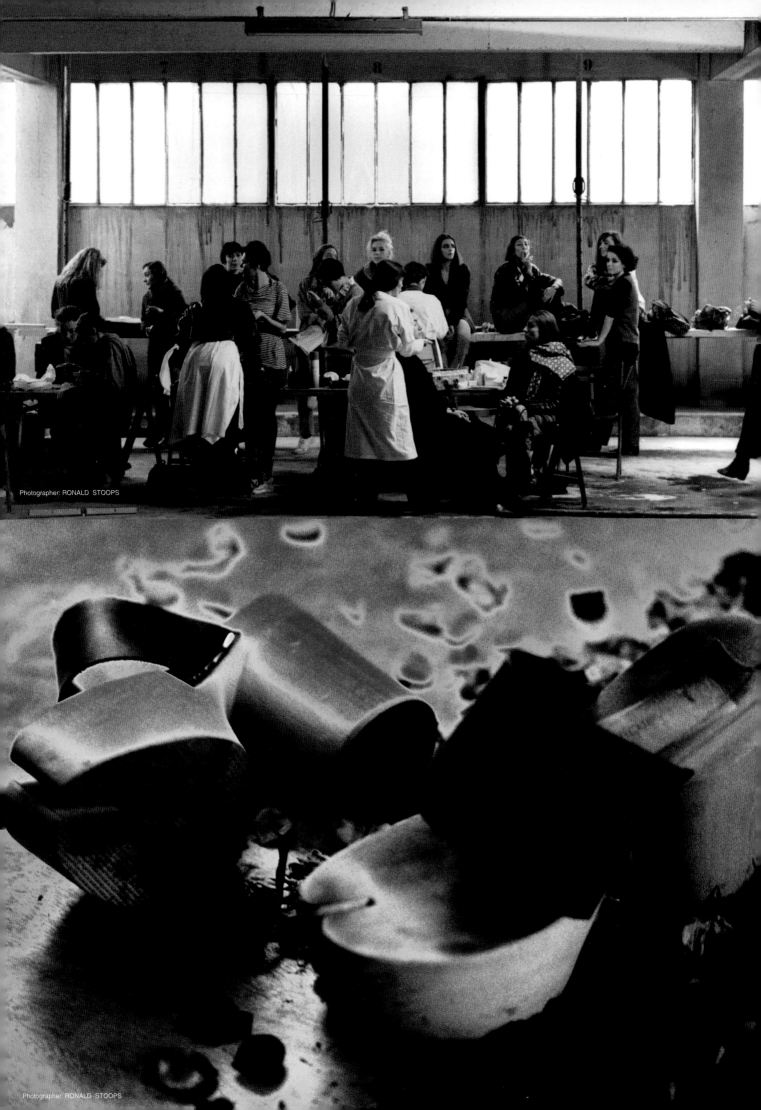

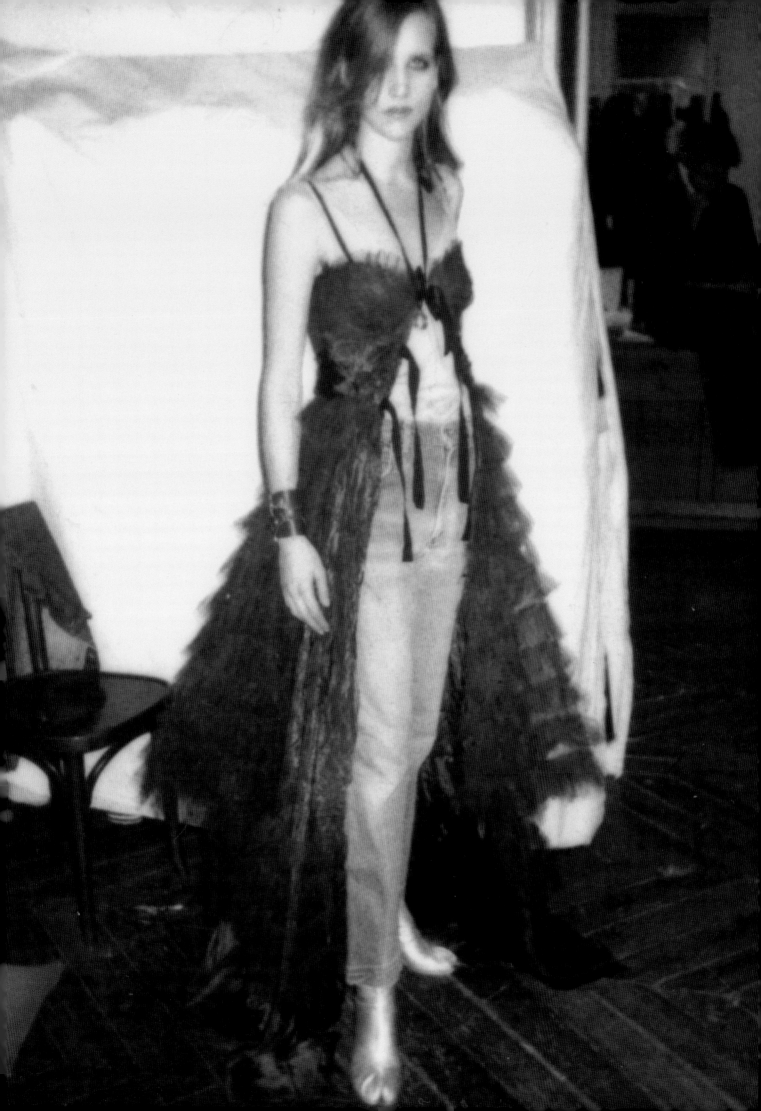

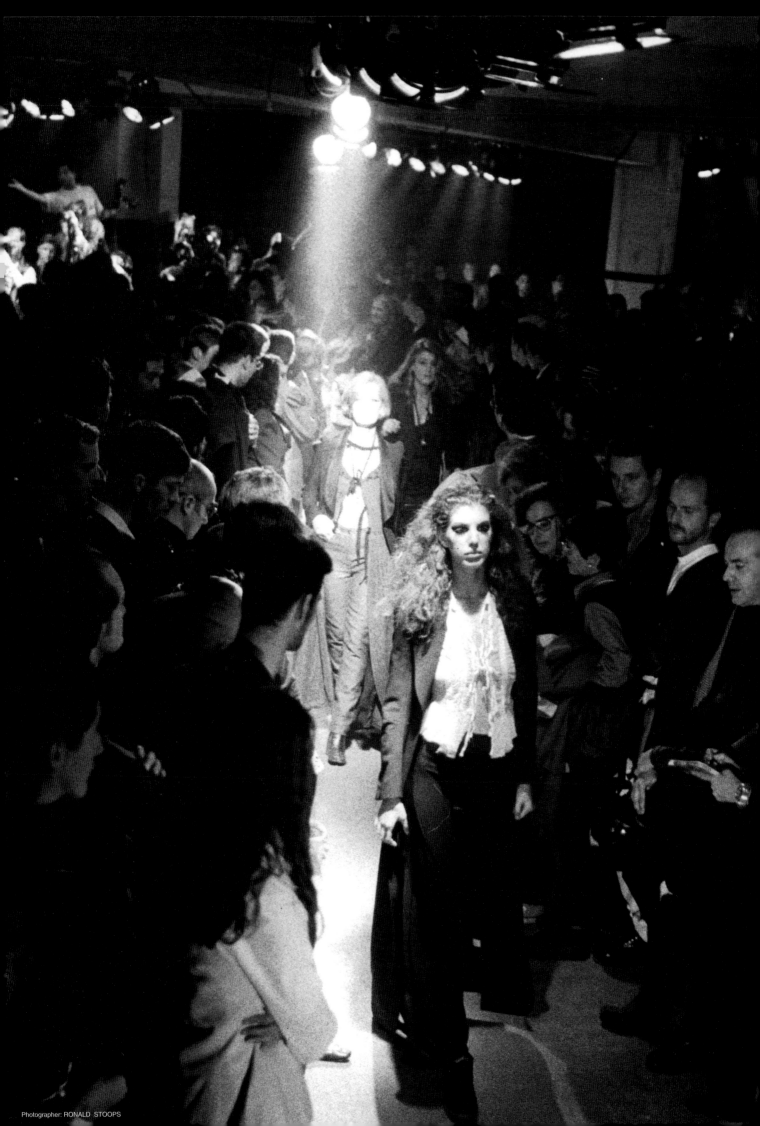

Photographer: TATSUYA KITAYAMA

Photographer: RONALD STOOPS

PATCHOULI 10 ml
SENTEUR
extrait
de
parfum
EMB.
01053
prim'style france

Photographer: RONALD STOOPS

ショールーム
13 Bld St-Denis Paris 75003

プレゼンテーション

手書きの電話番号を招待者に送る。その電話番号にかけると留守番電話のアナウンスでプレゼンテーションの場所、時間が聞ける様になっている。その日一日を"Portes Ouvertes"（ギャラリーと同じ仕組で、誰でもフリーで入れる）にする。招待者達は自由に部屋から部屋へと移動できる。最初の部屋には、今までに雑誌掲載されたコピーを敷き詰める。そして、赤ワインが置いてあるテーブルが次の部屋へと導く。その部屋は壁一面に落書ができる様にし、自由に書き込める。3番目の部屋のドアには"赤"の言葉の定義を拡大したものを貼る。その部屋の中は全てが（モデルの服も、ベルベットのアームチェアも壁も）真っ赤だ。そして、布をかけたシャンデリアがある大きな部屋では、新コレクションをスーパー8で撮影したものを壁に投影する。最後の部屋は真っ白で、モデル達が、小さな白い紙ふぶきを投げ合う。

コレクション

黒のフェルト又はベロアでできた丈の長いケープを作ったり、服を白のラテックスで塗ったり、又ミリタリーの靴下をパッチワークでセーターに仕立てる。そして、"ネイビー"セーターは、いくつかのパーツに切り落とされ、袖と、衿の部分を別々に着て、ボディの部分はVネックのタバード（官服）の様に着せられる。サイドレスの服のシリーズでは、前身は後身で結ばれ、後身は前身で結ばれる服。前回のコレクションで使った木のプラットフォームは、靴に改変され、木の部分にフェルトをホッチキス止めする。

<u>Showroom</u>
13, Boulevard Saint-Denis, Paris 75003

<u>Presentation</u>
March 1991

A handwritten telephone number, connected to an answering machine giving the time and place of the presentation, is sent to the invitees. The presentation is an 'open day' at the showroom. The public may move through the space room by room. The floor of the first room is carpeted with our press cuttings. A layed table with beakers of red wine welcomes them into a second room, its bare walls may be graffittied.An enlarged definition of the word red is put on the door of a third room in which everything - the outfits of the women, the velvet covered armchairs and the walls - are red. In another larger room muslin dressed chandeliers hang and a 'Super 8' film showing the collection is projected on a wall. The final room is entirely in white, there, models throw white confetti about.

<u>Collection</u>
Long black capes in velvet or felt, garments painted in white latex, sweaters made from military socks. 'Naval' sweaters are cut apart, their sleeves and collar worn separately, the body worn as a 'V-Neck' tabard. A series of side-less garments, their front section is secured by a tie at the back, their back tied at the front. The wooden soled platform clogs of the previous season are adapted as shoes, a felt upper is stapled to the wood.

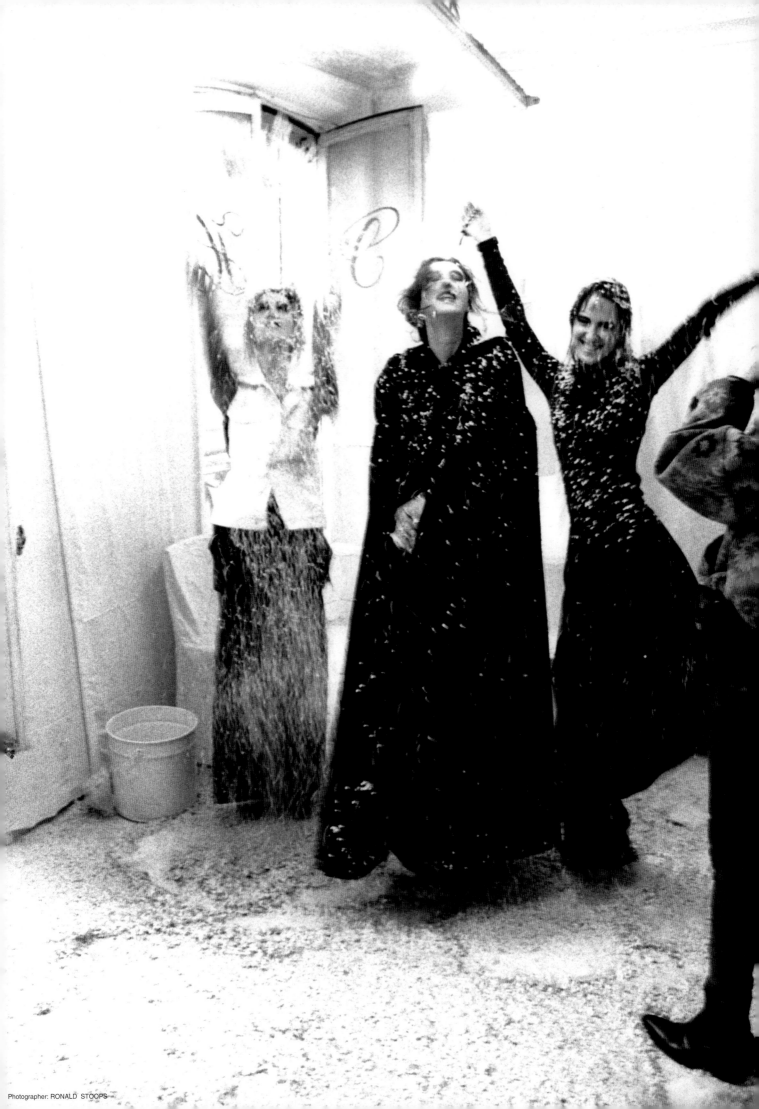

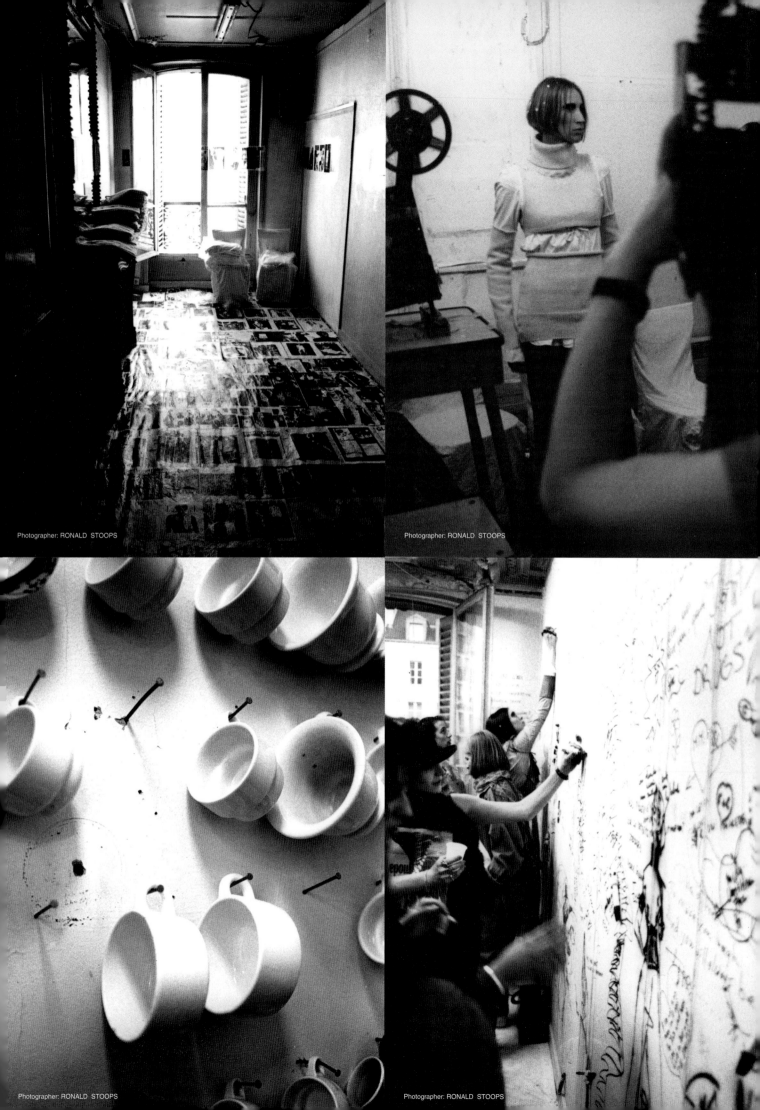

Photographer: RONALD STOOPS

Photographer: RONALD STOOPS

Photographer: RONALD STOOPS

Photographer: RONALD STOOPS

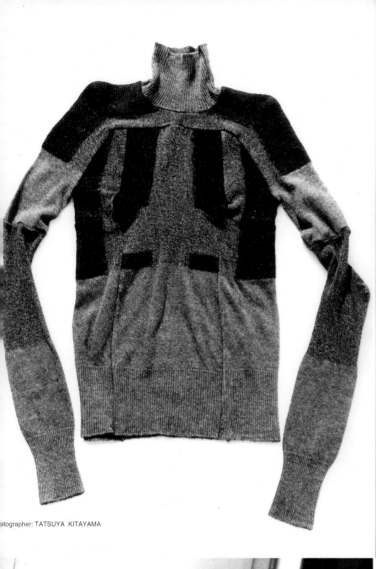

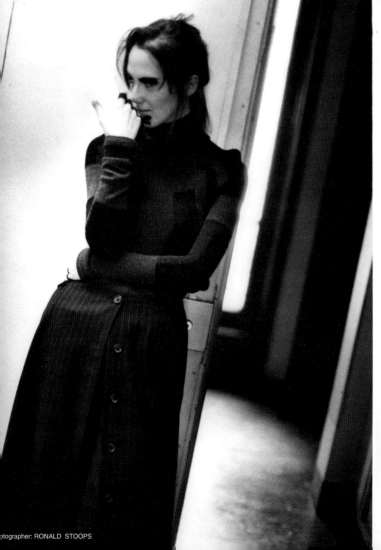

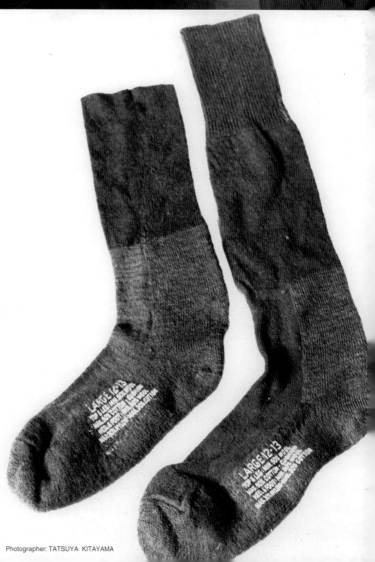

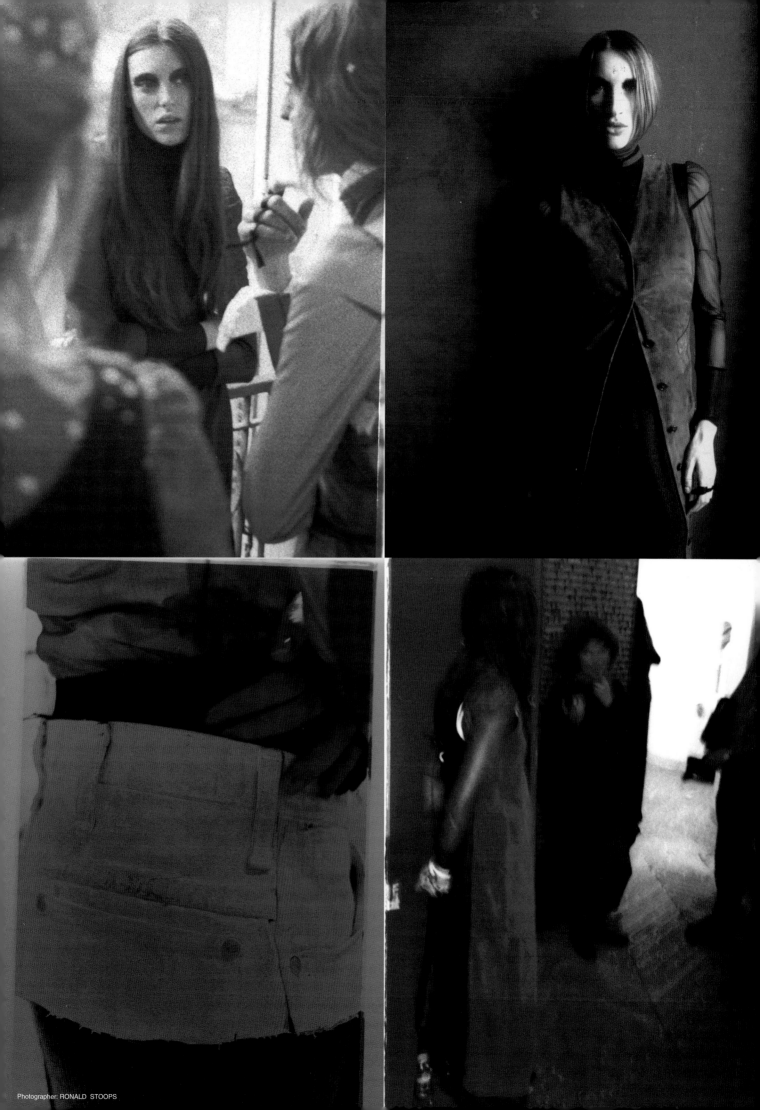

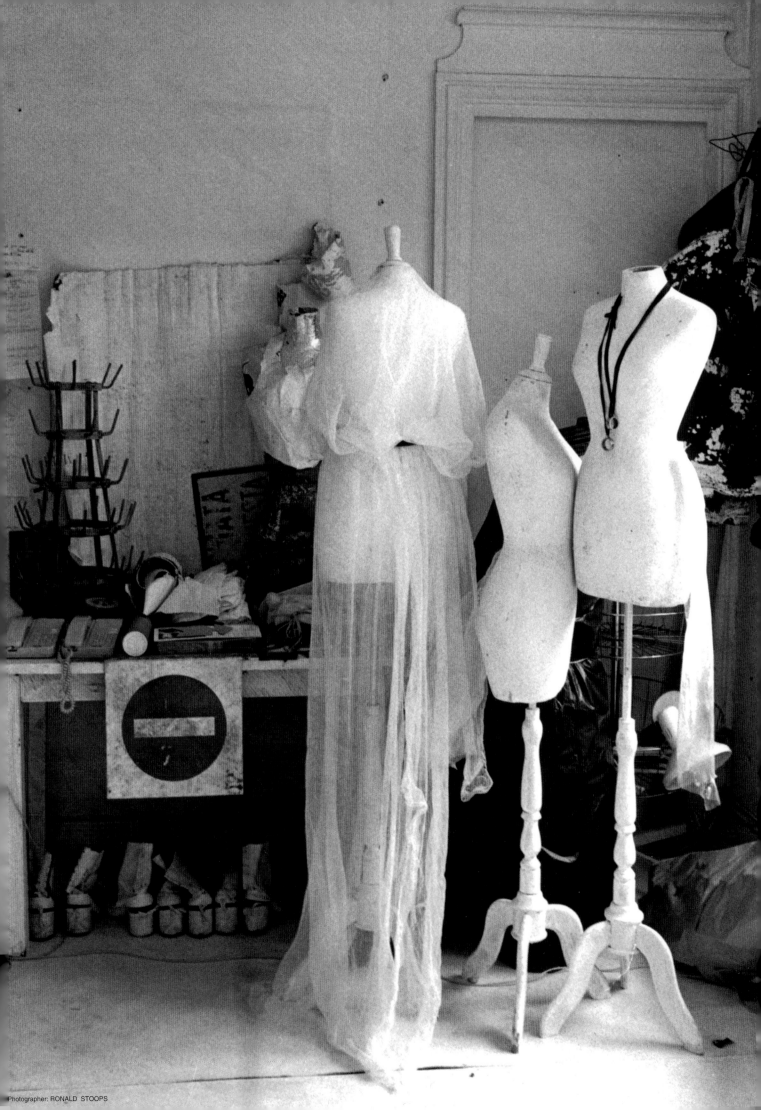

SUMMER '92

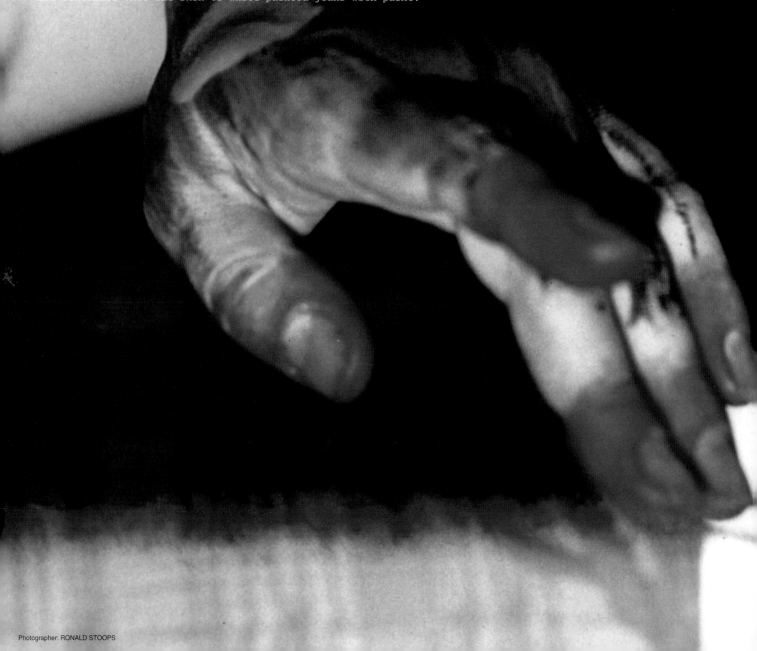

ショールーム

13, Bld St-Denis Paris 75003

プレゼンテーション

1991年10月

1939年より封鎖されているメトロ"St-MARTIN"の駅構内で行う。1600本の教会用の大蠟燭を3つのメイン階段に立て、照明とする。ロックコンサートの拍手喝采の部分の音をバックに、モデル達は階段を登り降りする。メイクにフェイクのダイヤを目元に貼る。又、服の延長上にそのモチーフをボディペインティングする。

コレクション

どのシルエットも体にピッタリしたもので、マルチカラーにする。ほとんどの服は、いろいろな年代に使用されたスカーフを使い、体に巻き付けたりする。そして、チェック素材をプリーツ加工する事によって伸縮させ、Tシャツに仕上げる。大きなスナップボタンを使った透明素材の服はしわ加工をする。ヒップボーンのパンツの上にミニ丈のエプロンスカートを合わせる。アシンメトリックなTシャツは、もとの水平な縞模様を変え、その縞を肌や白く塗ったジーンズに延長してペイントする。

Showroom

13, Boulevard Saint-Denis, Paris 75003.

Presentation

October 1991

The Metro station 'Saint Martin' has been out of use since 1939. One thousand-six-hundred church beeswax candles lit the three main stairwells. The women wearing the collection descend and climb the stairs to a soundtrack of audiences clapping at rock concerts. Each woman has a rhinestone placed at the corner of each eye. The motifs of their garments continue onto their skin in body paint.

Collection

Each silhouette is multicoloured and close to the body. Most garments are made from used head scarves of varying periods and tied to the body. Permanently pleated polyester T-Shirts in 'Prince of Wales check' extend to take the form of the body. Transparent garments with large snap fasteners are permanently creased. Mini-aprons are worn on top of hipster trousers. Asymmetric T-shirts have distressed horizontal stripes which are continued onto the skin or white painted jeans with paint.

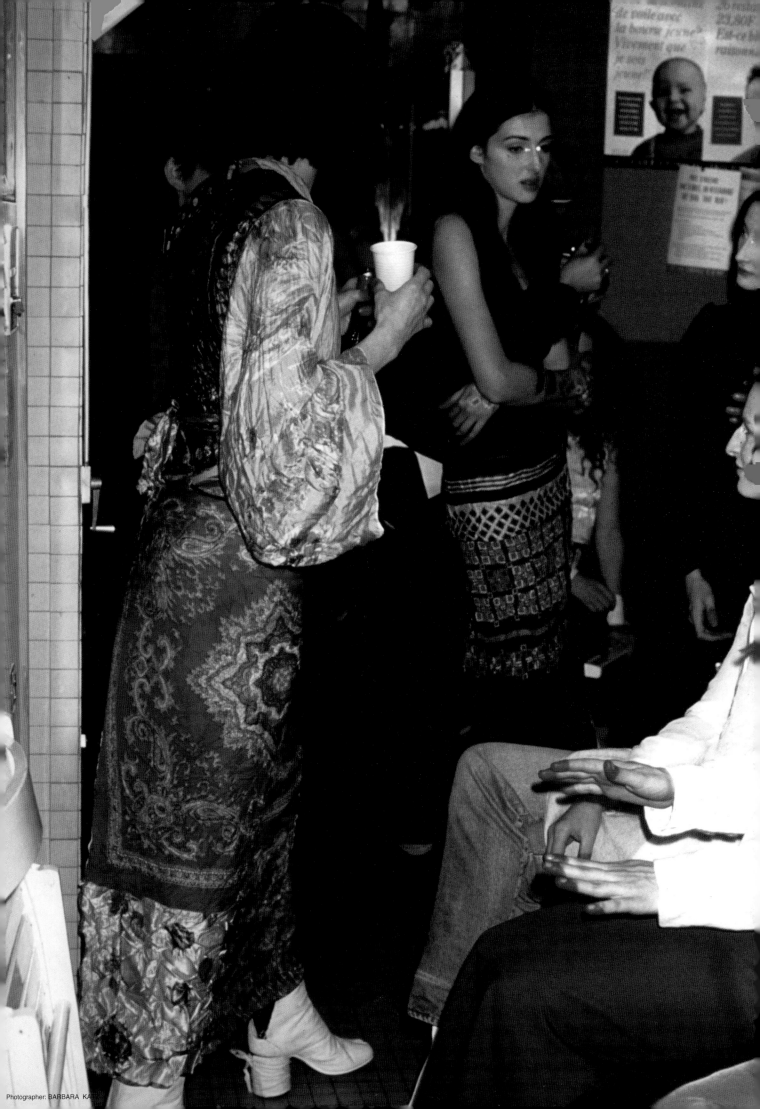

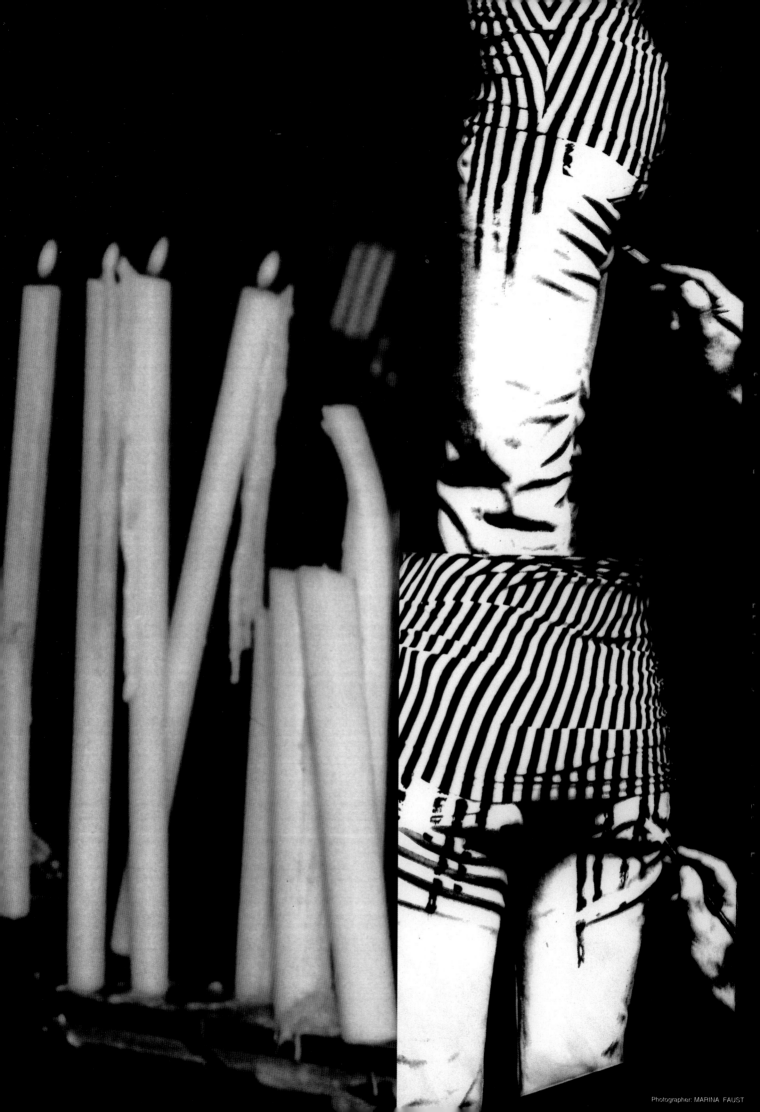

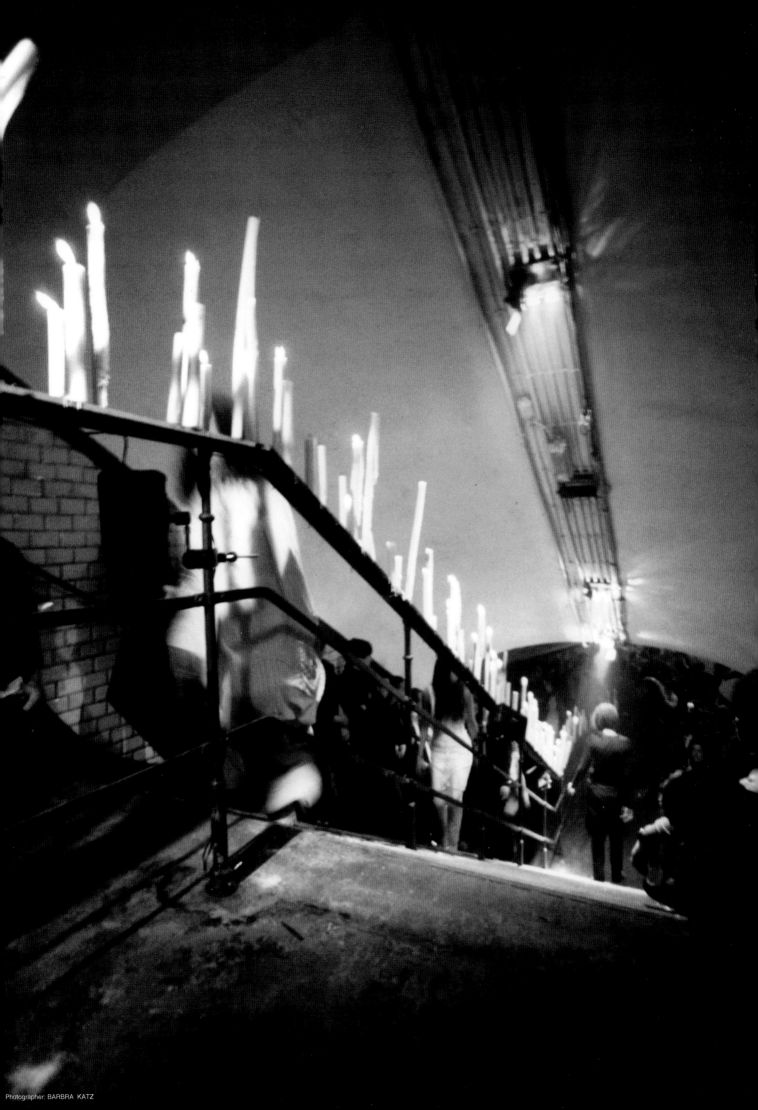

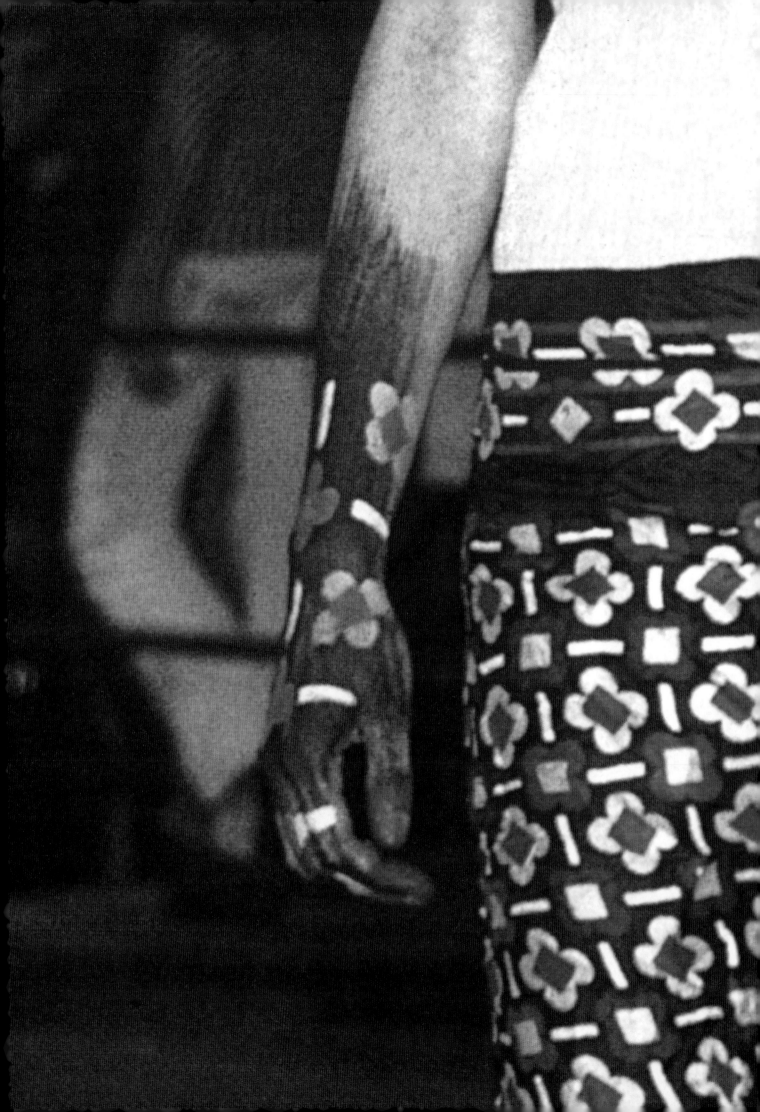

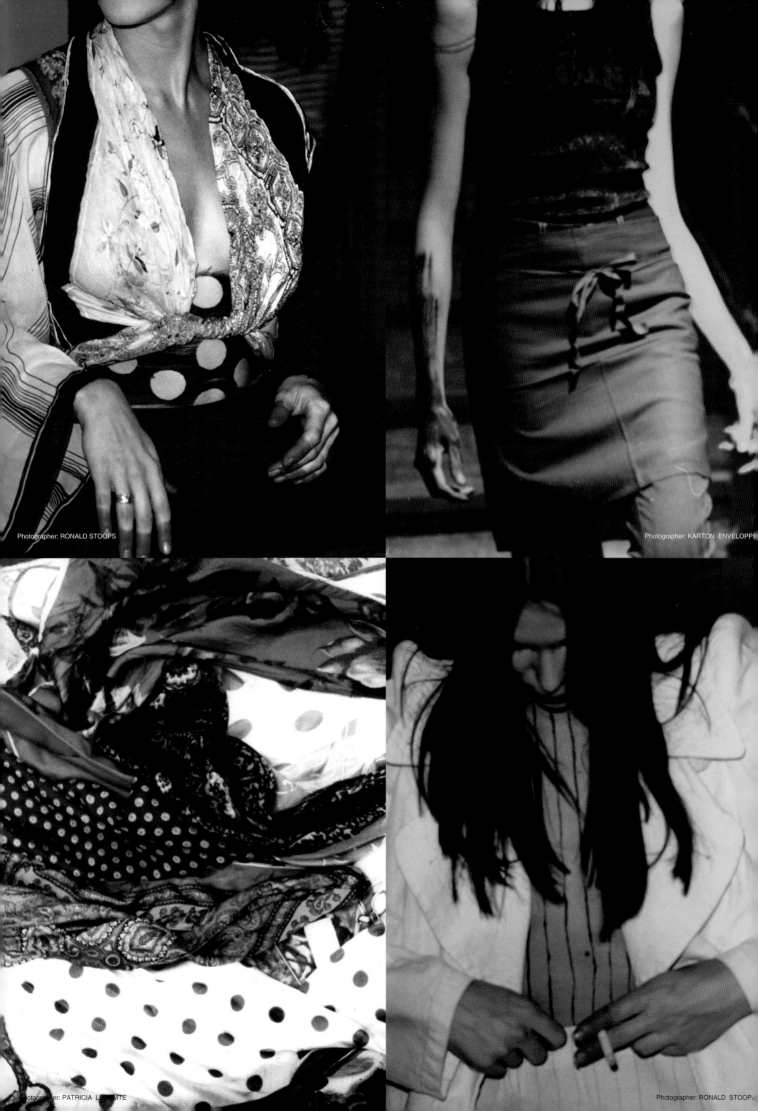

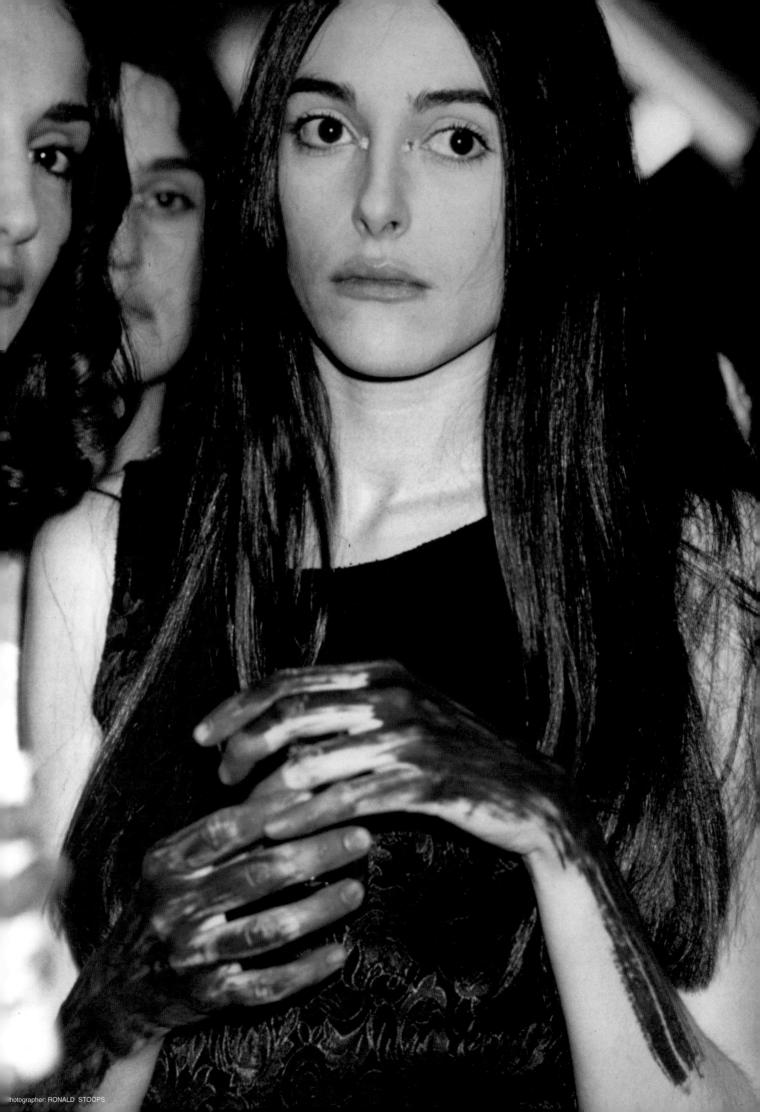

WINTER ' 92-'93

ショールーム

13 Bld St-Denis Paris 75003

プレゼンテーション

1992年3月

救世軍の倉庫でショーを行う。招待者達はそれぞれ家具や古着に座ったりして見ることになる。ブラスバンドを先頭に赤毛のモデルが歩く。まつげを黒く濃くし、黒の靴ひもをチョーカーにする。黒の服を着たモデル達は木底の付いている黒の皮のブーツを合わせる。

コレクション

全てを黒又はダーク系にまとめた。フィットしたTシャツと、フレアーなスカートはパンティーストッキングから作り、しわ加工したニットの上に着せる。そして、70年代の黒の皮コートを前後参逆にし、衿端にボルチェックテープを付け後で交差させ結ぶ様にし、チュニックやワンピースに作り直す。又、ビニール（透明）でできているドレスカバー（商品納品時に使用しているもの）は、体のラインに合わせ、スコッチテープで巻き付けワンピースにした。聖職者の法衣もオーバーコートとして着た。同様にオーバーサイズの洗いざらしのクレープやサテンのワンピースを厚手のセーターの上に合わせた。

Showroom

13, Boulevard Saint-Denis, Paris 75003.

Presentation

March 1992

Held in the sales depot of the Salvation Army. The invited public sit on the furniture and racks of used clothing. A brass band leads the women through the room. Each model has her hair coloured red, thick black eyelashes and a shoelace as a choker. Dressed in black, they wear black leather boots with wooden platform soles.

Collection

Everything is in either black or dark tones. T-Shirts are fitted, skirts are flared, made from panty-hose and worn over creased knitwear. 1970's leather overcoats are reversed and worn as tunics or long dresses with a high neckline and crossed at the back. Transparent plastic protective covers for clothing are moulded to shape with 'Scotch tape' and worn as dresses. There is also a priest's cassock worn as an overcoat as well as oversized washed crepe and satin dresses worn over thick sweaters.

ARMÉE DU SALUT

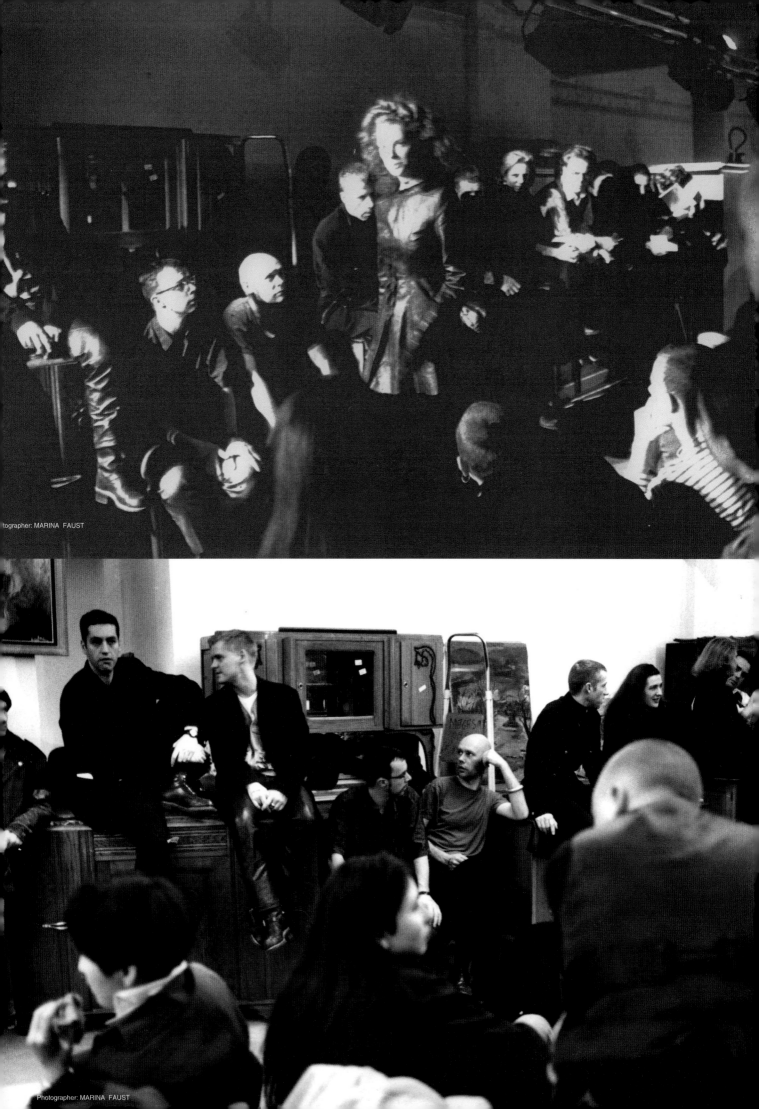

tographer: MARINA FAUST

Photographer: MARINA FAUST

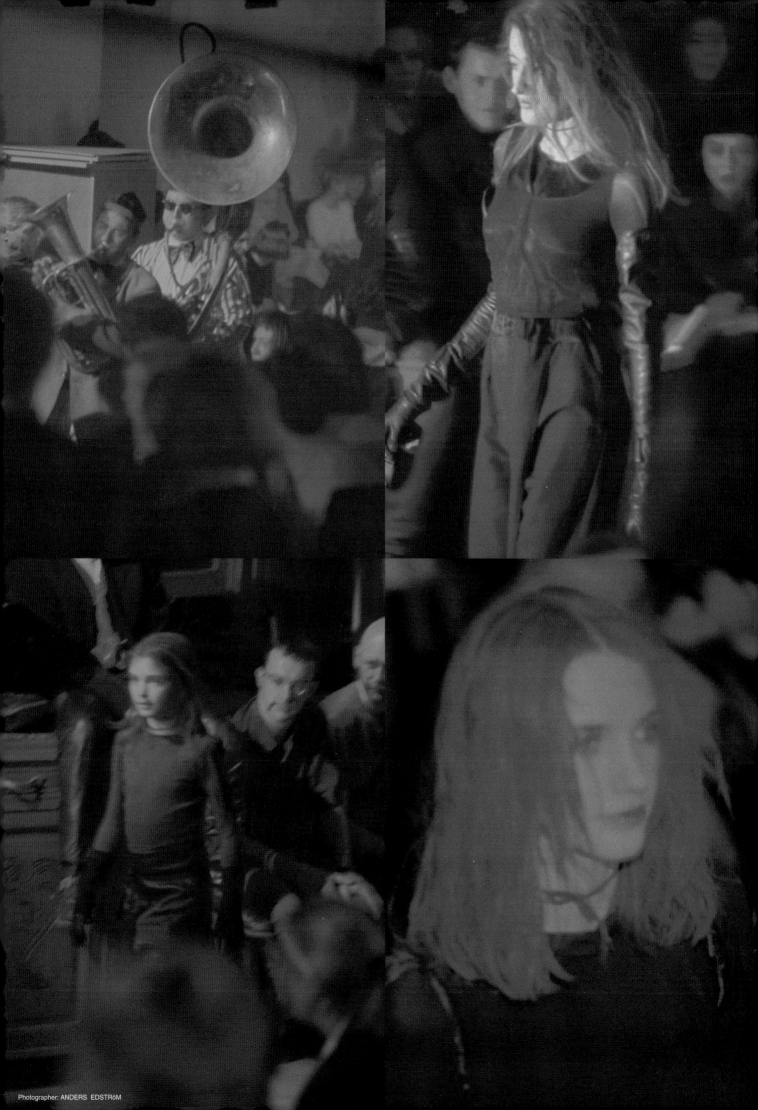

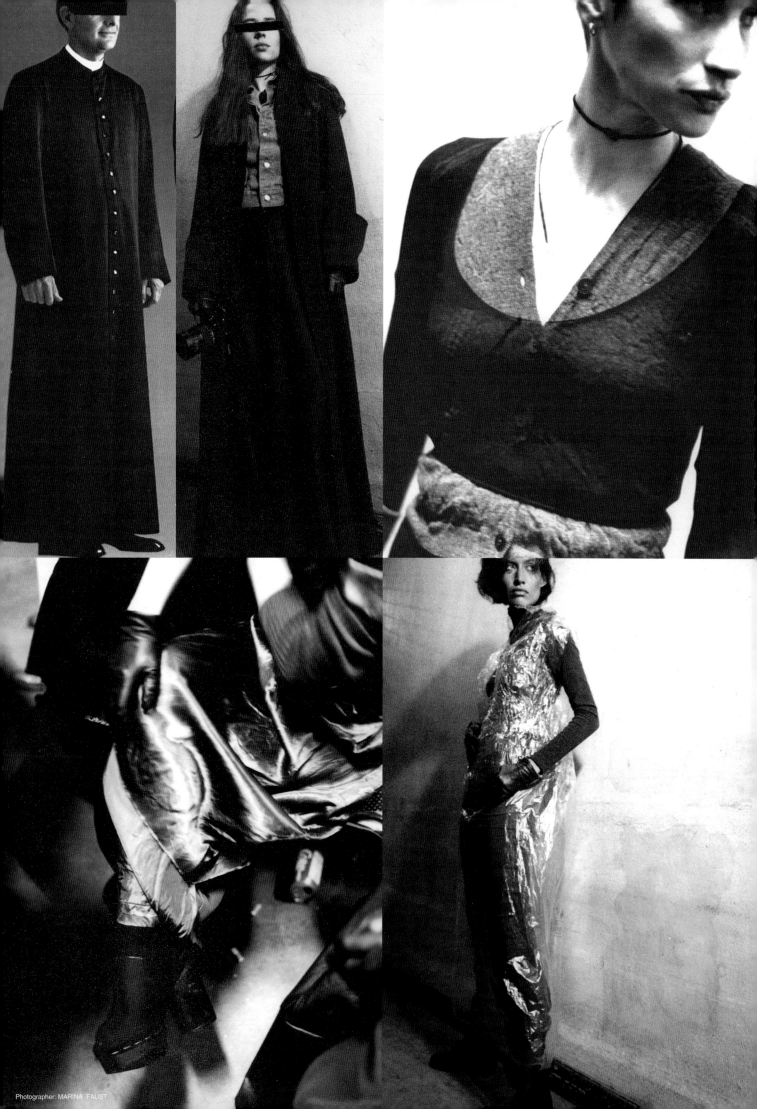

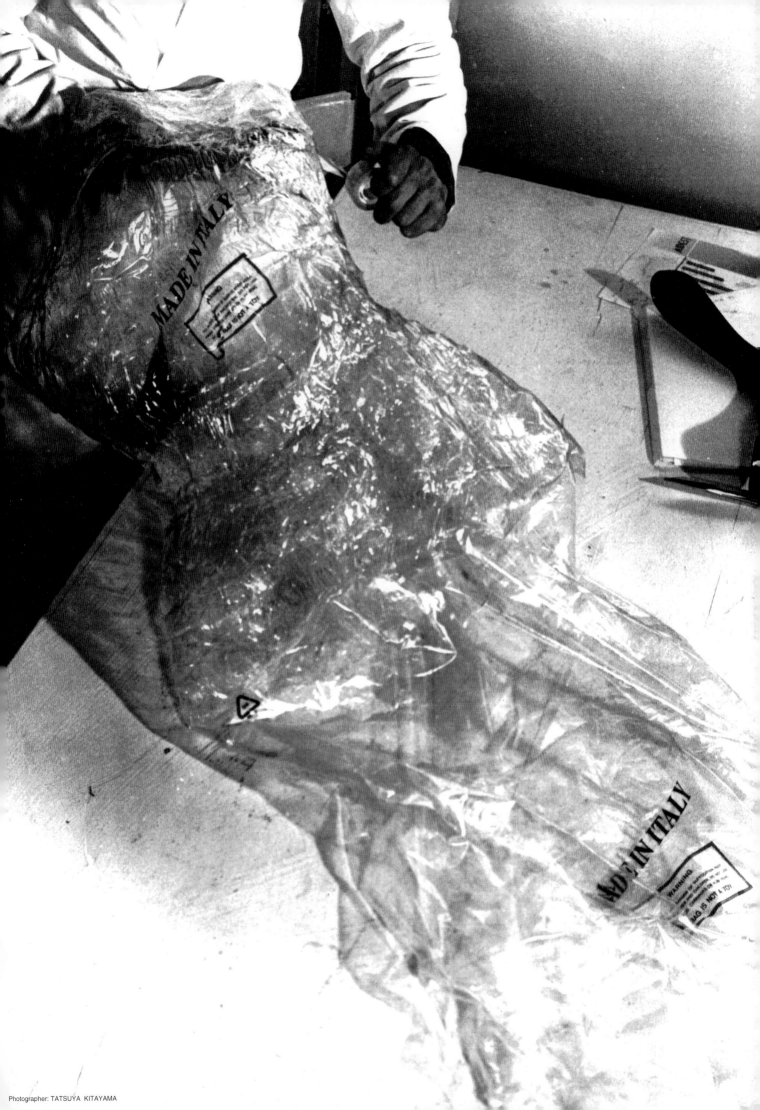

1. BLANC, BLANCHE [blɑ̃, blɑ̃ʃ]. *adj.* et *n.* (1080; frq. °*blank* « brillant »; Cf. Leuco-, et dér. du lat. *albus*).

I. *Adj.* ♦ 1° Qui est d'une couleur dont la nature offre de nombreux exemples : *blanc comme la neige, le lait* (V. **Lactescent**; lacté, laiteux), *l'albâtre, la craie, le lis. La synthèse des sept couleurs du spectre donne la lumière blanche. Blanche hermine, blanche colombe. Fromage* blanc. La gelée* blanche. Drapeau* blanc.* ♦ 2° D'une couleur pâle voisine du blanc. *Peau blanche.* V. **Clair.** *Race blanche. Teint blanc.* V. **Blafard, blanchâtre, blême.** *Être blanc,* avoir mauvaise mine; pâlir sous le coup d'une émotion. *Fam.* N'être pas bronzé. — *Cheveux blancs.* V. **Argenté.** ◇ *Spécialt.* Se dit de choses claires, par opposition à celles de même espèce qui sont d'une autre couleur. *Raisin, vin blanc. Pain blanc. Boudin blanc. Fer* blanc. Arme blanche :* non bronzée, opposée à l'arme à feu. *Bois* blanc. Eau* blanche.* Fig. *Houille* blanche.* ♦ 3° Qui n'est pas écrit. *Page blanche.* V. **Vierge.** *Bulletin (de vote) blanc. Espace blanc.* Fig. *Donner carte blanche,* tous pouvoirs pour agir au nom de qqn. ♦ 4° *Fig.* Qui n'est pas souillé, coupable. *Il est sorti de cette affaire avec les mains blanches. « Selon que vous serez puissant ou misérable, Les jugements de cour vous rendront blanc ou noir »* (LA FONT.). V. **Immaculé, innocent.** ♦ 5° Qui n'a pas tous les effets habituels. *Examen blanc. Mariage blanc. Voix blanche,* sans timbre. *Vers blancs,* sans rime. ♦ 6° Qui fait la synthèse de toutes les fréquences, dans un intervalle donné. *Bruit blanc.*

ショールーム

13, Bld St-Denis Paris 75003

プレゼンテーション

1992年10月

同日、同時間、2つのショーを場所を分けて行う。1つは白のみを使ったコレクション。もう1つは黒のみのコレクションにする。招待者達は2ヵ所に分かれる事になる。白のコレクションはモンマルトル地区にある昔病院だった建物の一室で行う。モデルはパール系のメークアップに白のまつげをつける。黒のコレクションはピガールにある古い一軒家の中のガレージで行う。モデル達の目のラインに合わせ、大きめの平筆で、黒のインクのラインを入れる。多くのモデル達は素足のままで、皮でベルト式になっている指輪をつける。

コレクション

18世紀又はルネッサンススタイルの昔のテアトルコスチュームを作り直し、後染めする。絹のベロア素材だったり、細かく刺繍などがされていたこれらコスチュームを直接着て、安全ピンで止める。又、黄揚の生葉を使用し小さなブーケにまとめ首飾りにしたり、又肌に直接テープで止める。そして、昔多くの人達がまだロングドレスを普段着として着ていた頃の、下着やライニングスカートをオーバーサイズのメンズジャケットと組み合わせる。

Présentation Printemps/Eté 1993; 2,rue Carpeaux 75018 Paris le 15. octobre 1992 à 20:30 heures

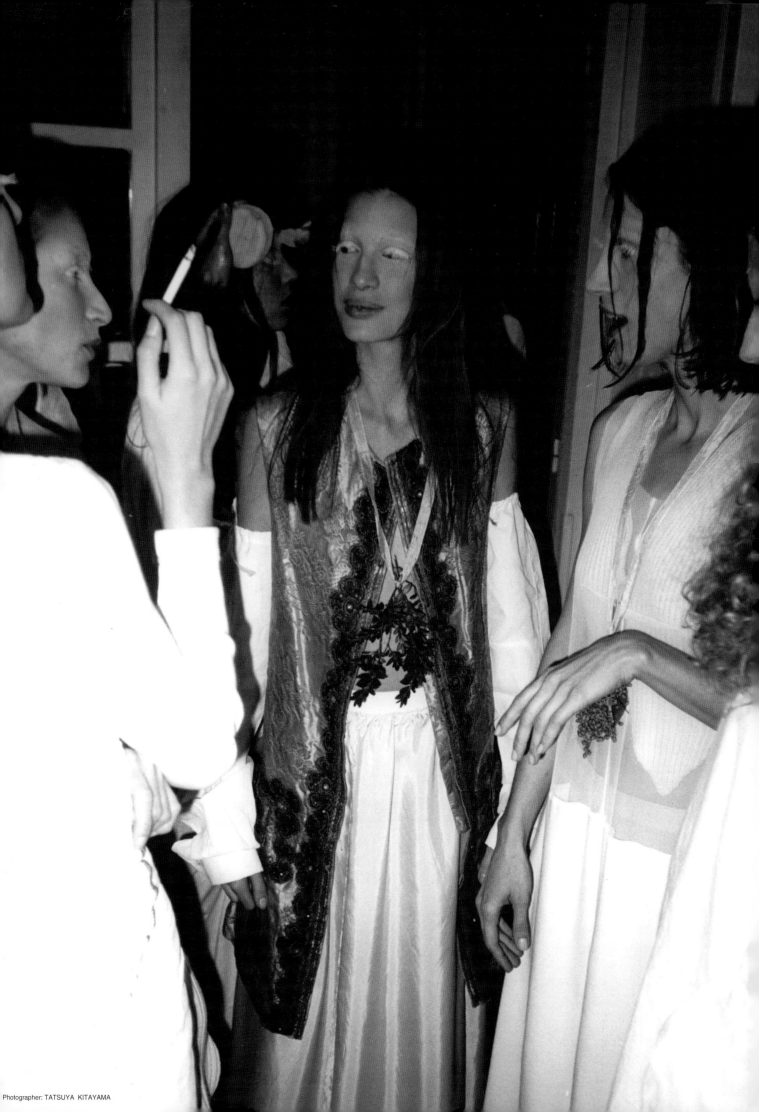

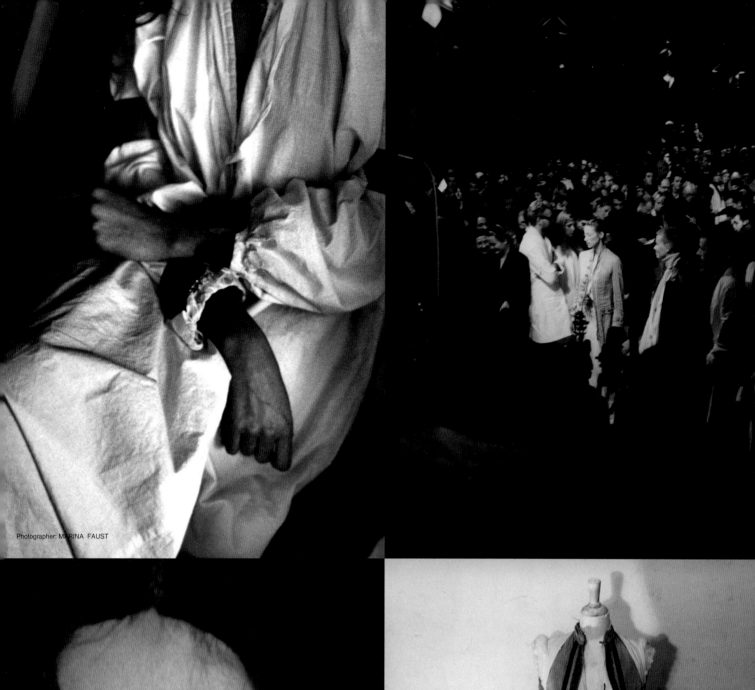

Photographer: MARINA FAUST

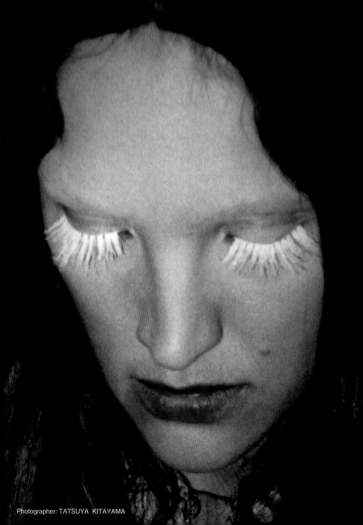

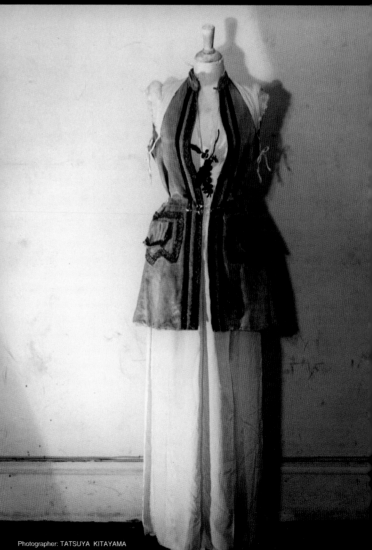

Photographer: TATSUYA KITAYAMA

Photographer: TATSUYA KITAYAMA

NOIR, NOIRE [nwaʀ]. *adj.* et *n.* (XII°; *neir*, 1080; lat. *niger*).

I. *Adj.* **A** *(Concret).* ♦ 1° Se dit de l'aspect d'un corps dont la surface ne réfléchit aucune radiation visible (V. Noirceur, noircir; mélan(o)-). *Noir comme du jais, comme de l'encre, comme du cirage, comme du charbon, comme de l'ébène. Yeux noirs. Cheval* (V. **Moreau**), *chat noir. Fourmi noire. Bêtes noires,* au pelage noir *(chasse).* Fig. *C'est sa bête* noire.* — *Perles noires. La Pierre noire de La Mecque* (Kaaba). — *Drap, velours noir. Soutane, jaquette noire. Le drapeau noir des pirates. Mettre un costume noir, une cravate noire* (en signe de deuil). — *Par ext.* Qui porte un vêtement noir. *Moines noirs. Le Prince Noir* (à cause de la couleur de ses armes). — *Gravure à la manière noire. Tableau* noir. La couleur noire* (à la boule, à la roulette). *Le huit noir est sorti.* — *Épaisse fumée noire. Un café noir, bien noir.* V. **Fort.** *Ellipt.* (1859) *Garçon, un noir !* ◊ (Phys.) *Corps noir,* enceinte fermée, absorbant toutes les radiations qui tombent sur elle. *Lumière noire.* ♦ 2° Qui est d'une couleur (gris, brun, bleu) *très* foncée, presque noire. *Cheveux noirs :* très bruns. *Teint noir.* V. **Basané, noiraud.** *Être tout noir après un séjour à la mer.* V. **Bronzé, hâlé.** ♦ 3° (*Neir,* 1080). Qui appartient à la race « mélano-africaine », à peau très pigmentée (V. **Nègre**). *Des hommes à la peau noire. Une femme noire. Race noire, peuples noirs* (V. **Négritude**). *Par ext.* Propres aux personnes de cette race. *L'âme noire. Le problème noir aux États-Unis.* **Subst.** *Les Noirs* (II, 6°).

<u>Showroom</u>

13, Boulevard Saint-Denis, Paris 75003.

<u>Presentation</u>

October 1992

Two simultaneous fashion shows at different addresses. One presents entirely white silhouettes, the other black.People are invited to either one or the other.The'White' show takes place in a disused hospital at Montmartre. The models wear long white false eyelashes and have pale make-up. The 'Black' show takes place in a garage adjoining an old house at Pigalle where the women have a black paint brushstroke across their eyes. Most of the women wear buckled leather rings on their bare toes.

<u>Collection</u>

Reworked and overdyed jackets of old renaissance and eighteenth century style theatre costumes in velvet and brocade worn on bare torsos and closed with safety pins. A sprig of fresh box either worn as a pendant or 'scotch taped' directly onto the skin. Historically inspired underwear and skirts worn with oversized men's jackets.

Présentation Printemps/Eté 1993; 8,cité Veron 75018 Paris le 15. octobre 1992 à 20:30 heures

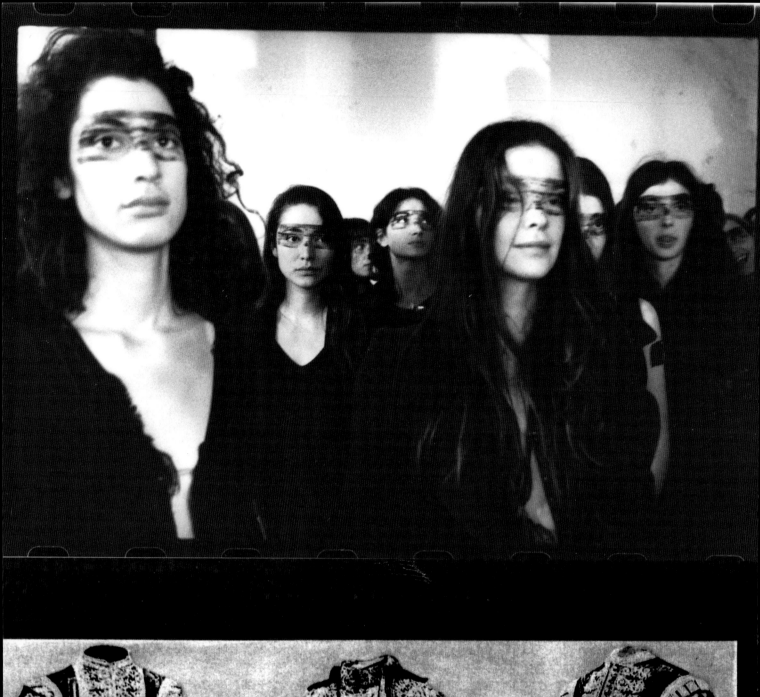
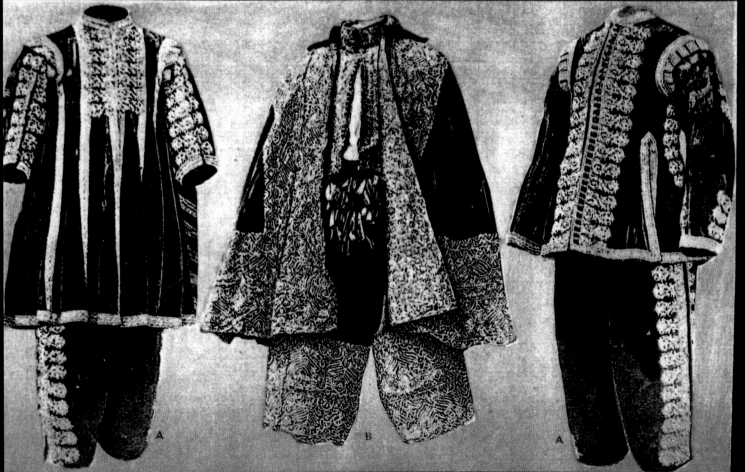

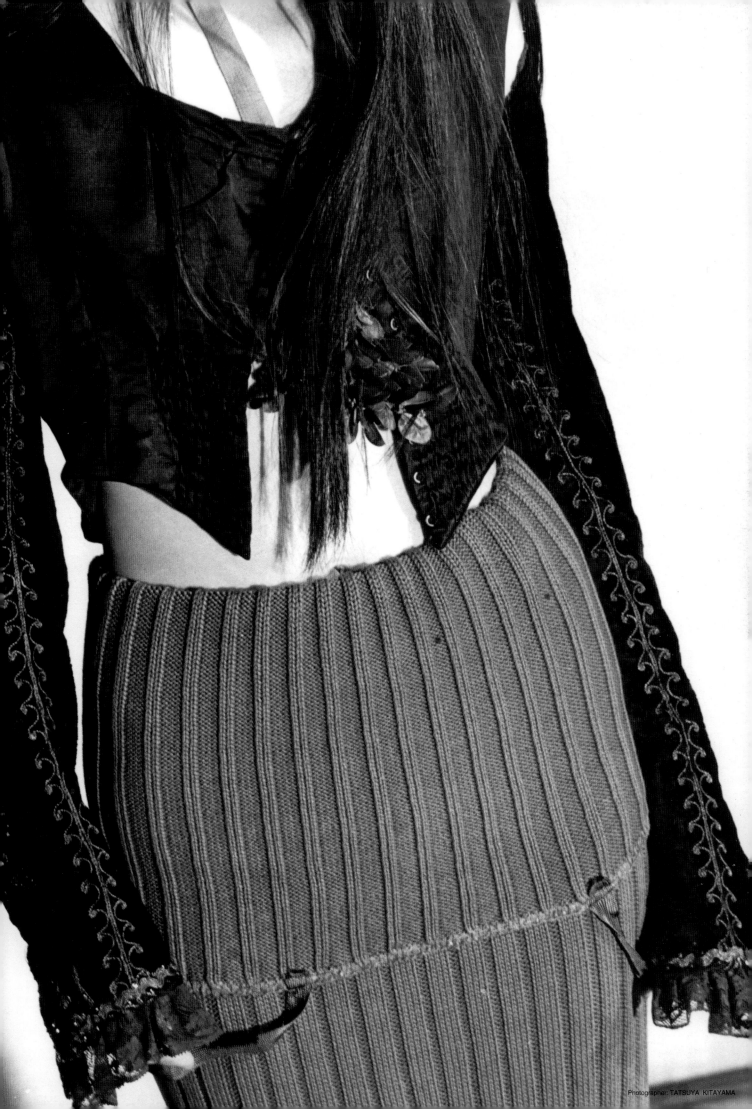

WINTER '93 '94

This package is to provide information on the completed
broadcast featuring your latest collection presented at the
Paris Collections as described below:

Name of your Collection: MARTIN MARGIELA.

Title: Fashion Tsushin (Fashion News)
Broadcast Date: April 5, 1993 (Monday),
 22:00 - 22:30
Broadcaster: TV Tokyo (Channel 12) and its national
 affiliates
Category: A weekly fashion program that regularly
 covers fashion shows held in Paris, Milan,
 London, New York, Madrid, and Tokyo;
 interviews and discussions with designers
 regarding their views on fashion as well
 as lifestyles, etc.
Reporter: Ms. Junko Ouchi, one of the best-known
 fashion journalists in Japan

Reference Photos

ショールーム

13 Bld St-Denis Paris 75003

プレゼンテーション

1993年3月

これまで、9シーズンのコレクションを重ねてきたが、この10シーズン目のプレゼンテーションは、ファッションショーとは異なった形式をとることにする。まず、7名のそれぞれ年令も国籍も仕事も異なる女性を選び、それぞれ彼女達に結び付くシチュエーションで白黒フィルムで撮影する。プレス、バイヤー達をそれぞれ小グループに分けて招待し、壁にスーパー8で撮影したものを投影する。マルタンがフィルムに沿って説明し、その後一点づつハンガーにかかっている作品のカットや素材の説明を行う。

コレクション

全てが長身のシルエットで、40年代の古着は、パステル系の花柄プリントかブラッククレープ素材で、ミスマッチでアシンメトリックなワンピースにデザインされる。裏にフェルトを張り合わせたコットンやシルバーラメのドレスは、きちんと始末されたものとされてないものの両方を作る。70年代の羊の毛を刈り込んだ毛皮の古着を、ボンバージャケットやコートにリサイクルする。洗いざらしのメンズジャケットはそのまま長い袖丈で、肩幅も自然のままにし、革の細いベルトで締める。それらには皮でできた細いベルトを合わせる。そして、ストーンウォッシュしたライダーズジャケットの革のチュニックはダーツと縫い線を強調し、ウールレースのスカートを合わせる。

Showroom

13, Boulevard Saint-Denis, Paris 75003.

Presentation

March 1993.

To mark our tenth season we decide to adopt a form of presenting the collection other than a fashion show. Seven women of different ages, nationality and professions are filmed in black and white 'Super 8' at their homes or in a setting corresponding to their life. Small groups of press and buyers are invited to our showroom to view the film which is projected on a wall. Martin provides a commentary on the film and shows the clothes themselves while explaining their cut, inspiration and fabrics.

Collection

Everything is long. Used 'forties' dresses are cut to form mismatched asymmetrical dresses in either pastel flower prints or black crepe. Garments made of cotton with felt backing and dresses of silver lame are 'cut clear' and left unfinished. Recycled 1970's shearlings are used to make bomer jackets and overcoats. Washed men's jackets, their sleeves too long , with unpadded shoulders are belted with thin leather belts. 'Biker' leather tunics have distressed seams and darts. Skirts are made from wool lace.

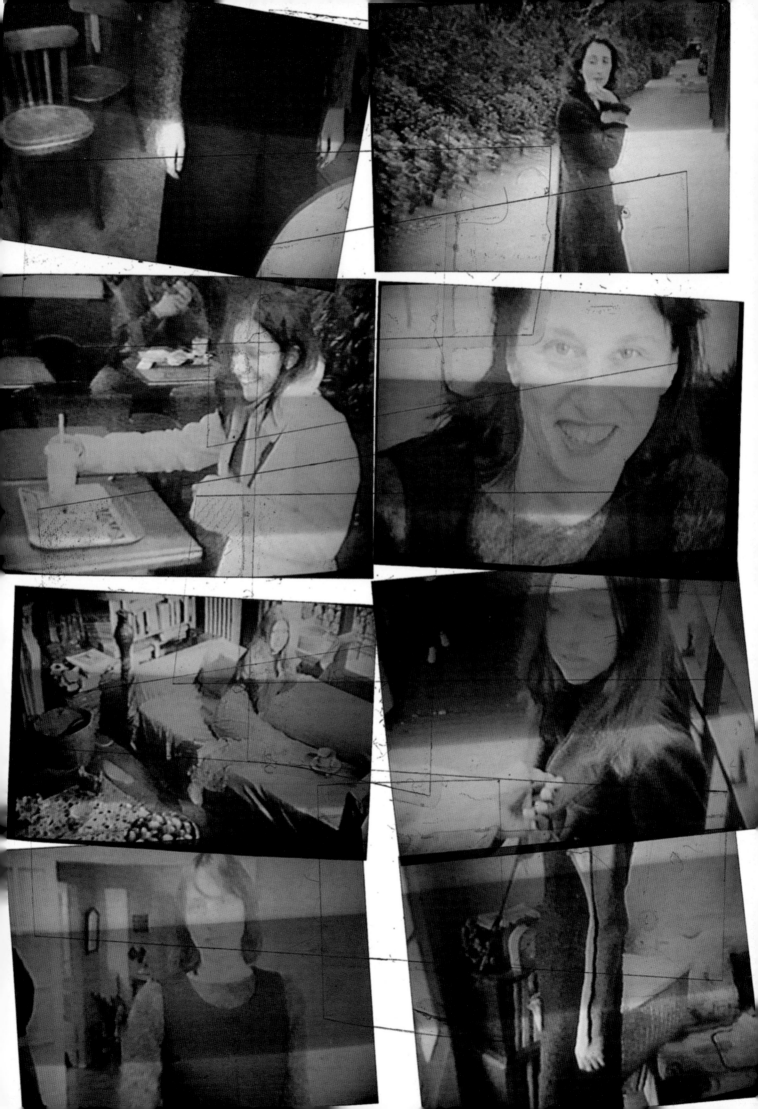

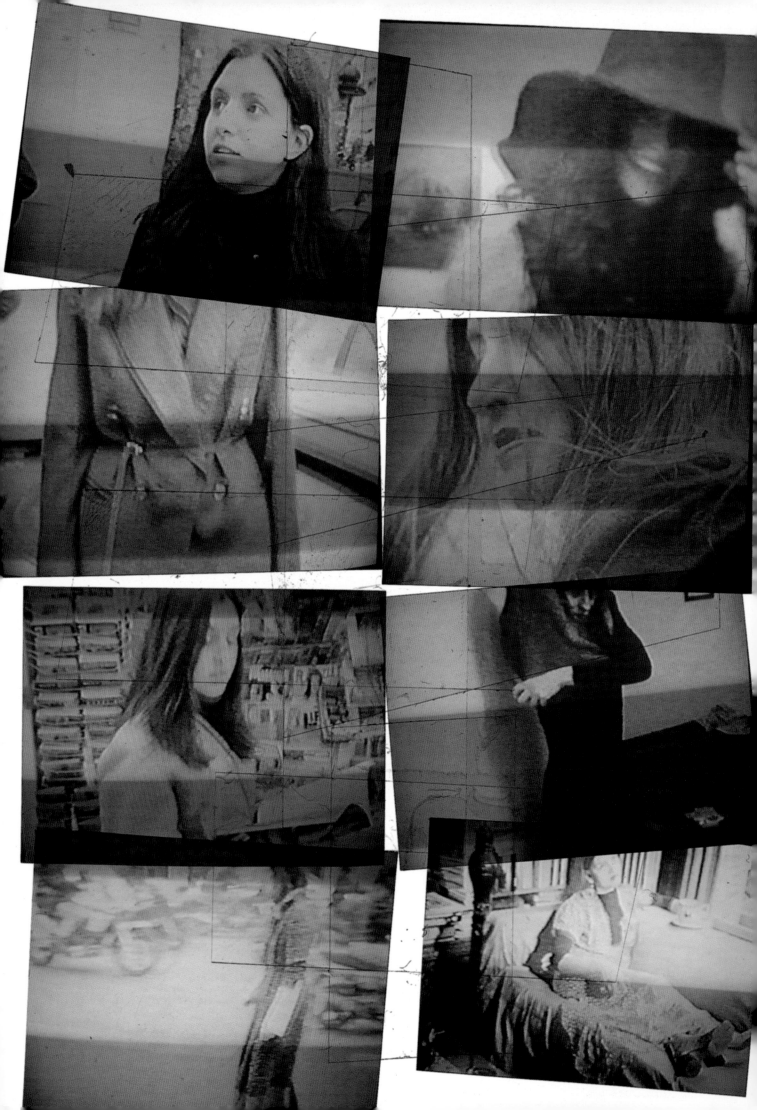

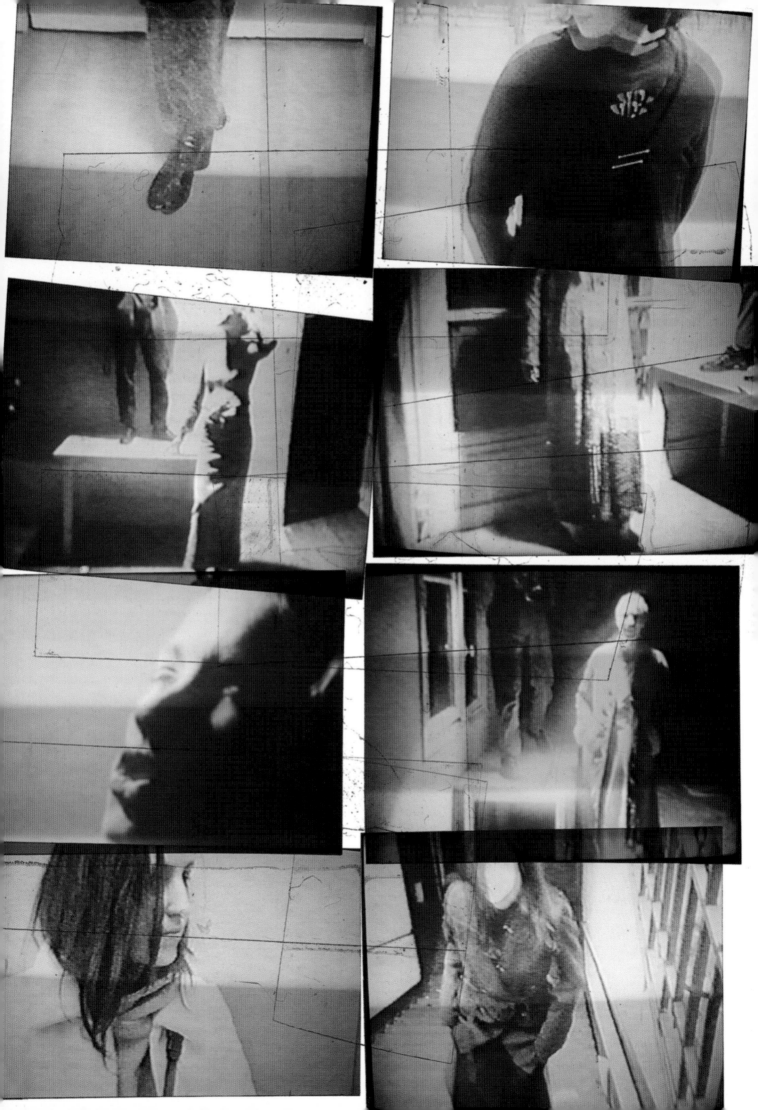

SUMMER '94

ショールーム

13, Bld St-Denis Paris 75003

プレゼンテーション

新しいコレクションは発表しない。1989-1994の過去の作品の中よりセレクションし直す。全てグレーに染め直し、ネームタグの部分にこの作品はいつのものでどのシーズンだったかがわかるようスタンプを押す。使われていないスーパーマーケットをショールームとして、毎日10人のモデルが作品を着て、10日間にわたりプレス、バイヤー等にプレゼンテーションする。又、どの作品がいつのものかモデル達を見てすぐにわかるように、首に直接スタンプを押す。このスペースは、アーティザナル（職人作業）のアトリエ、過去10コレクションのイメージフィルムを流す場所、受注する場所、それら全てを兼ねている。

コレクション

アーティザナルの作品を多く再び発表する。例えば皿の破片のジレ、50年代のロングドレスを染め直しコートに作り直したもの、スーパーマーケットの袋を使用したTシャツ、40年代のワンピースをパッチワークし新たにワンピースに作り直したもの、靴下でできたセーター、テアトルコスチュームを使用した服、裏地の服、ウェイターのエプロン、タトゥーTシャツ、肩幅を切り詰めたジャケット、ロングスカート。

Showroom

13, Boulevard Saint-Denis, Paris 75003.

Presentation

October 1993

No new collection but a selection of our favorite garments from each of the former collections, 1989 - 1994. Everything is overdyed in grey. The original season of each piece is stamped on the label. For ten days an empty supermarket serves as showroom. Ten girls present the collection to press, buyers and public. Each girl wears a silhouette from a previous collection, the date of which is marked on her body in black paint. The space also includes a workshop of our 'Artisanal' production, a screening area where images of ten previous seasons are projected and tables where the collection is sold to our boutiques.

Collection

Many pieces of the artisanal production are represented such as the waistcoats made from broken crockery, the 1950's ball-gowns, the plastic shopping bag T-Shirts, the 1940's patchwork dresses, the military sock sweaters and the used theatre costumes. There are also garments in lining fabrics, waiter's aprons, tattoo shirts, crushed oversized garments worn under net, constructed jackets with cropped shoulders and long skirts.

Photographer: RONALD STOOPS

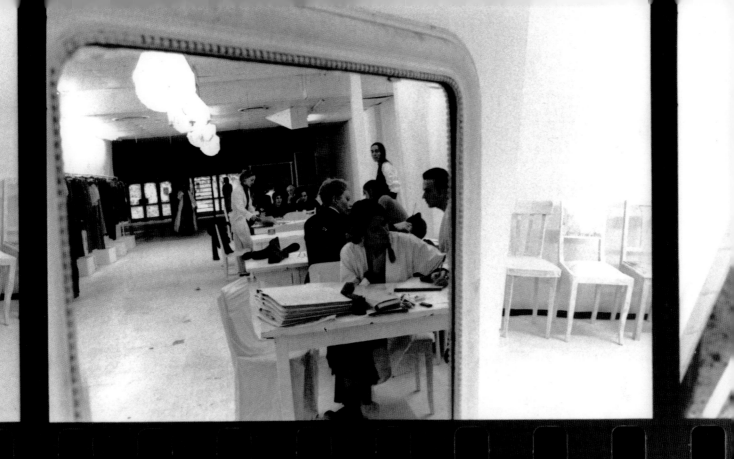

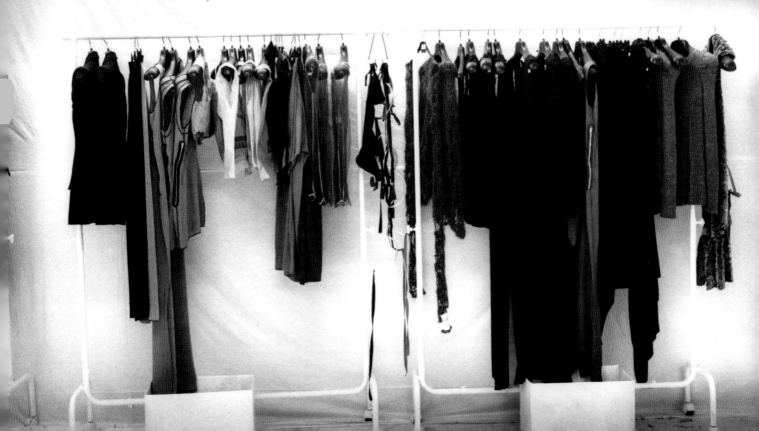

COLLECTION
PRINTEMPS
ÉTÉ 90

COLLECTION
AUTOMNE
HIVER 90.91

Photographer: MARINA FAUST

Photographer: TATSUYA KITAYAMA

Photographer: TATSUYA KITAYAMA

Photographer: MARINA FAUST

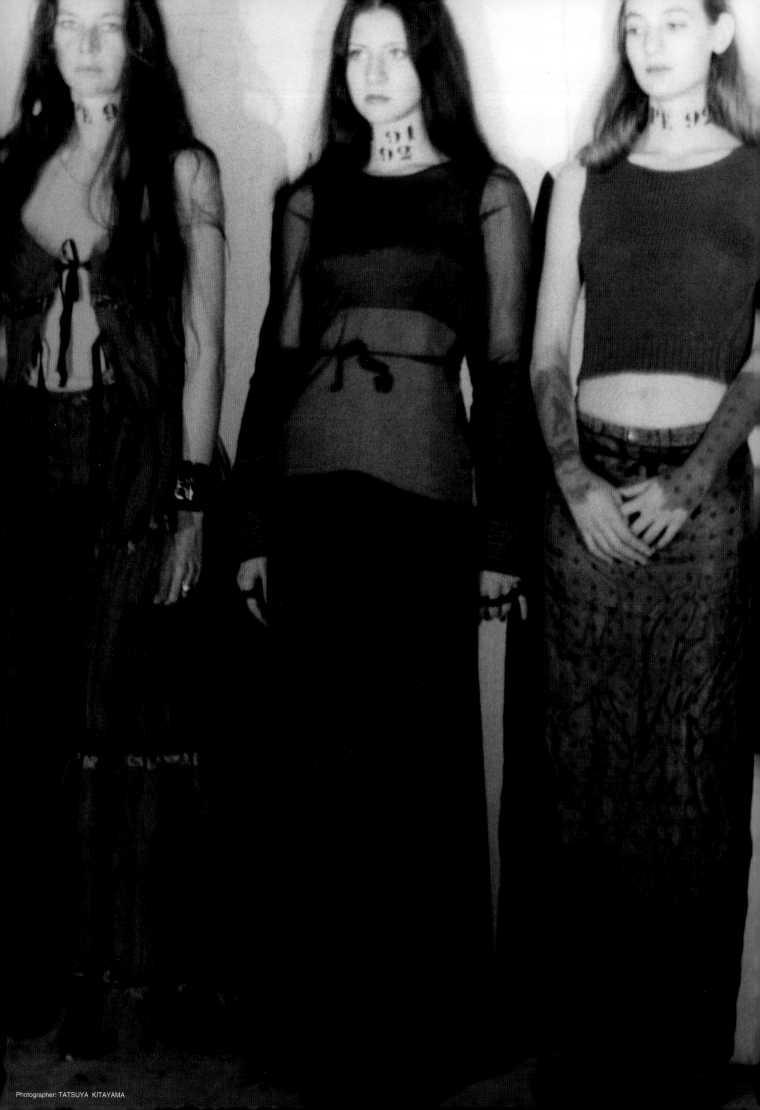

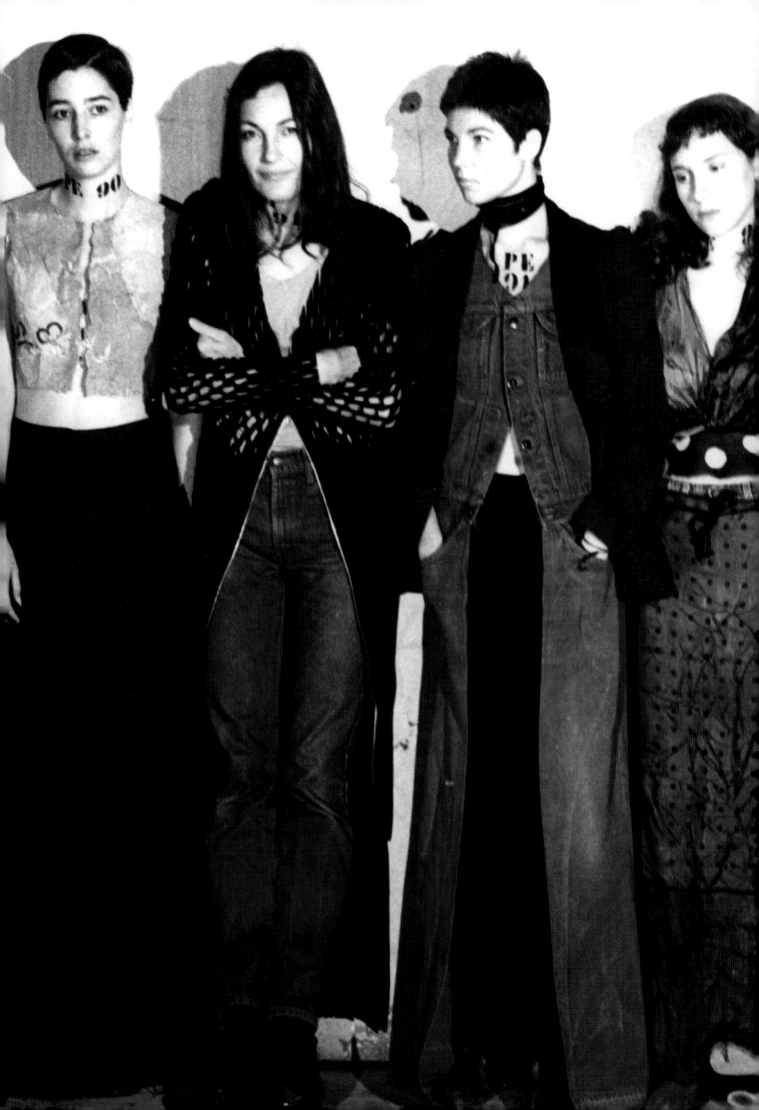

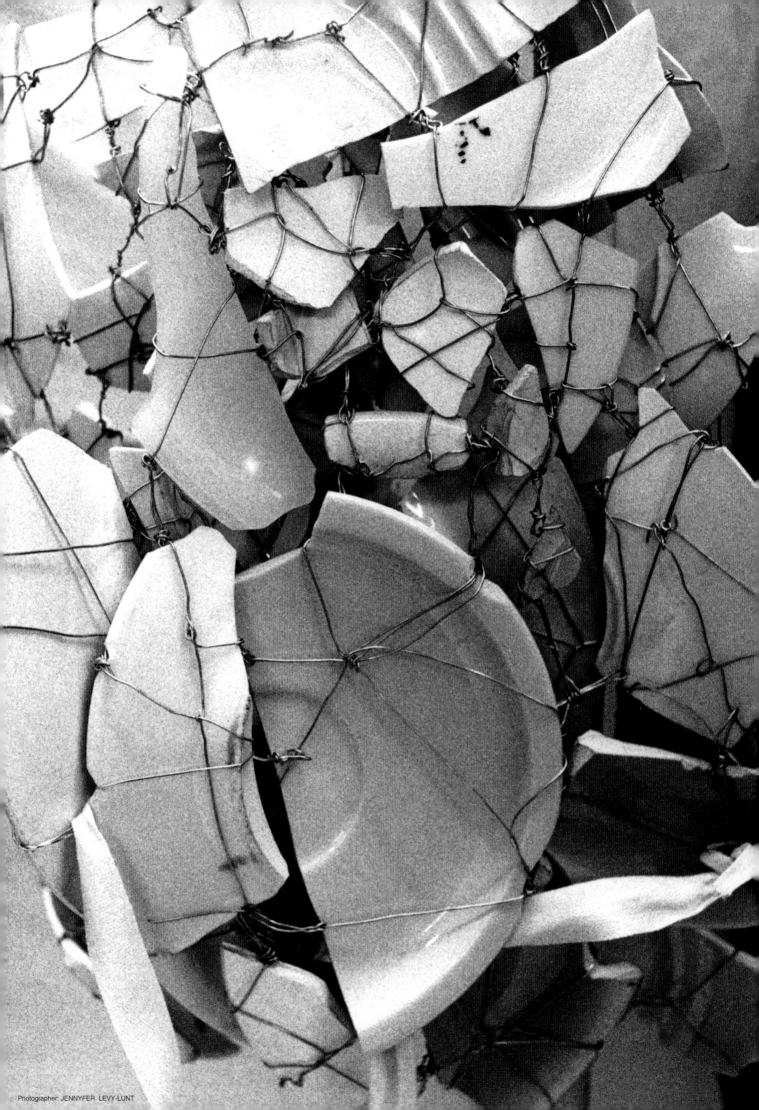

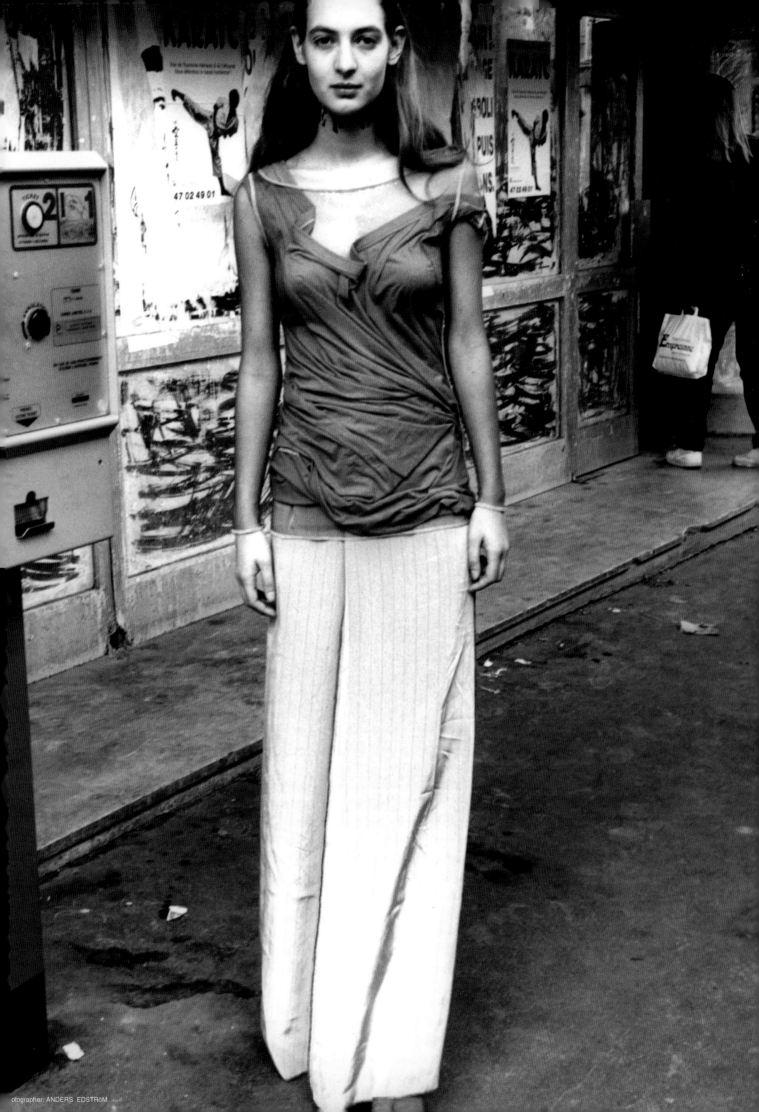

ショールーム

2 BIS PASSAGE RUELLE PARIS 75018

新たに引っ越しをする。アーティザナルアトリエとオフィス、ショールームを合体させる。もちろん、白に塗り直す。

プレゼンテーション

1994年3月　受注

1994年9月7日　プレゼンテーション

私達のショールームにバイヤーだけを招待して商品を受注する。30体のマネキンにコーディネートしプレゼンテーションする。これは、初めて商品をコレクションとしてプレゼンテーションすることの効果を試すプロジェクト。その時点で顧客はもちろん、プレスも同時にそれを見て、ショップですぐに商品を買えるという設定にする。この試みは世界6都市で行う。パリ（4ヵ所で行った）、ロンドン、ニューヨーク、東京、ミラノ、ボン。各地とも全て9月7日の夜7時（ローカルタイム）に行う。顧客、プレス、ショップ、デザイナー全ての人達が一つのプレゼンテーションに参加する。

コレクション

コレクションは5つのグループから成る。それらをグループ別に着るのではなく、全てを組み合わせコーディネートする。様々な時代の服に忠実に再現したものは、その原型と時代の詳細をスタンプしてある。

Showroom

2 bis, Passage Ruelle, Paris 75018.

A former workshop. Offices and their contents are painted entirely in white and adjoin a vast
wooden, balconied warehouse. The atelier for our 'Artisanal' production is now incorporated in the
showroom.

Presentation

Sales in March 1994

Presentation September 7th 1994

In March the new collection is shown only to our clients at the showroom. Thirty shop dummies are
dressed in various silhouettes representing the collection. A project to experience the effects of
presenting a collection for the first time when the garments arrive in the shops. The collection
is represented by twelve featured outfits in six cities, Paris (four representations), London,
New York, Tokyo, Milan and Bonn. The nine simultaneous presentations take place on the 7th of
September at 7pm local time. For the first time customers press as well as the shops and designer
are involved in a fashion presentation together.

Collection

The collection comprises five groups of garments. Each of the twelve proposed ensembles
representing the collection combine elements taken from these five groups. Garments that are exact
reproductions of pieces from varying periods are stamped with details of their origin and epoch.

グループ　III　：　人形のワードローブを、そのカットと不均衡さを尊重しながら、人間の大きさに拡大したもの。

GROUP　III : pieces from a doll's wardrobe, enlarged to human size. the exact
cut and disproportions have been recreated.

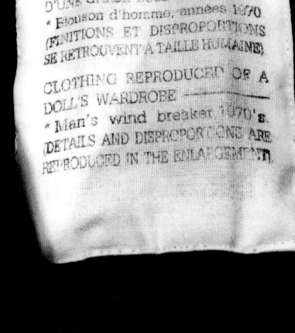

REPRODUCTION D'UN VETEMENT
D'UNE GARDE-ROBE DE POUPÉE —
* Blouson d'homme, années 1970
(FINITIONS ET DISPROPORTIONS
SE RETROUVENT A TAILLE HUMAINE)

CLOTHING REPRODUCED OF A
DOLL'S WARDROBE ——
* Man's wind breaker, 1970's.
(DETAILS AND DISPROPORTIONS ARE
REPRODUCED IN THE ENLARGEMENT)

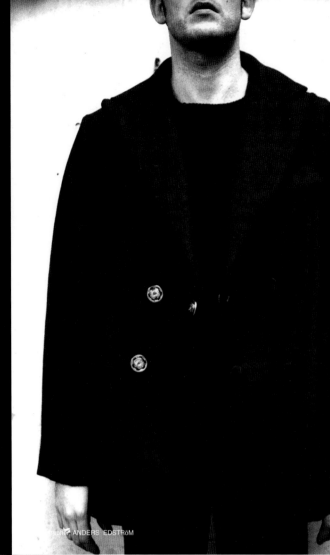

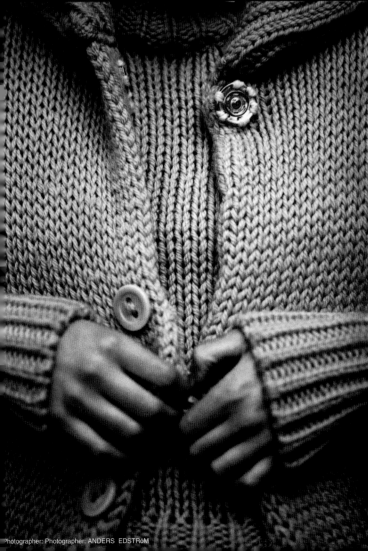

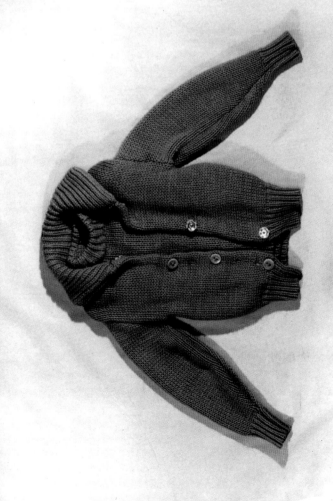

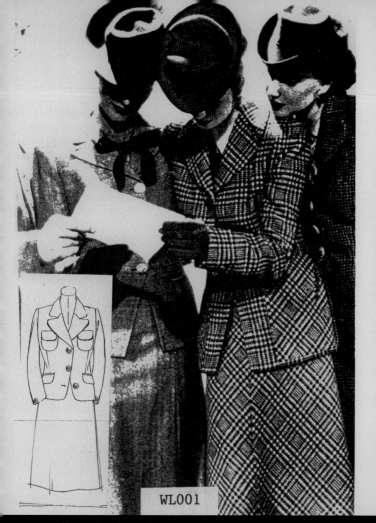

WL001

Photographer: RONALD STOOPS

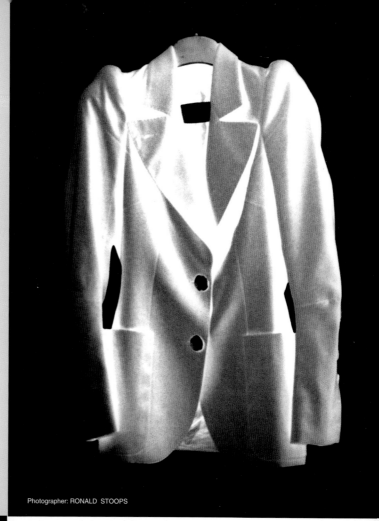

グループ II ：様々な時代の服を、全く修正せずに再現したもの。
GROUP II : exact reproductions of a wide selection of clothing varying in origin and period.

グループ I ：マルタン マルジェラ の過去のコレクション （1989-1993） よりセレクトしたもの。
GROUP I : selection of garments from past MARTIN MARGIELA collections 1989-I

Photographer: TATSUYA KITAYAMA

グループ IV ：アーティザナルの作品、古着などに手を加え手作りされたもの
GROUP IV : garments made by hand from new or used clothing, objects and

グループ V ：メンズ、レディス、子供もの全ての下着から作り直されたものでベースになるもの
GROUP V : basic range of garments taken from men's, women's and childre

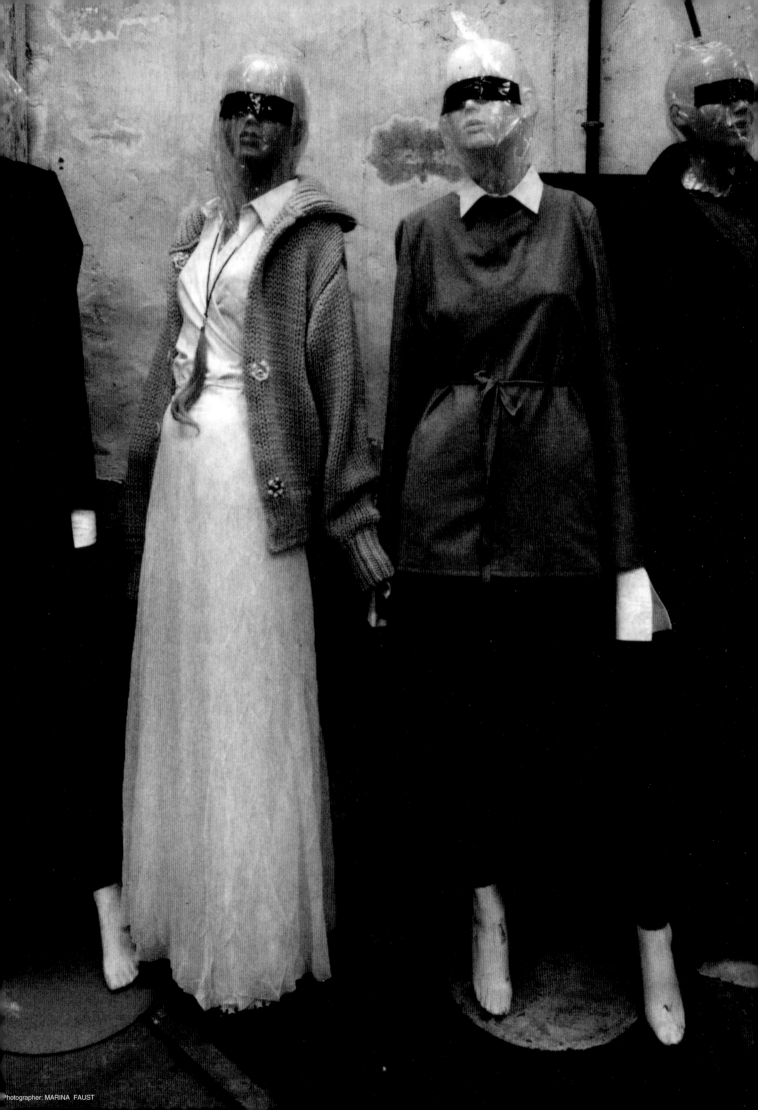

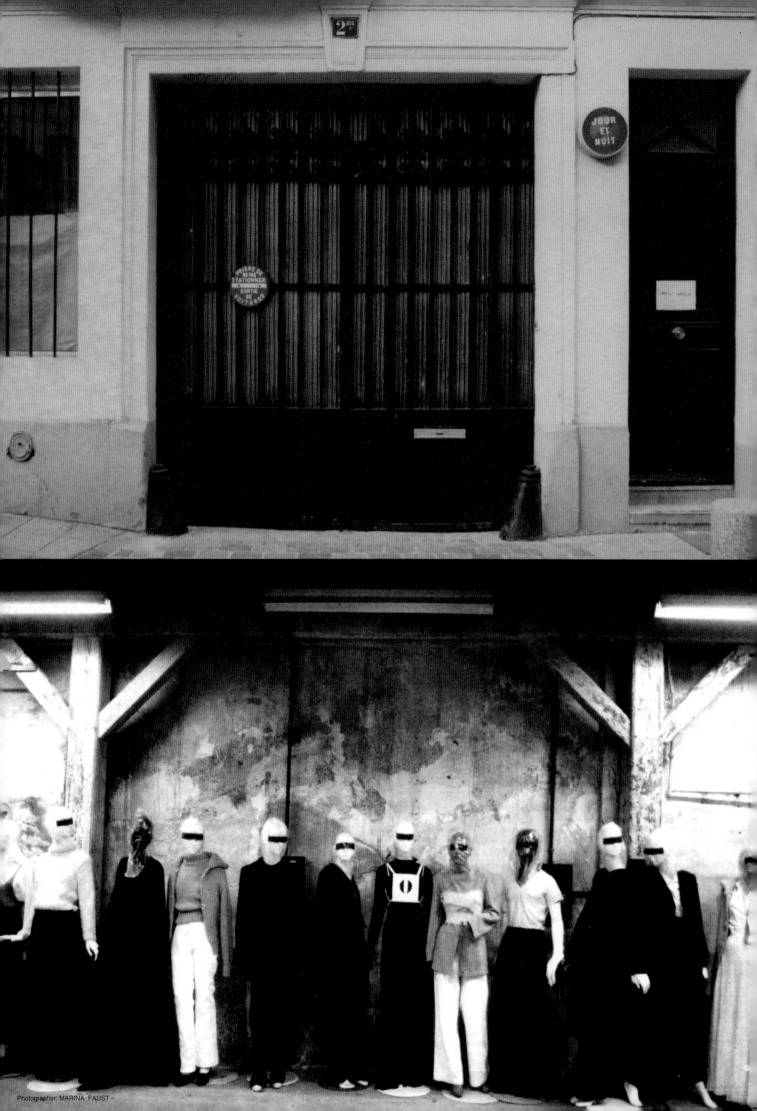

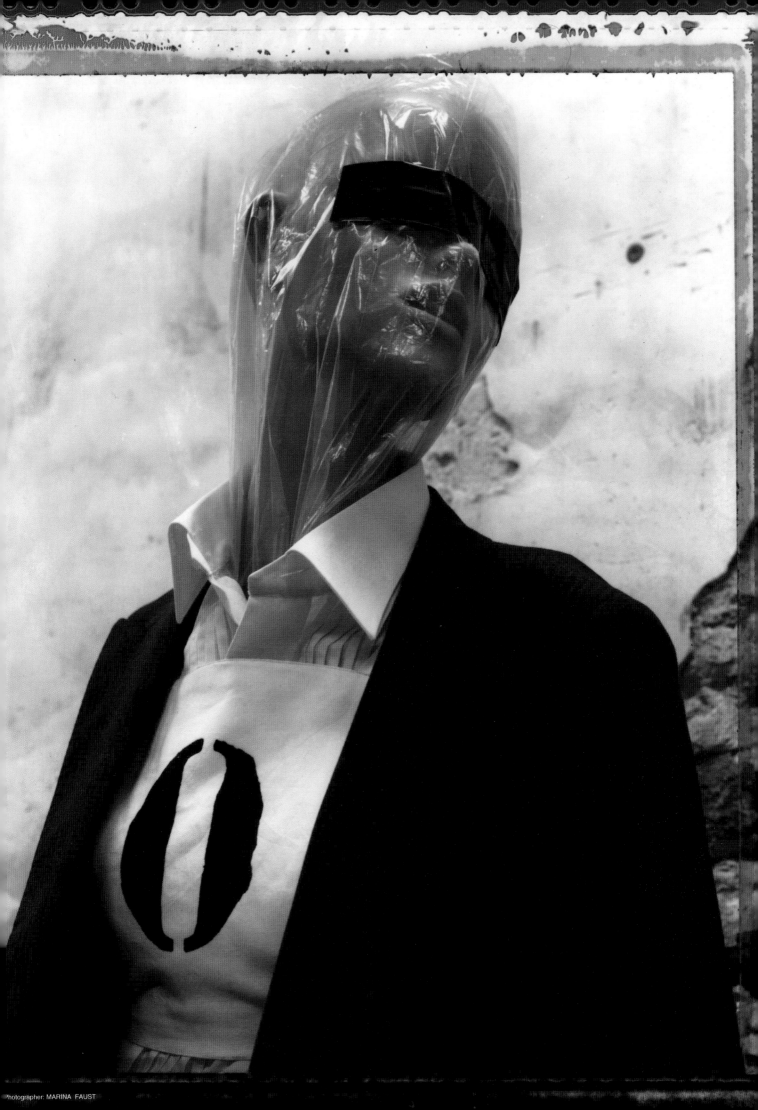

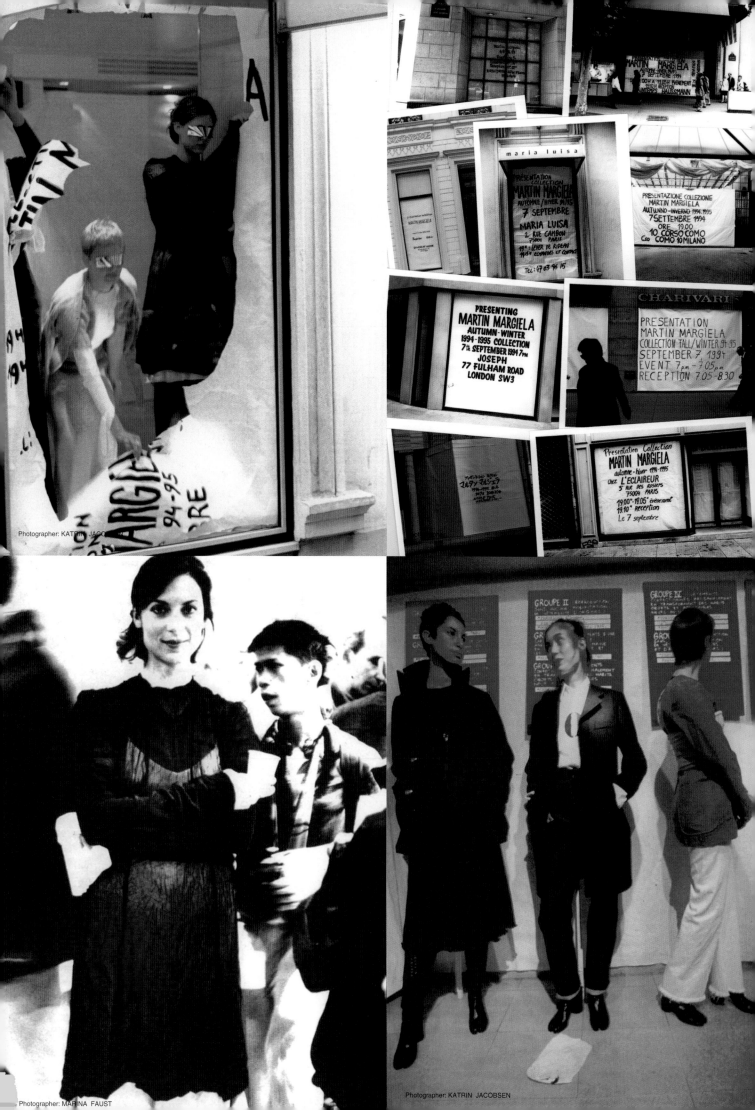

Photographer: KATRINA JACO

maria luisa

PRÉSENTATION
COLLECTION
MARTIN MARGIELA
AUTOMNE/HIVER 1994-1995
7 SEPTEMBRE 1994

MARIA LUISA
2 RUE CAMBON
75001 PARIS

19ʰ : LEVER DE RIDEAU
19ʰ35 ÉCHANGES ET CONTACT

Tel: 47 03 96 15

PRESENTAZIONE COLLEZIONE
MARTIN MARGIELA
AUTUNNO-INVERNO 1994-1995
7 SETTEMBRE 1994
ORE 19.00
10 CORSO COMO
Cso COMO 10 MILANO

PRESENTING
MARTIN MARGIELA
AUTUMN-WINTER
1994-1995 COLLECTION
7ᵗʰ SEPTEMBER 1994 7pm
JOSEPH
77 FULHAM ROAD
LONDON SW3

CHARIVARI

PRESENTATION
MARTIN MARGIELA
COLLECTION FALL/WINTER 94-95
SEPTEMBER 7, 1994
EVENT 7pm - 7.05pm
RECEPTION 7.05-8.30

Presentation Collection
MARTIN MARGIELA
automne - hiver 1994-1995
chez L'ECLAIREUR
5 RUE DES ROSIERS
75004 PARIS
19.00ʰ - 19.05ʰ événement
19.10ʰ réception
Le 7 septembre

GROUPE II GROUPE IV

Photographer: MARINA FAUST

Photographer: KATRIN JACOBSEN

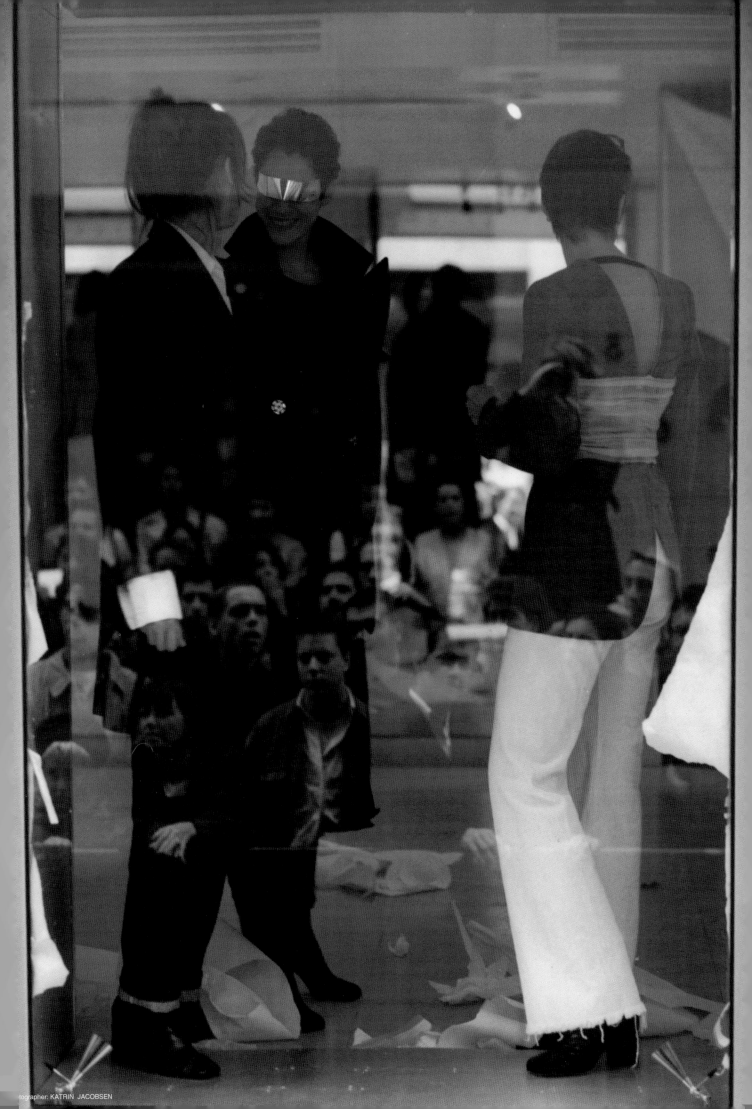

SUMMER ' 95

ショールーム
2 BIS PASSAGE RUELLE PARIS 75018

プレゼンテーション
1995年10月

パリにある"Theatre de la Potiniere"という小さな劇場で行う。36人のモデル達はそれぞれこの春夏のコレクションを着て、招待者に入り混じって座る。まず舞台に大きなスクリーンを設置し、そこに94年9月に行った6都市9ヵ所でのプレゼンテーションをミックスしたフィルムを上映。その後、アフリカンパーカッション（ライブ）のリズムにのりモデル達は立ち上がり舞台へと歩き出す。彼女達の通路のみハーフライトを当てる。そして、彼女達全員が舞台に上ると、一人づつにスポットライトを当てコーディネート等を見てもらう。その後、招待者と一着にエントランスに出て、赤ワインを楽しむ。

コレクション

前回の5つのグループに加え、インナーや裏地の服のグループを加える。パステルカラーと、"プリンスオブウェールズチェック"素材を使用したメンズスーツ、古着のメンズパジャマと古着のホワイトシャツをストラップレストップとワンピースにする。又、靴は以前からあるブーツタイプを短く切り落とし、足首には細いベルトを巻く。ほとんどのスカートはひざ丈で、ズボン、ストッキングを足首のところで切ったもの、男性用パジャマのズボン、の上に着る。そして、オーバーサイズのTシャツドレスには生花のバラをネックラインにテープで止める。

Showroom
2 bis, Passage Ruelle, Paris 75018.

Presentation
October 1994

Thirty-six women wearing outfits from the collection enter the auditorium of the Theatre de la Potiniére and take their seats amongst the invited crowd. An edited video showing the nine presentations of the Autumn / Winter collection is projected on stage. African drums sound when the video is over and the thirty-six women rise from their seats in half light and make their way on stage. A spotlight travels along the line of women. When all outfits are spotlight the women leave the stage.by the wings to join the invitees in the foyer for a glass of wine.

Collection

Five groups, as before, with one new group - the interiors and linings of garments. Pastel colors and men's suits in 'Prince of Wales check', secondhand men's pyjamas and white shirts transformed into strapless tops and dresses. The leather boots of former seasons are cut into shoes with separate ankle straps. Most skirts are knee-length and worn over trousers, footless stockings or men's jersey pyjama bottoms. Oversized T-Shirtsare worn as long, loose dresses with fresh tea-roses 'scotched' to the skin at the neckline.

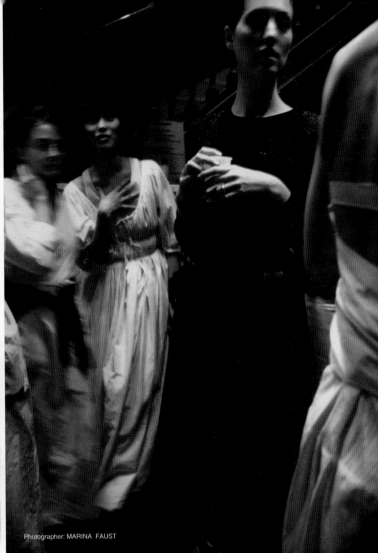

Photographer: MARINA FAUST

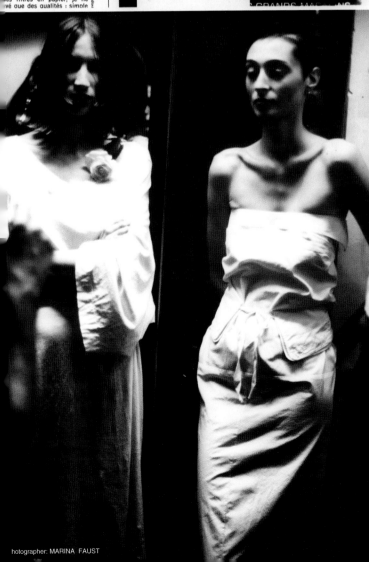

hotographer: MARINA FAUST

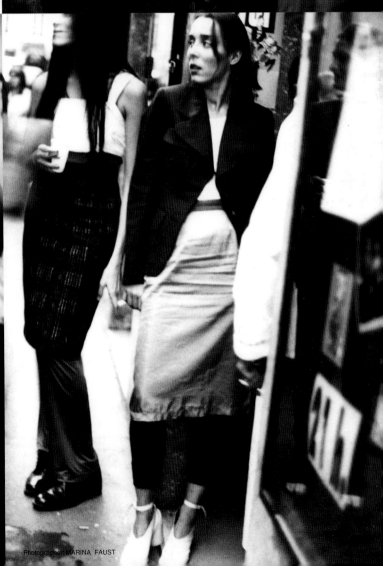

Photographer: MARINA FAUST

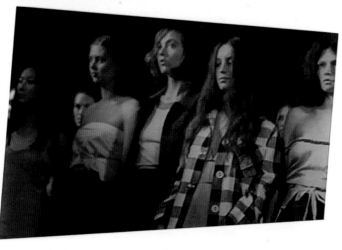
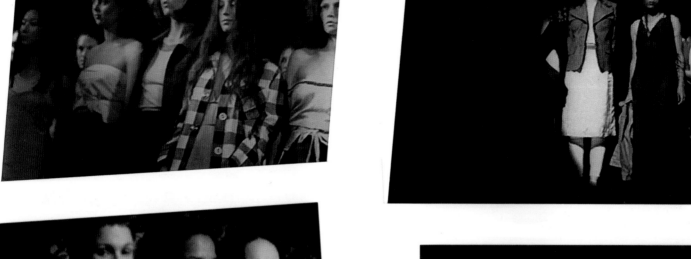
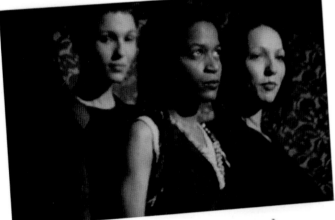
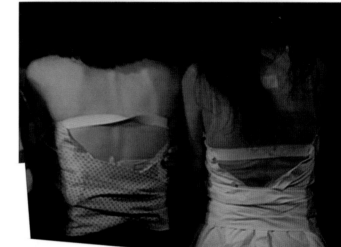
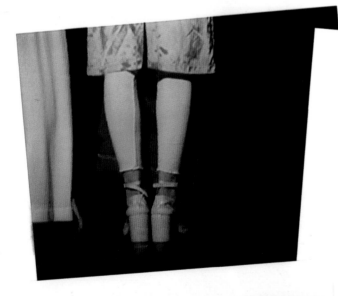

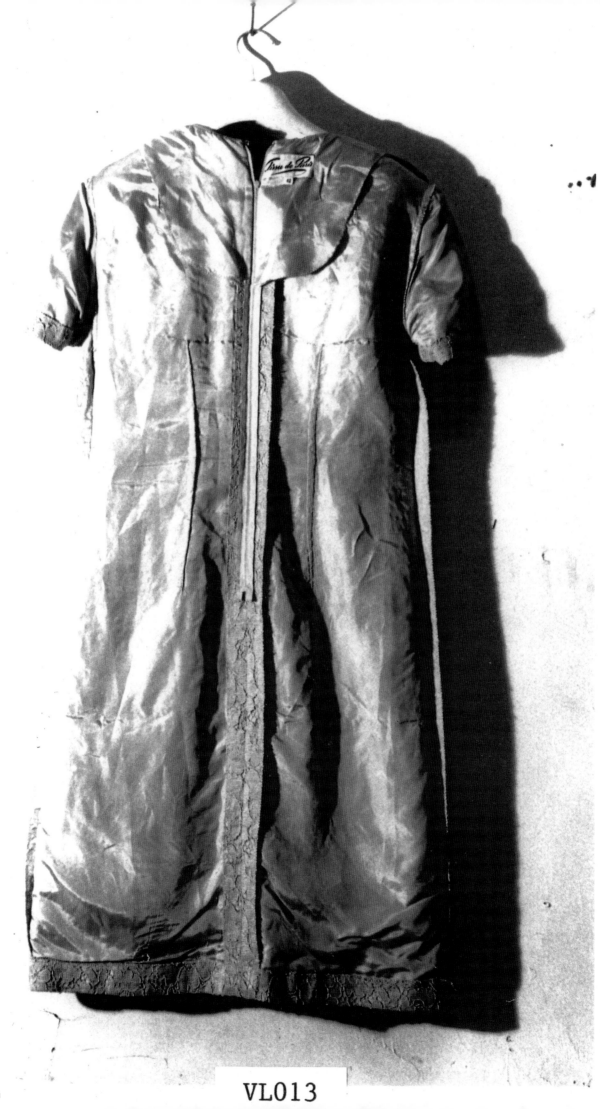

VL013

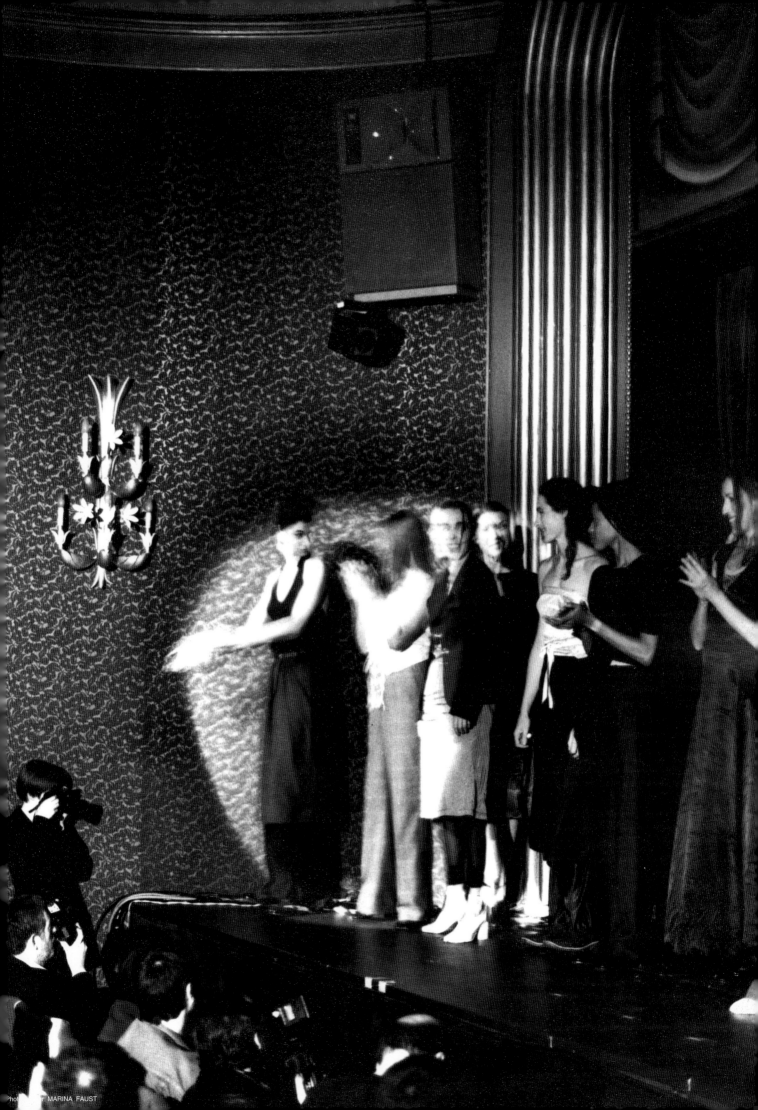

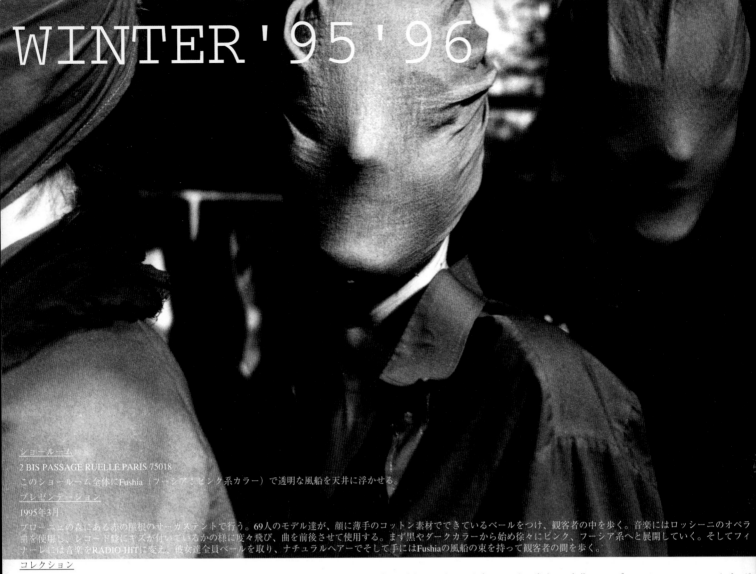

ショールーム
2 BIS PASSAGE RUELLE PARIS 75018
このショールーム全体にFushia（フーシア：ピンク系カラー）で透明な風船を天井に浮かせる。
プレゼンテーション
1995年3月
ブローニェの森にある赤の屋根のサーカステントで行う。69人のモデル達が、顔に薄手のコットン素材でできているベールをつけ、観客者の中を歩く。音楽にはロッシーニのオペラ曲を使用し、レコード盤にキズが付いているかの様に度々飛び、曲を前後させて使用する。まず黒やダークカラーから始め徐々にピンク、フーシア系へと展開していく。そしてフィナーレには音楽をRADIO-HITに変え、彼女達全員ベールを取り、ナチュラルヘアーでそして手にはFushiaの風船の束を持って観客者の間を歩く。
コレクション
大きめのジッパーが付いた作業服用オーバーオール、それを胸元まで開け、ダミーヘアーを三つ編みにしたベルトをウエストに巻く。40年代のメンズ、レディスのスーツのリプロダクション。ウールジャージで作った60年代のワンピースはひざ丈で下に皮のパンツを合わせる。ライニングスカートやワンピースの下にはウールストッキングをはき、毛皮の付け衿とパンプス。ベルベットをしわにしたドレスにはポニーテールを細い革ベルトに付けたものをウエストに巻く。ジャージクレープのドレスにはうさぎの毛皮でできている付け衿（元々コート等に付いていたもの）、手の部分を切り取ったロング手袋を付け袖として使う。新しく、ウール、コットン、ナイロン素材のひざ丈のケープを発表する。

Showroom

2 bis, passage Ruelle, Paris 75018.
Hundreds of transparent fuschia ballons are attached to the ceiling.

Presentation

March 1995

A red circus tent in the Bois de Boulogne. Sixty-nine women, wearing cotton muslin veils obscuring their faces, pass among the seated public. A record of Rossini opera music is played over and over again. Silhouettes of black and dark colors evolve, as the women pass, into outfits of combined pinks and fuschias. When the last silhouette has passed the music changes to radio hit played loudly. All of the women come out again. They wear the same outfits without their veils, smiling, their hair is loose and the are holding many helium filled fushia ballons.

Collection

Workmen's overalls with large zippers are worn open with deep necklines and are belted with plaits of hair. Reproductions of 1940's men's overcoats and women's suits. Knee-length 1960's jersey dresses are worn over leather trousers. Lining skirts and dresses are worn over woolen stockings and with fur collars and pumps. Ponytails are clipped onto tiny leather belts and worn with evening dresses in crushed velvet. Other evening dresses are in rabbit fur and fluid jersey crepe. Long leather gloves are without hands and worn as sleeves. There are many capes to the knee in wool, cotton and nylon.

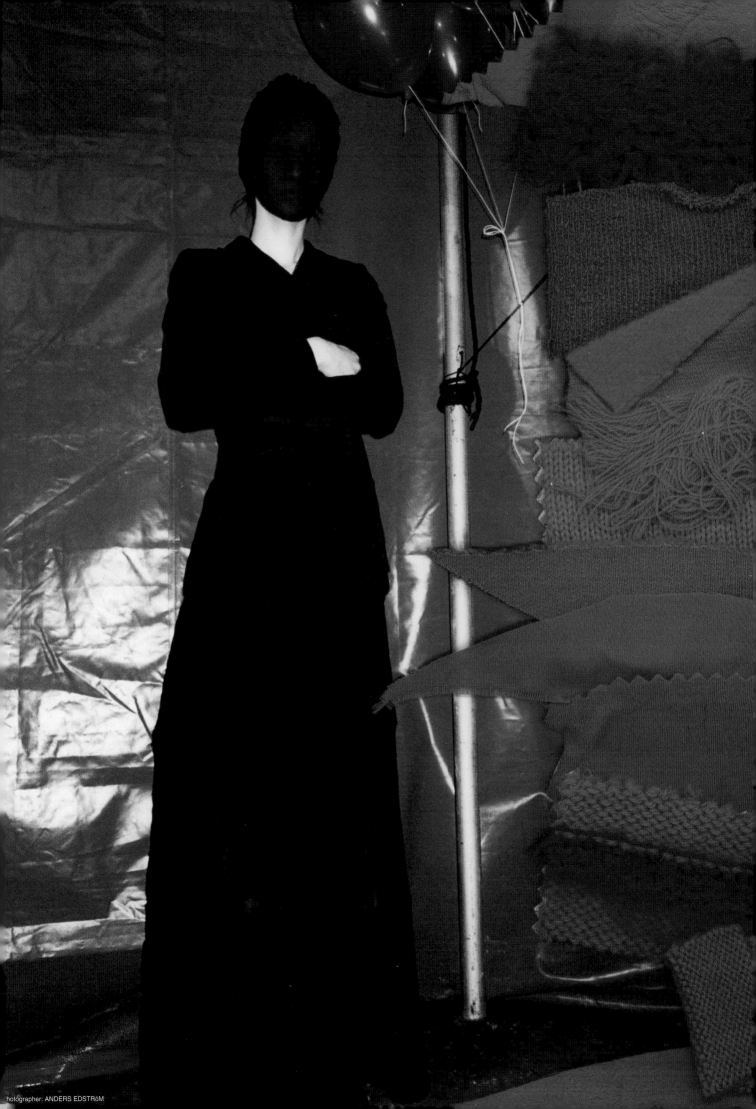

Photographer: RONALD STOOPS

Photographer: ANDERS EDSTRÖM

GL016

L depuis
329F
la combinaison

Coupe lar
aux épa

Double
fermeture
très
robuste

Taille
élastiquée
dos

Poignets
resserrables
par pression

rt U.S.

rouge

Photographer: MARINA FAUST

Photographer: RONALD STOOPS

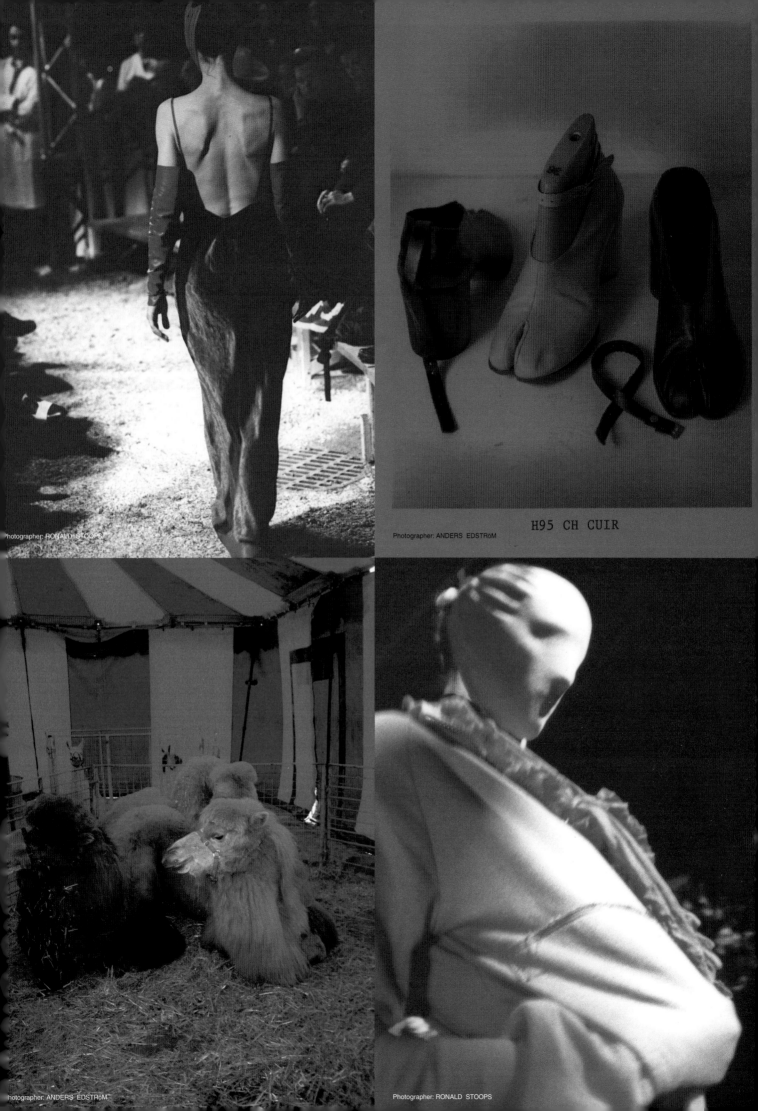

Photographer: RONALD STOOPS

Photographer: ANDERS EDSTRöM

H95 CH CUIR

Photographer: ANDERS EDSTRöM

Photographer: RONALD STOOPS

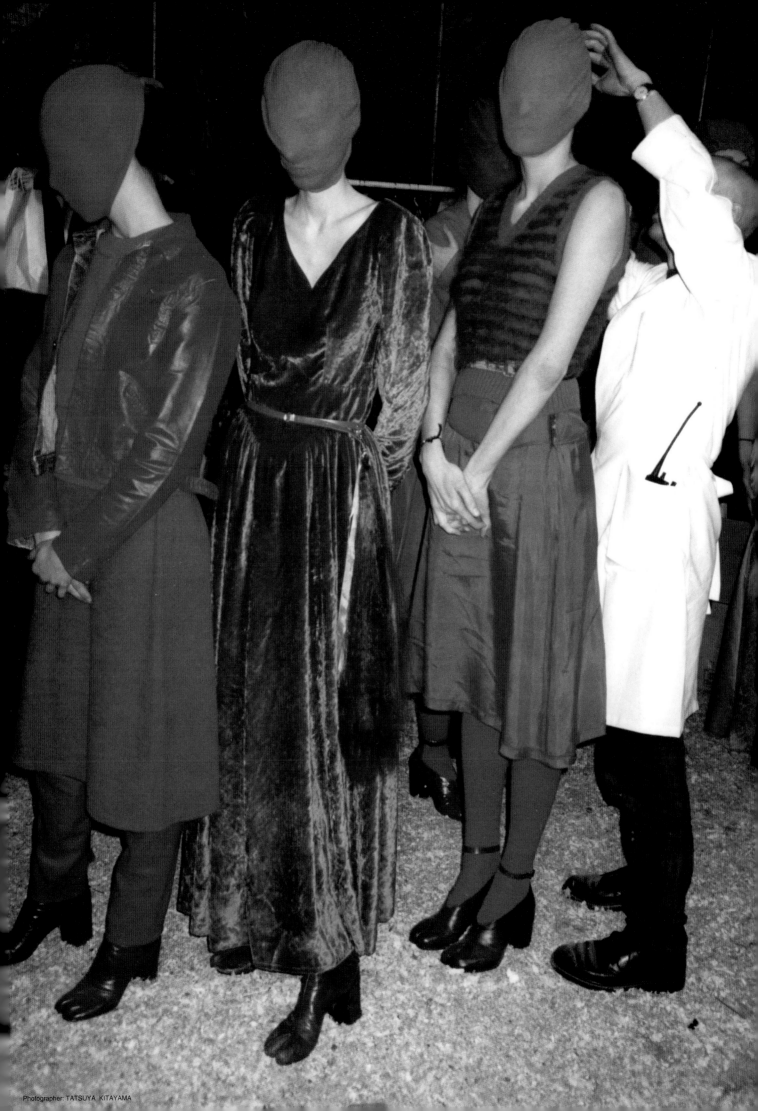

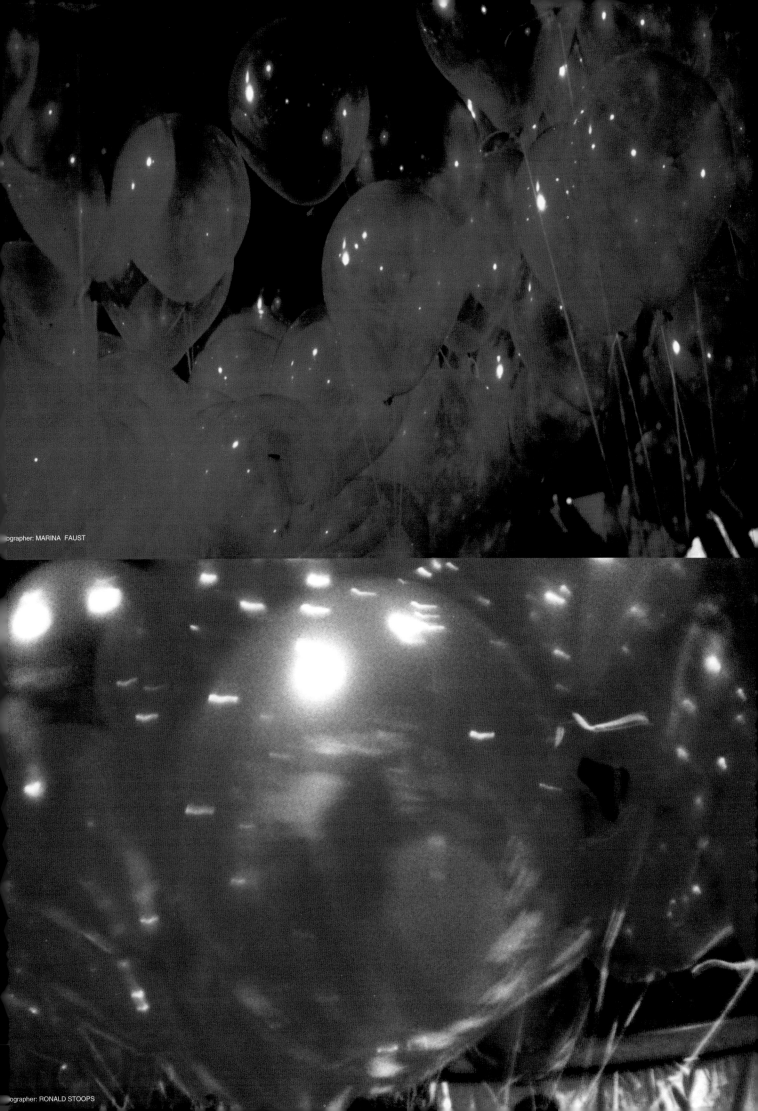

SUMMER'96

ショールーム

2 bis Passage Ruelle パリ18区

ショールームの中に木で作った舞台を設置。壁の一面のみラフなまま残し、その一面以外は全て白に塗り上げる。仕切りに立てた壁の上部から横並びにクリーニングハンガーにかけた12体のフォトプリントを発表する。

プレゼンテーション

1995年10月

La Maison de la Mutualite.パリ左岸にある共済組合会館で行う。一列22mで四列に別れた不布用テーブルの上を44名の女性に歩いてもらう。招待者の方々が自分でサーブできるようにテーブルの上に赤ワイン、プラスティックカップを用意した。ショーは2パートに別れていた。初めのパートはすべての女性の顔、髪をすっかりベールで覆い、アウトフィットはフォトプリントに今までのコレクションの作品と組み合せ、フォトプリントのみのアウトフィットは2パート目に発表した。その時、全ての女性のベールは外され、まとめていた髪も自然な状態におろす。フォトプリントのスカートにフォトプリント以外のトップを着ていた人は上半身ヌードとなり、トップのみフォトプリントだった人は淡色のライニングスカートをはいた。ショーの音楽として女性がテーブルの上を歩く足音をアンプで増幅し流した。そしてその雰囲気を時々チアリーダー達の声援が中断した。

コレクション

フォトプリントの作品は軽くて薄い素材にプリントされ、シンプルな構造となる。カラーバリエーションは昔のカラー写真、またそれをカラーコピーしなおしたもの、白黒、セピア、茶系のトーンとなる。1930年代の後半のウェ、ベルトのついた厚みのあるメンズオーバーコートは薄くて軽いビスコースにプリントされ、1940年代のひざ丈のチェックスカートはシルクシフォンにプリントされた。サンプラスのアーミージャケットはストレッチコットンと軽いビスコースの素材に、重量感のある手編みのセーターはコットンとビスコース素材に、スパンコールのイブニングドレスはビスコース素材にプリントされ、またこのドレスはトップとスカートとにわけてもプリントされた。ジャケットとブルゾンは、黒のサテン地やPutty（パテ・毛淡褐色）のスウェード地、繊細なシフォン、チュール、ビスコース等の素材で、色はフォトプリントに関連させる。アーミーのオーバーオールは黒に染め直し、ブルゾンとして作り直し、スパンコールのイブニングドレスのフォトプリントと合わせ、ラインストーンを手付けした細いベルトをした。靴は足番のものの靴底のみを使用し、素足の上から靴底と一緒に透明のガムテープで巻いた。

Showroom

2 bis Passage Ruelle, Paris 75018.

A wooden 'set' is constructed within the showroom, painted white on the inside, its outer side is left rough and unpainted. A row of 12 Photo-Print garments hang on metal 'Dry Cleaner' hangers along a wall.

Presentation

October 1995

La Maison de la MutualitÈ on Paris' left bank. The forty-four women wearing the collection walk along four refectory tables each twenty-two metres long. Bottles of red wine and white plastic cups have been placed on the tables so that the invited public can serve themselves. The show has two parts. For the first part the women wear cotton veils hiding their faces and hair, their outfits combine the garments of photographs of garments from the previous winter collection with other pieces of the collection. Only the photographic prints are worn for the second passage. The women's faces are visible and their hair down. For those who wore a print skirt their breasts are now bare, the others who wore a print top, wear these with a simple flesh toned slip skirt. The sound of cheerleaders punctuates the atmosphere created by the amplified sound of the women's footsteps on the tables.

Collection

Photographs of garments are printed on light and fluid fabrics and made up into garments of very simple construction. The colours of old photographs and photocopies - black and white, sepia and tones of brown. A photograph of a 1930's heavy man's, half belted, overcoat is printed on a light viscose. 1940's checked skirts to the knee are shown on silk chiffon. A second-hand army surplus jacket is printed on stretch cotton and a lighter viscose. Heavy knit woollen sweaters are photographed unto cotton and viscose. The photograph of a long sequinned evening dress is printed on viscose, used as a dress, and cut into a skirt and top. With only one structured jacket, the collection combines blousons, in fabrics ranging from black satin to 'putty' coloured suede, with fragile chiffon, tulles and viscose in colours referring to the photo-prints. Army overalls are over-dyed in black and cut to make blousons which are belted with thin strings of rhinestone and combined with the photograph of the sequinned evening dress. The shoes of all previous seasons have their upper entirely cut away leaving only the sole. These are attached to bare feet with 'Scotch' tape.

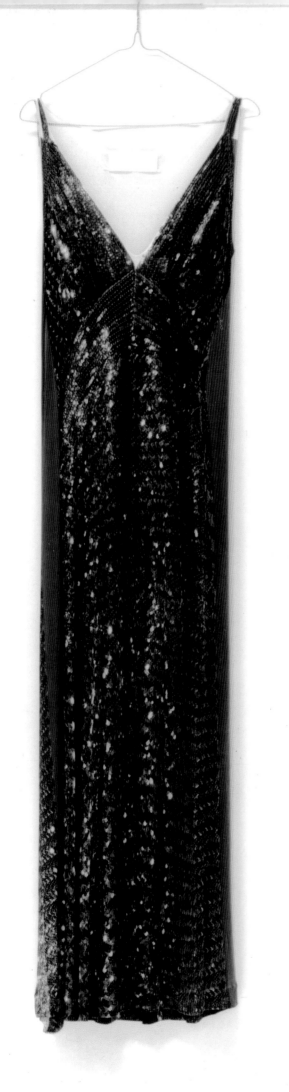
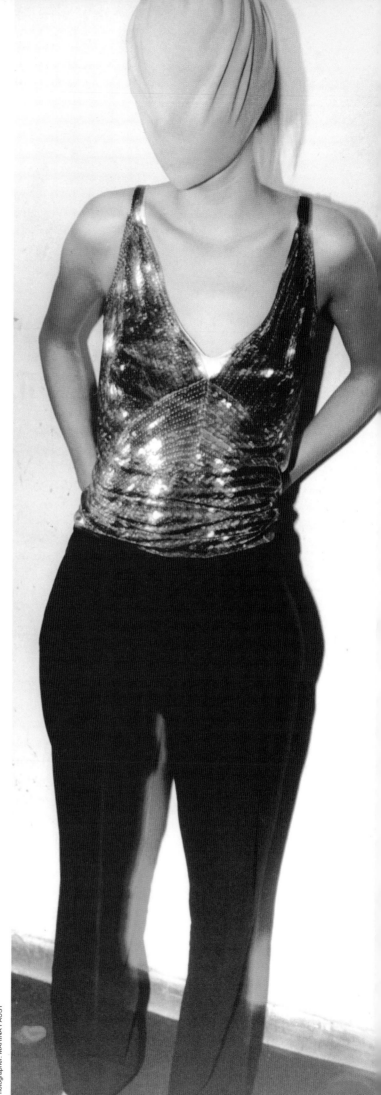

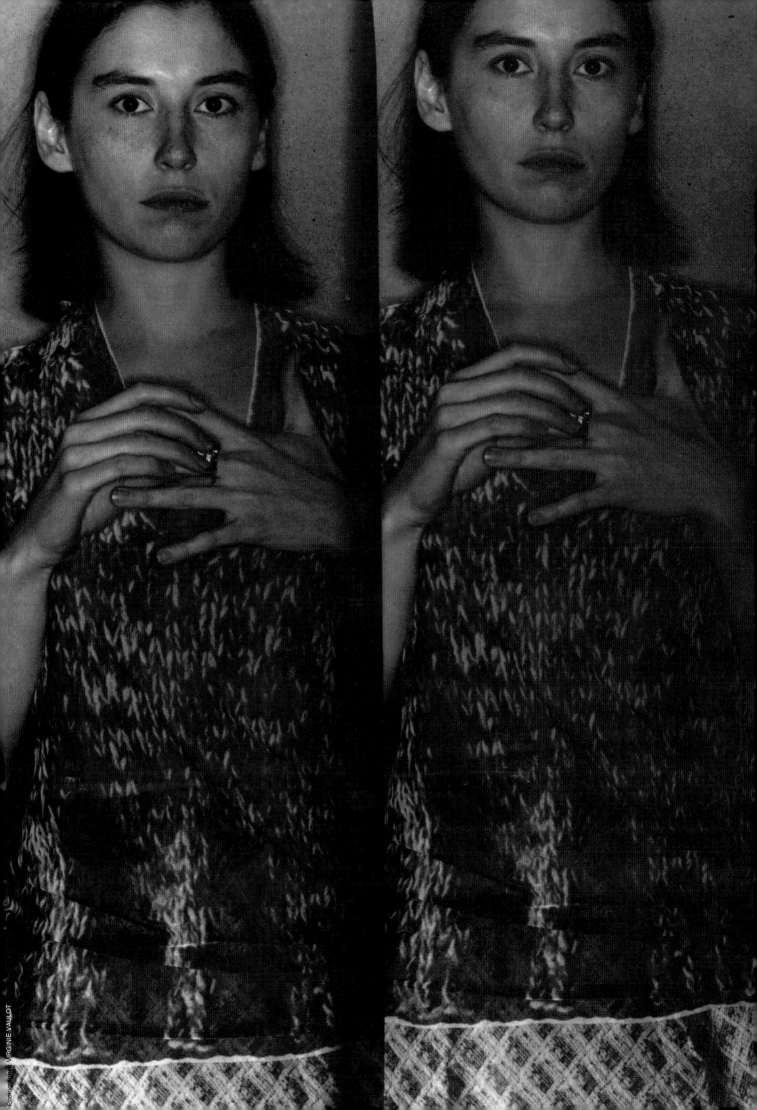

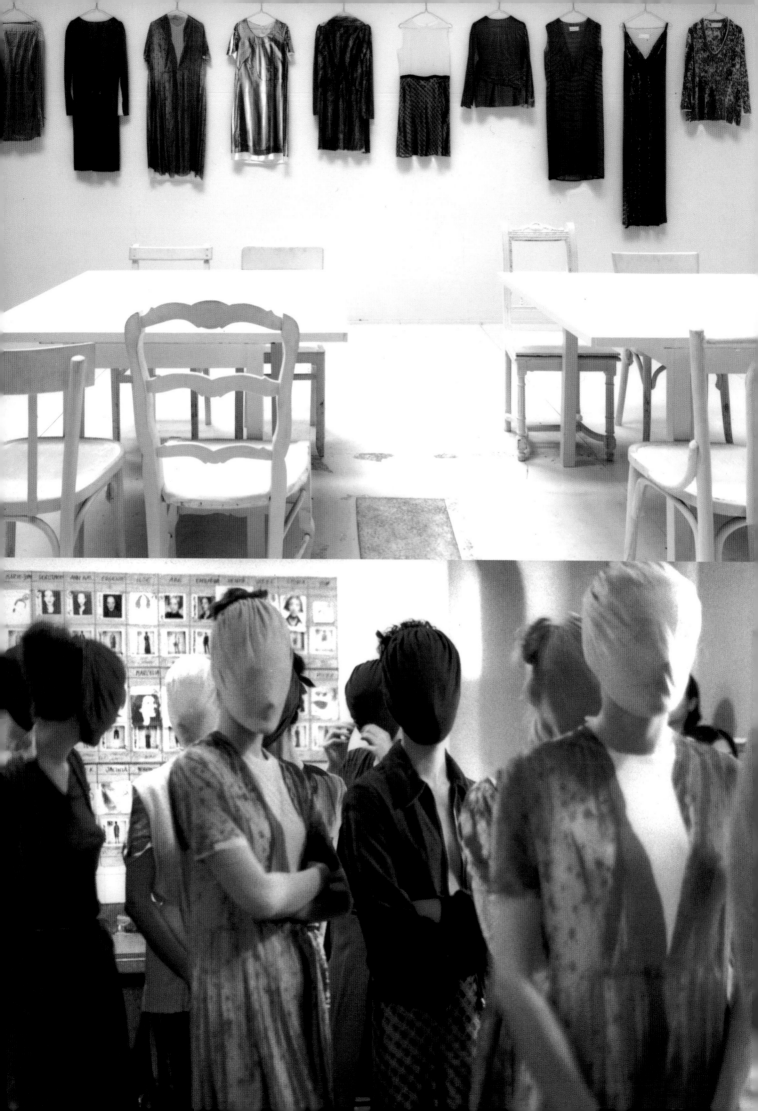

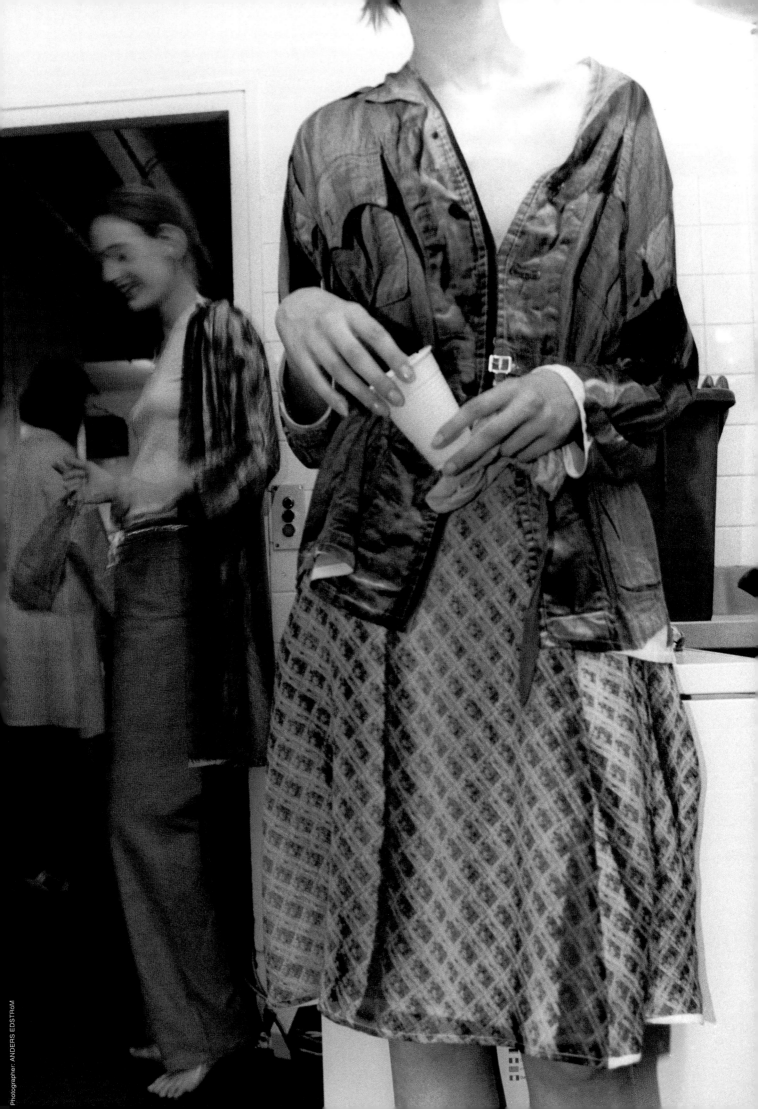

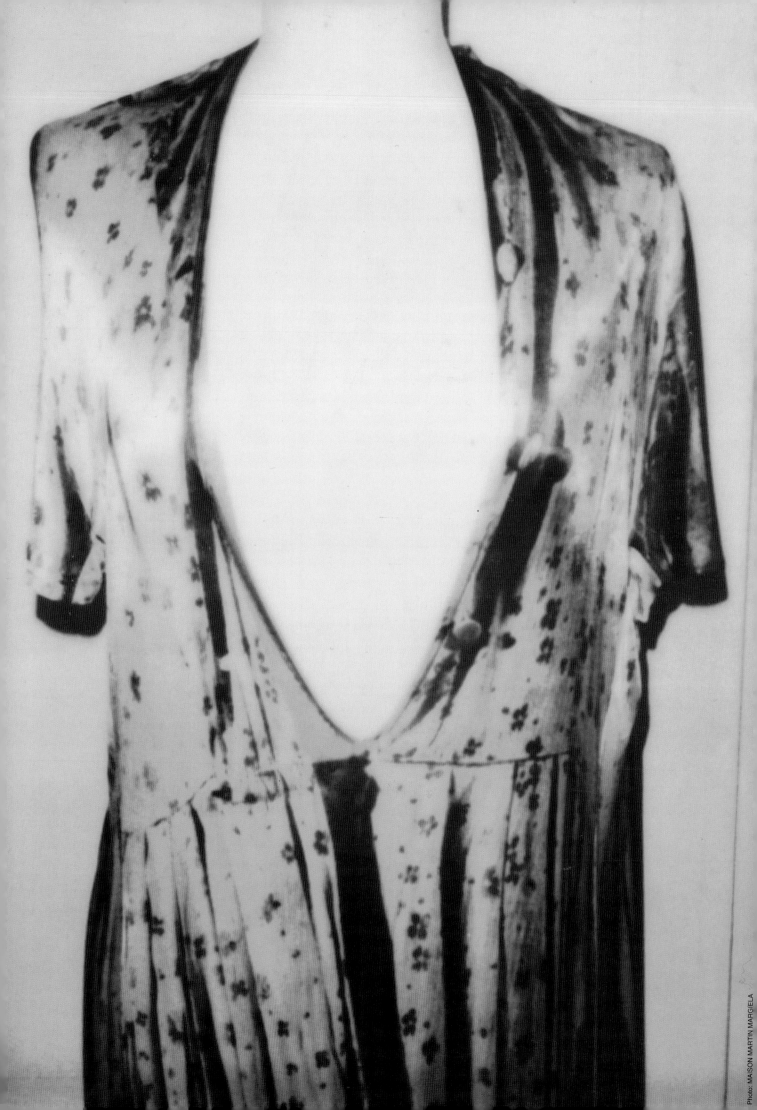

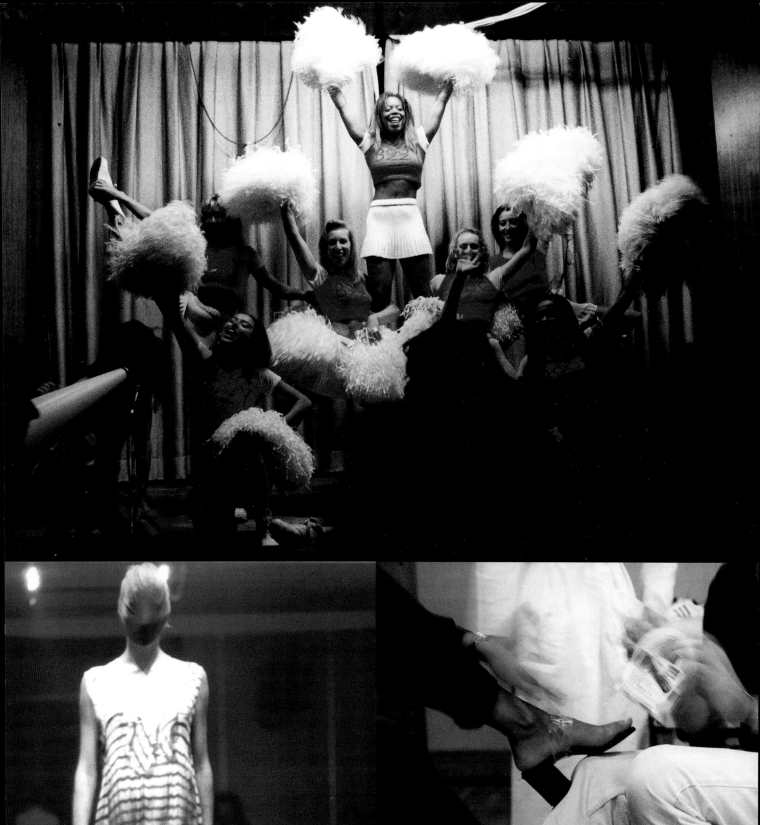

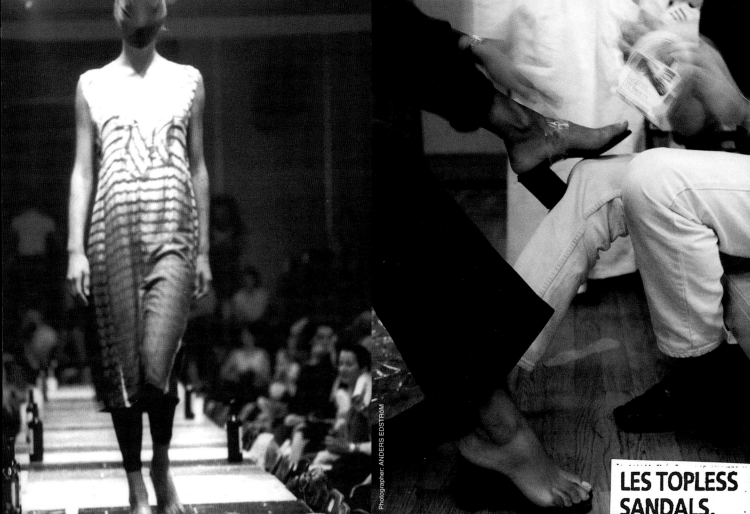

Photographer: ANDERS EDSTRÖM

LES TOPLESS
SANDALS.

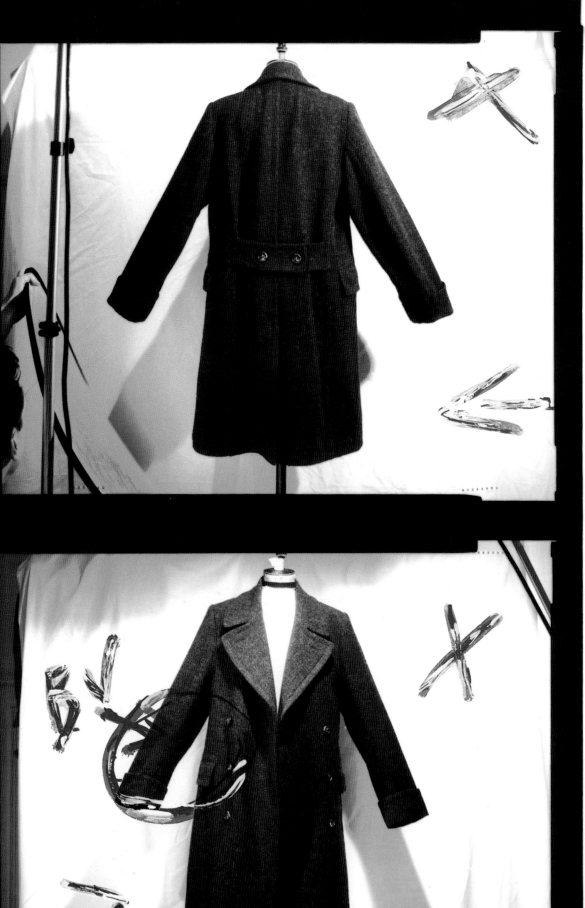

MARTIN MARGIELA

collection P/E '96 .

PHOTOS IMPRIMEES

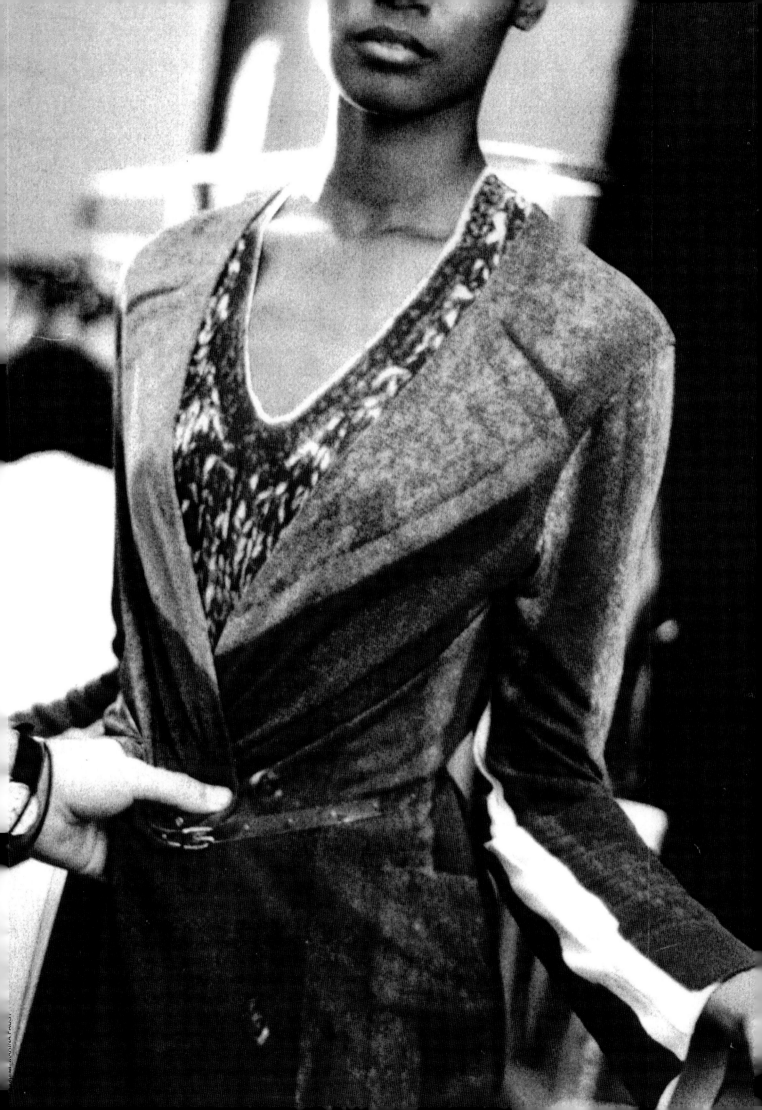

IMPRIMÉ PHOTO
ROBE RAYÉE

IMPRIMÉ PHOTO
ROBE FLEURS

IMPR. PHOTO
ROBE PAILLET.

IMPR. PHOTO
GRIS PULL

VAR NIBL

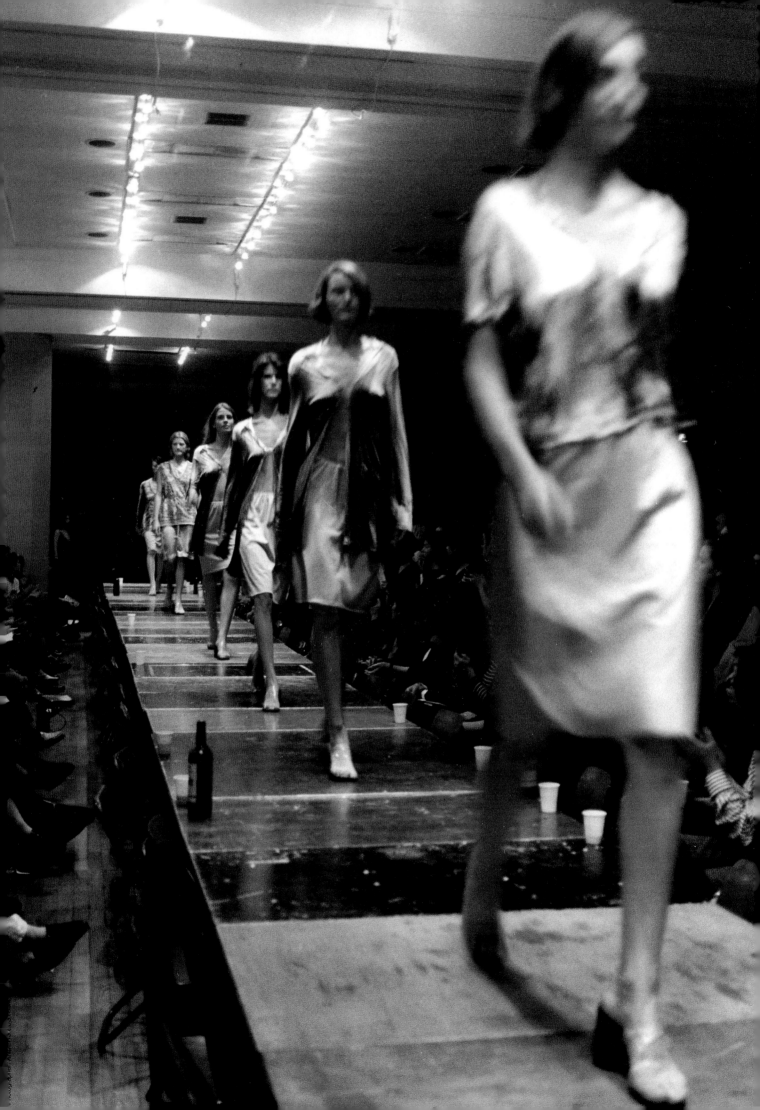

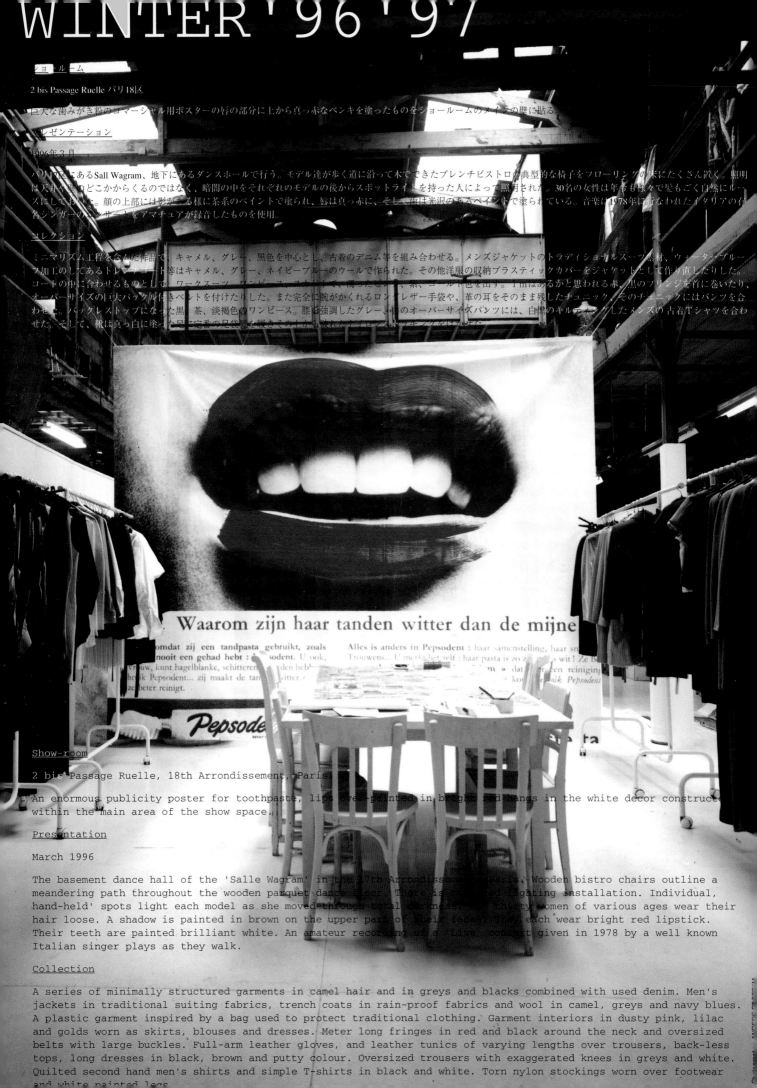

ショウ・ルーム

2 bis Passage Ruelle パリ18区

巨大な歯みがき粉のコマーシャル用ポスターの唇の部分に上から真っ赤なペンキを塗ったものをショールームのメインの壁に貼る。

プレゼンテーション

1996年3月

パリ17区にあるSall Wagram、地下にあるダンスホールで行う。モデル達が歩く道に沿って木でできたフレンチビストロの典型的な椅子をフローリングの床にたくさん置く。照明は天井や壁のどこかからくるのではなく、暗闇の中をそれぞれのモデルの後からスポットライトを持った人によって照明された。30名の女性は年令も様々で髪もごく自然にルーズにしておいた。顔の上部には影がある様に茶系のペイントで塗られ、唇は真っ赤に、そして歯は光沢のあるペイントで塗られている。音楽は1978年に行なわれたイタリアの有名シンガーのコンサートをアマチュアが録音したものを使用。

コレクション

ミニマリズム工程を含んだ作品で、キャメル、グレー、黒色を中心とし、古着のデニム等を組み合わせる。メンズジャケットのトラディショナルスーツ素材、ウォータープルーフ加工のしてあるトレンチコート等はキャメル、グレー、ネイビーブルーのウールで作られた。その他洋服の収納プラスティックカバーをジャケットとして作り直したりした。コートの中に合わせるものとしてワークスーツ、ワンピース、スカート、等、違ったピンク、紫、ゴールド色を出す。1m位はあるかと思われる赤、黒のフリンジを首に巻いたり、オーバーサイズの巨大なバックル付きベルトを付けたりした。また完全に腕がかくれるロング・レザー手袋や、革の耳をそのまま残したチュニック。そのチュニックにはパンツを合わせた。バックレストップになった黒、茶、淡褐色のワンピース。膝を強調したグレー、白のオーバーサイズパンツには、白黒のキルティングしたメンズの古着Tシャツを合わせた。そして、靴は真っ白に塗った足で定番の足袋型を履きそのまま歩いた。ナイロンストッキングをはいた。

Show-room

2 bis Passage Ruelle, 18th Arrondissement, Paris.

An enormous publicity poster for toothpaste, lips over-painted in bright red hangs in the white decor constructed within the main area of the show space.

Presentation

March 1996

The basement dance hall of the 'Salle Wagram' in the 17th Arrondissement, Paris. Wooden bistro chairs outline a meandering path throughout the wooden parquet dance floor. There is no fixed lighting installation. Individual, hand-held' spots light each model as she moved through total darkness. Thirty women of various ages wear their hair loose. A shadow is painted in brown on the upper part of their faces. They each wear bright red lipstick. Their teeth are painted brilliant white. An amateur recording of a 'live' concert given in 1978 by a well known Italian singer plays as they walk.

Collection

A series of minimally structured garments in camel hair and in greys and blacks combined with used denim. Men's jackets in traditional suiting fabrics, trench coats in rain-proof fabrics and wool in camel, greys and navy blues. A plastic garment inspired by a bag used to protect traditional clothing. Garment interiors in dusty pink, lilac and golds worn as skirts, blouses and dresses. Meter long fringes in red and black around the neck and oversized belts with large buckles. Full-arm leather gloves, and leather tunics of varying lengths over trousers, back-less tops, long dresses in black, brown and putty colour. Oversized trousers with exaggerated knees in greys and white. Quilted second hand men's shirts and simple T-shirts in black and white. Torn nylon stockings worn over footwear and white painted legs.

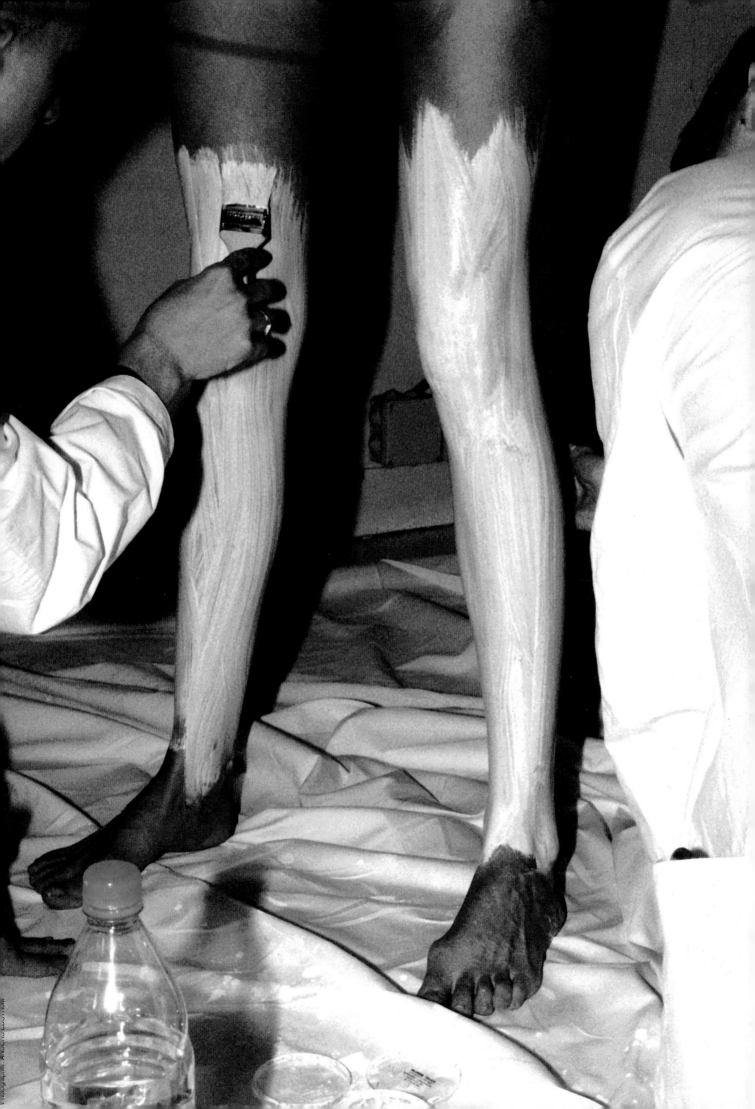

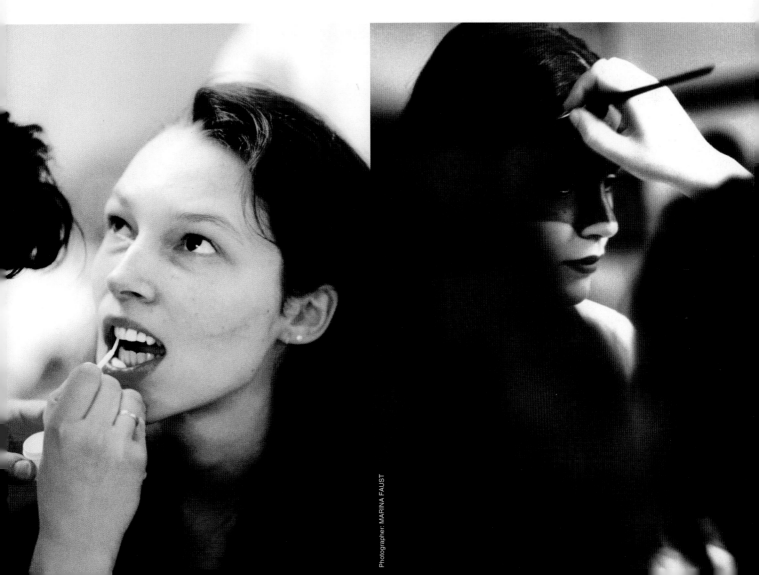

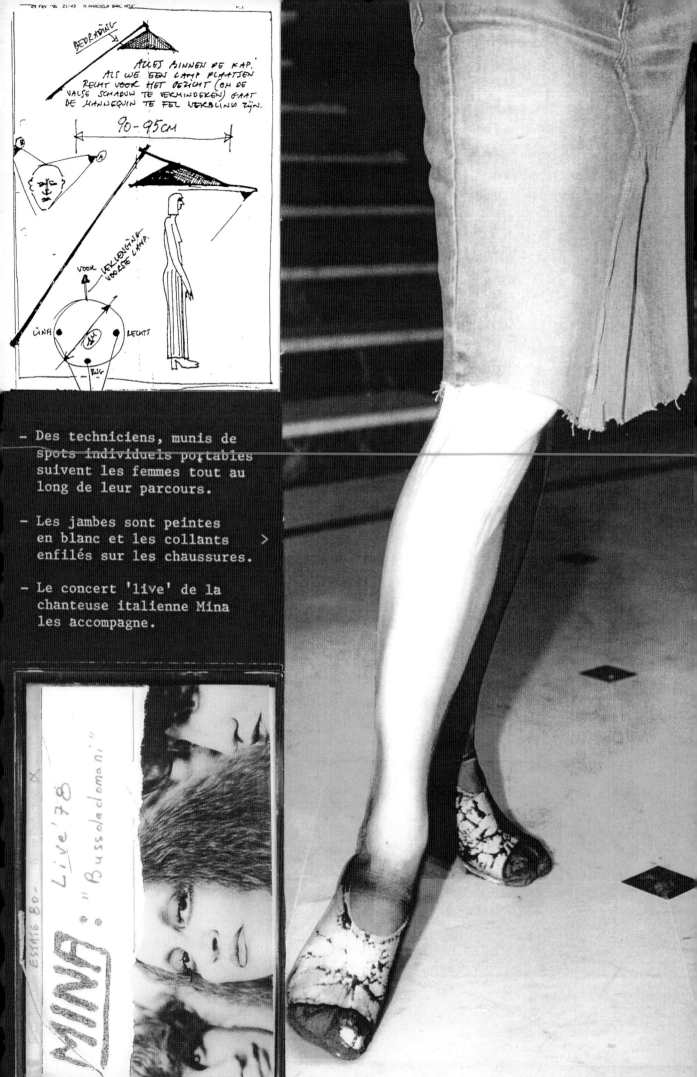

- Des techniciens, munis de
 spots individuels portables
 suivent les femmes tout au
 long de leur parcours.

- Les jambes sont peintes
 en blanc et les collants
 enfilés sur les chaussures.

- Le concert 'live' de la
 chanteuse italienne Mina
 les accompagne.

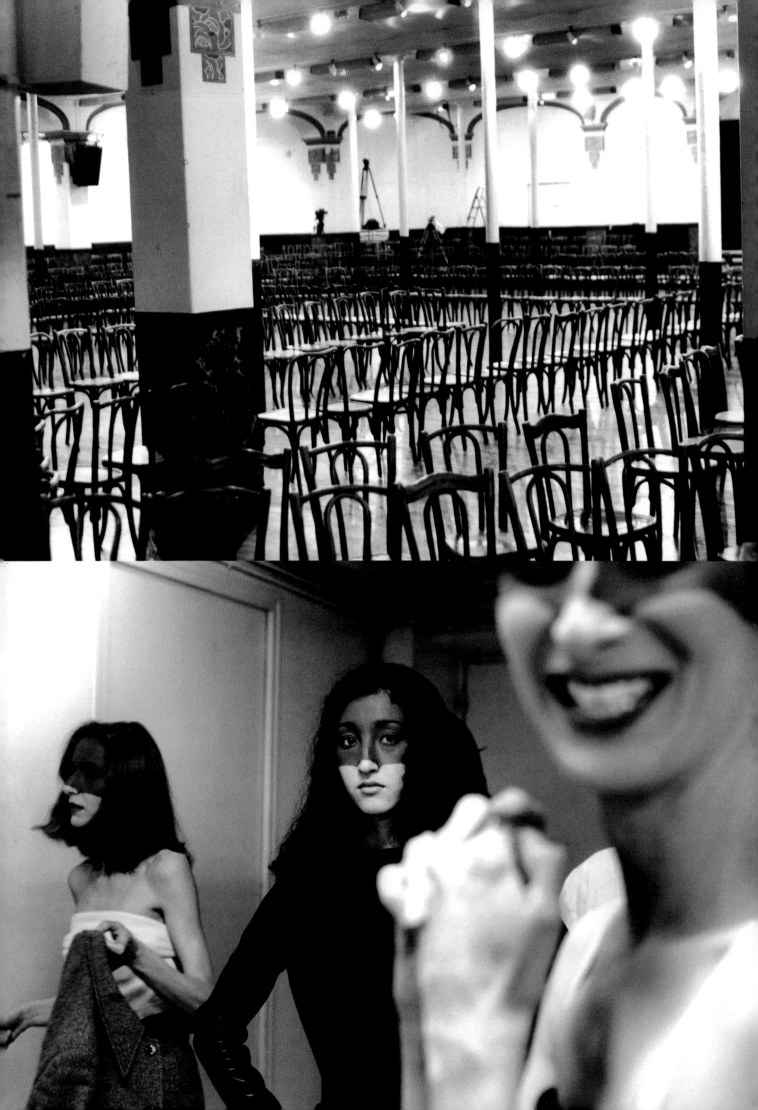

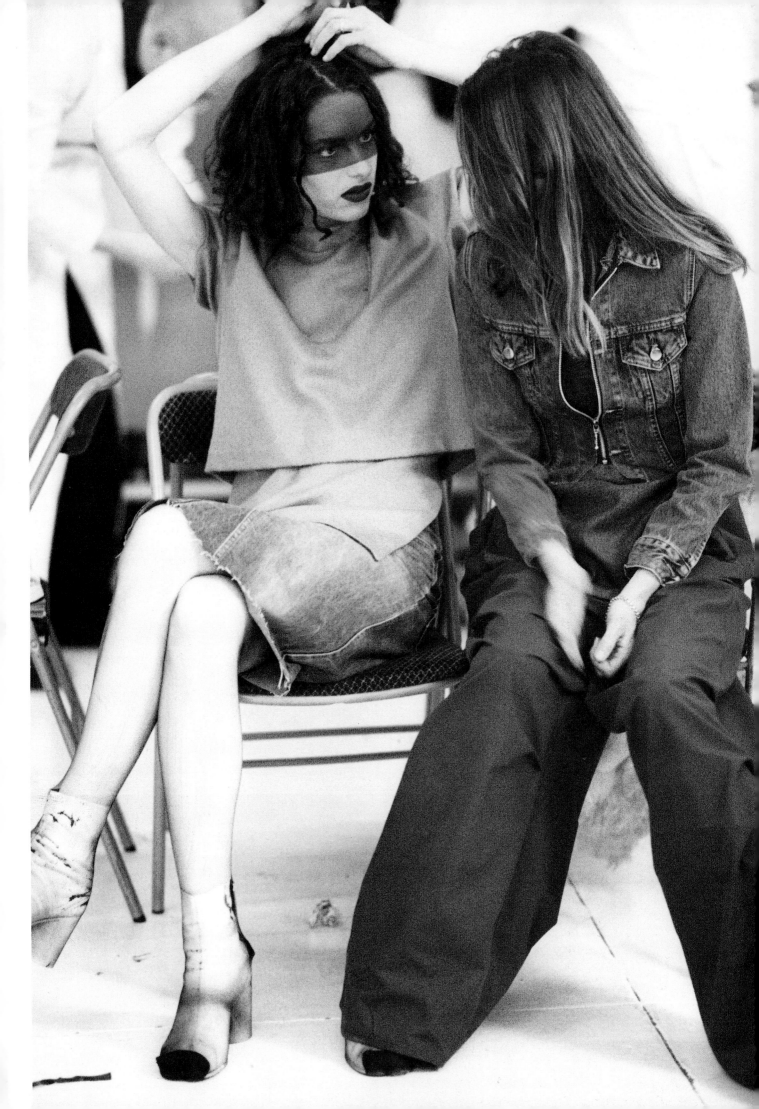

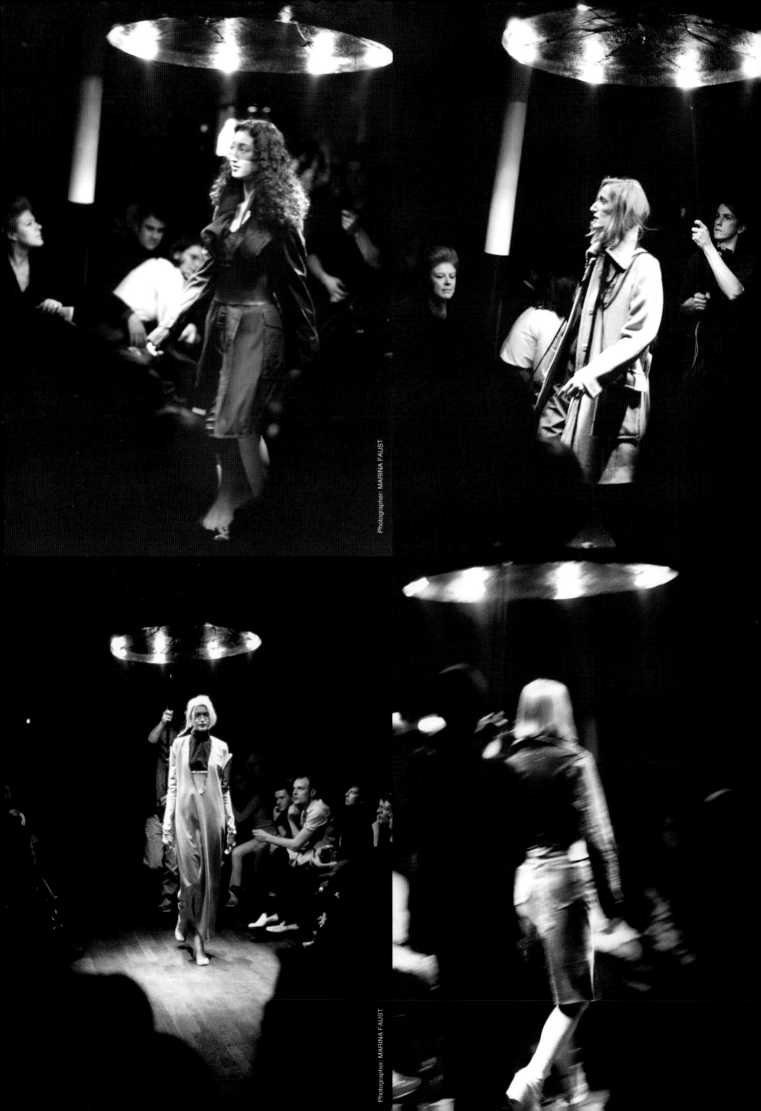

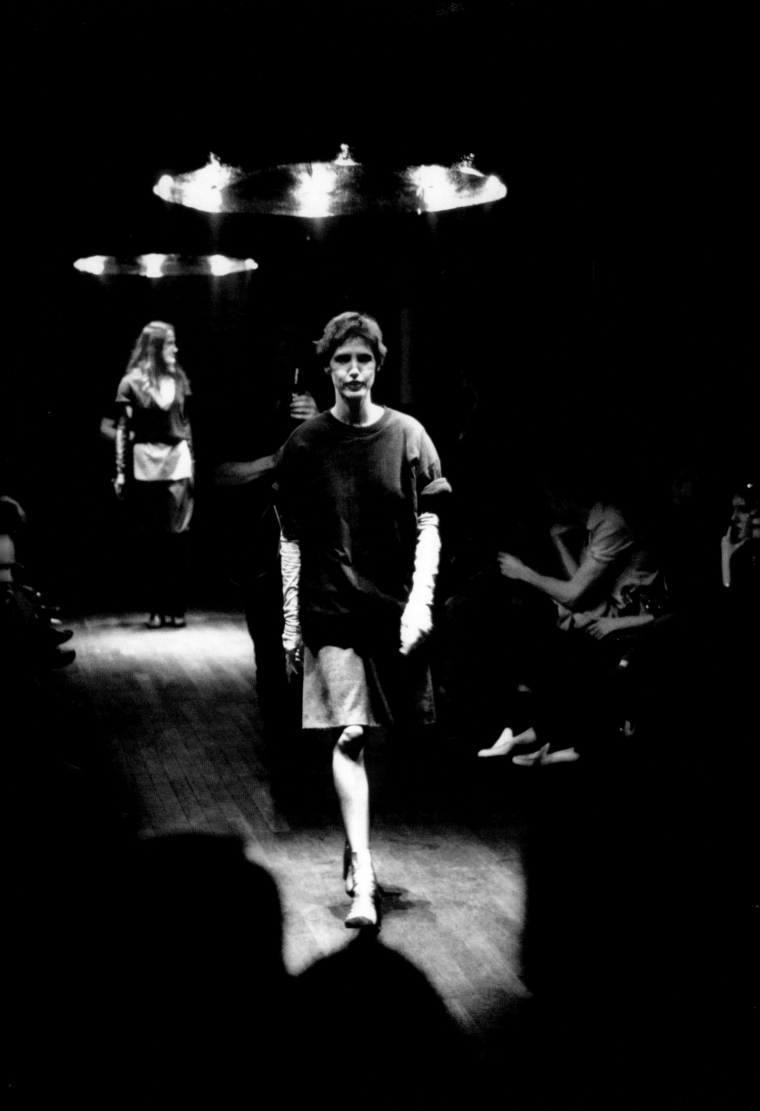

SUMMER '97

ショールーム

2 bis Passage Ruelle パリ18区。

白の木造舞台をショールームのメインに設置する。造花のひまわりの花畑を作る。展示会及びプレスミーティングも全てこの花畑の真ん中で行なった。

プレゼンテーション

1996年10月

ショールームから、ショールームの近くの地下鉄までの道のりを2名の女性にコレクションを着てもらいフィルム撮影する。世界各国のプレス、バイヤー達がパリに着く前に、私達のアトリエでの製品を撮り、そのフィルムの間、間に分割して挿入した。プレスの招待者にはパリの宿泊先へそれぞれFAXを流し、アポイントメントをとってもらうよう連絡した。そのアポイントメントはそれぞれ個人、雑誌、新聞社等の編集者に来てもらった。洋服とコレクションのテーマは、ビデオと洋服をコーディネイトしたショールームモデルで説明された。また、オーケストラ演奏による"MUSAK"が全体に流れた。

コレクション

2シーズン同テーマによるコレクションのファーストコレクション。ラフなリネンの立体裁断に使われるテーラー用のドレスダミーがこのコレクションのベースとなる。そのジャケットは肌に直接着、スリングスカートを合わせたり、パーマネントに染色されたブルージーンズを合わせた。アトリエでの作業の工程の様々な要素、ショルダーパッドやバインディング、修正ライン等がボディ（テーラー用ボディ）にピン止めされる。ごくシンプルな切ったままの四角形の生地は不規則なヘムラインを描く、スカートやワンピースとなった。ジャケットはメンズのサイズ、プロラスでカットした。そしてそれを一度作り上げ、内部の芯地、肩パット、裏地等をはずし、レディスサイズの芯地、肩パット、裏地とつけ替える事によって二つ目のレディースのショルダーラインを作る。ジャケットと同じショルダーラインのニットカーディガン、ノースリーブカーディガン、洗いざらしのTシャツ等がそのジャケットと合わされる。ライニングスカートの上に前身のみのスカートをつける。それは白からパールグレイ、ダークグレイ、ネイビーブルーそして黒までと幅広く展開。その中で唯一ビビッドカラー、イエローをベルベット、ライニング素材で混ぜた。過度に幅狭に作ったワンピースは、コンシールファスナーを使用し、それを開ける事で着られるようになっていて、着る人によって違う形になるようになっている。ドレープドレスの立体裁断ドレスは、コルセットや平ゴムを使用する事によってやわらく、着心地良くされた。そしてヒールをつけた靴底だけを足につけた。

Showroom

2 bis Passage Ruelle, 18th Arrondissement, Paris.

A white decor stands within the main area of the showroom space. A field of imitation sunflowers is planted in the floor. The sales of the collection as well as press meetings take place amid the flowers.

Presentation

October 1996

A video showing two women wearing the collection walking through the streets and metro adjacent to the showroom, inter-cut with segments showing the production of pieces at our 'atelier, is prepared the week before the international press and buyers arrive in Paris. A fax is sent to the hotels of the press inviting them to take an appointment at our showroom. Appointments are made with individuals and the editorial teams of magazines and newspapers. The garments and themes of the collection are explained verbally, by video and on a showroom model who wears certain combinations of pieces for the visitors. Light orchestral 'musak' plays throughout the space.

Collection

The first part of one collection for two seasons. The mould of a Tailor's dummy (or Dress form) in rough linen is a foundation for the collection. The object is worn directly on the skin, either with a slip skirt or a permanently dyed Blue Jean. Various elements, from the varying stages of an atelier's work, are pinned to the Tailor's dummy form: shoulder pads, binding and garment studies. A simple unfinished square of fabric becomes a skirt or a dress with an irregular hem-line. Jackets are cut to a man's proportions. Once finished the internal structure of the prototype was removed and a second, feminine, shoulder line is added through the use of shoulder pads over which the original, man's, shoulder line hangs. Knit cardigans, some without sleeves, and washed T-shirts, with the same shoulder-line as the jackets, are worn with a trial for the front panel of a traditional skirt and the lining of a skirt. A series of structured garment fronts, in yellow velvet, and their yellow linings is the only point of vivid colour amid a colour pallet ranging from white through pale greys, anthracite, navy blue to black. Overly narrow dresses may only be worn by opening hidden zips which determine the form the dress takes on each person wearing it. Studies for various parts of draped dresses in chiffon are worked by hand onto structures in elastic and corset bones, becoming garments in their own right. The soles of our shoes, mounted on heels, are worn on the feet.

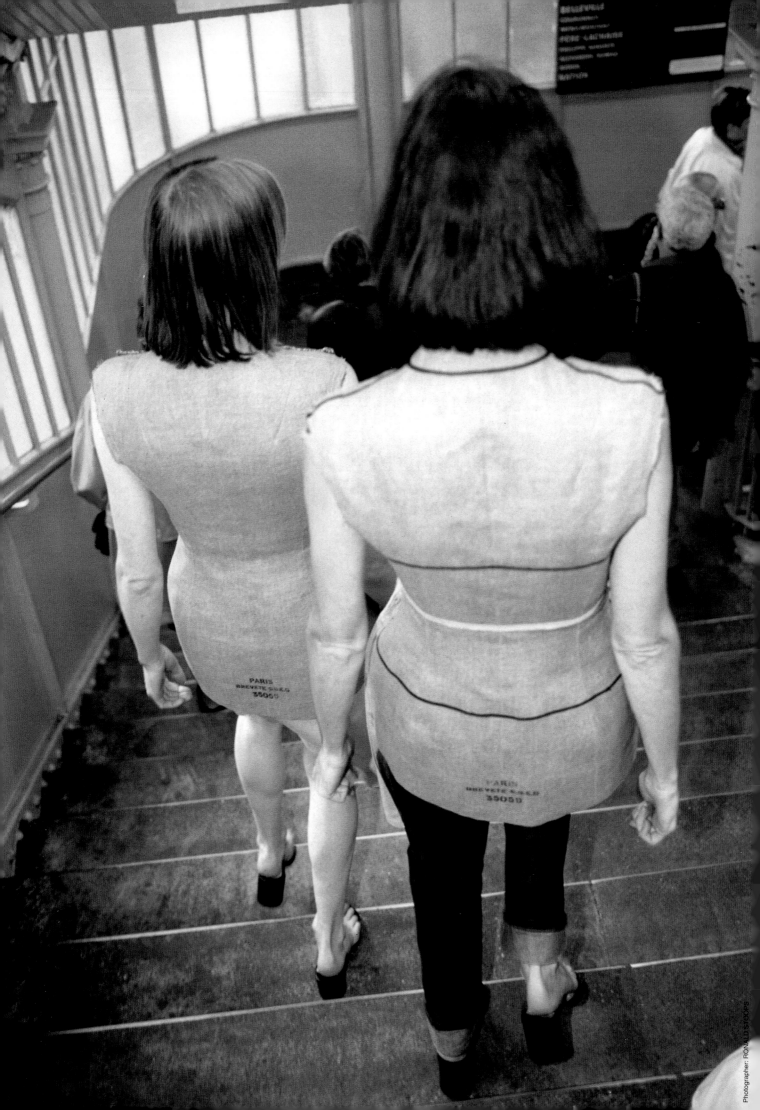

DOS

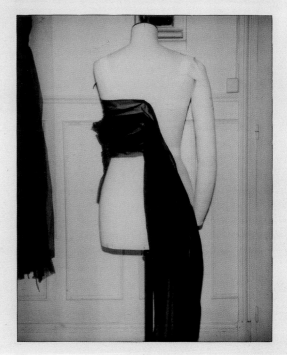
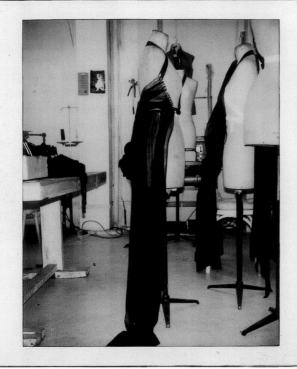

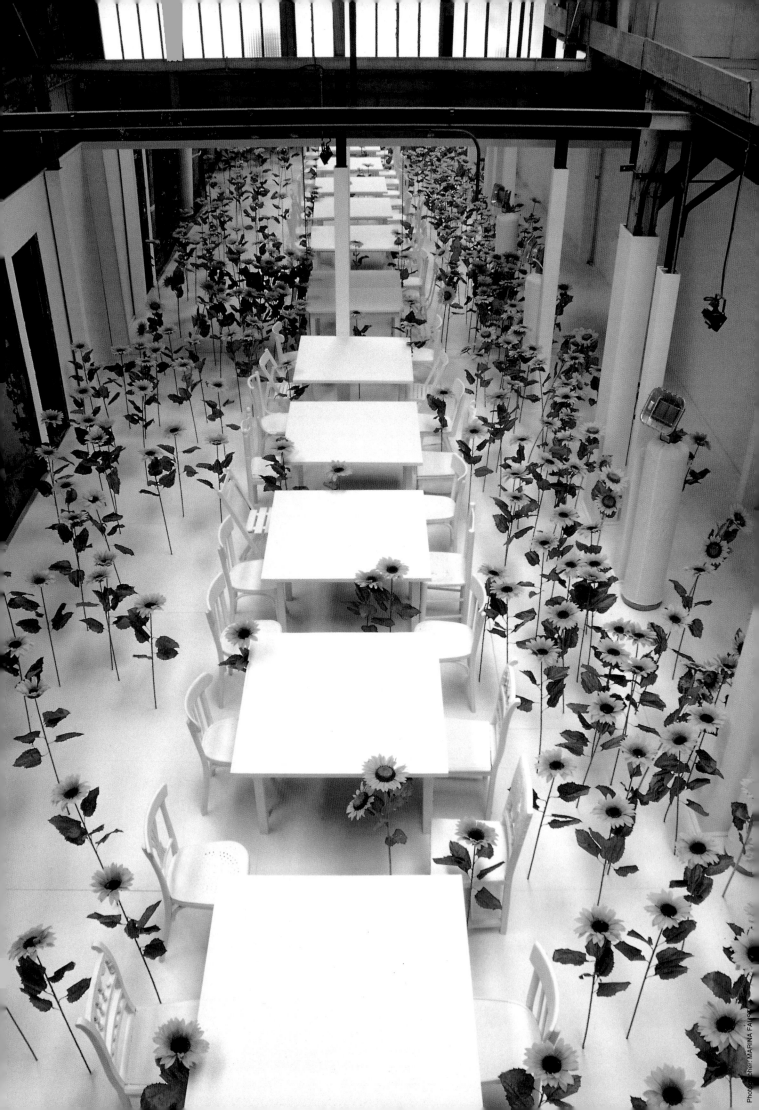

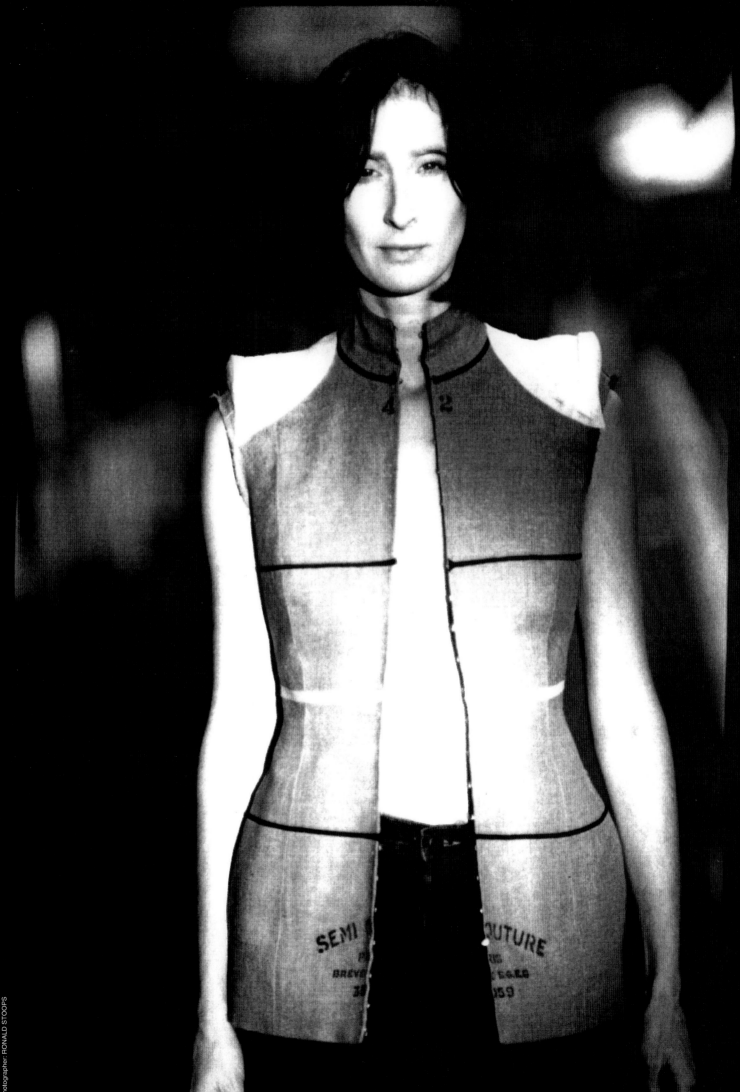

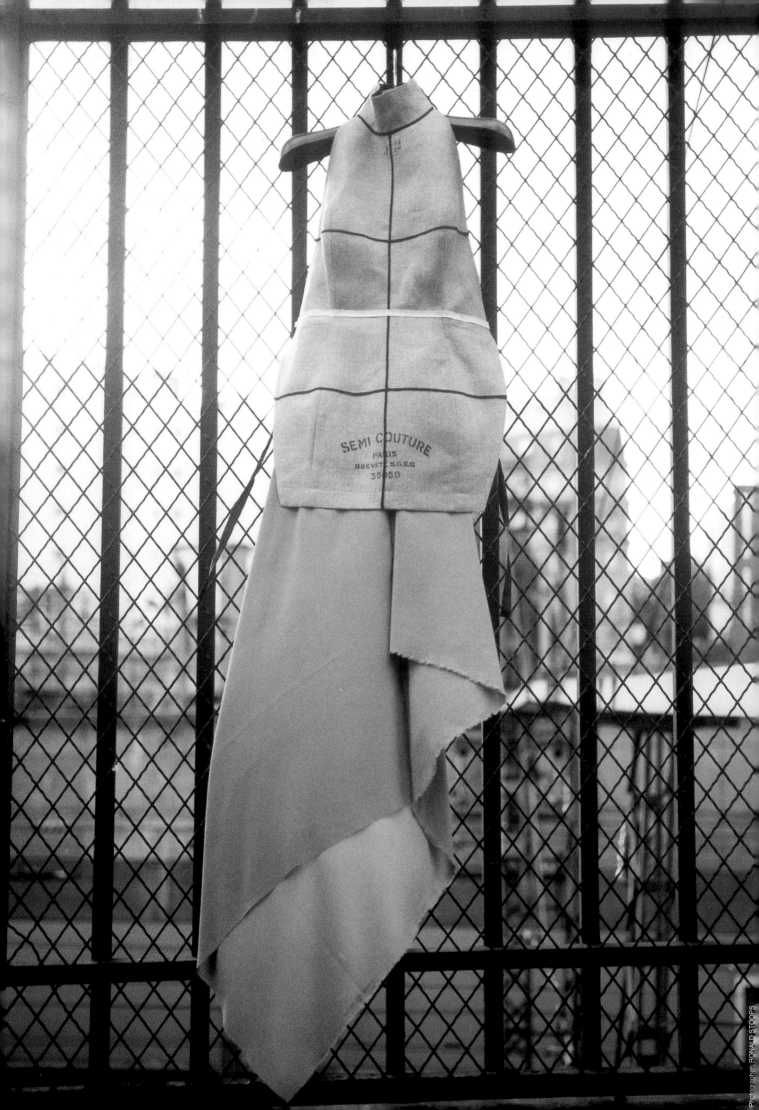

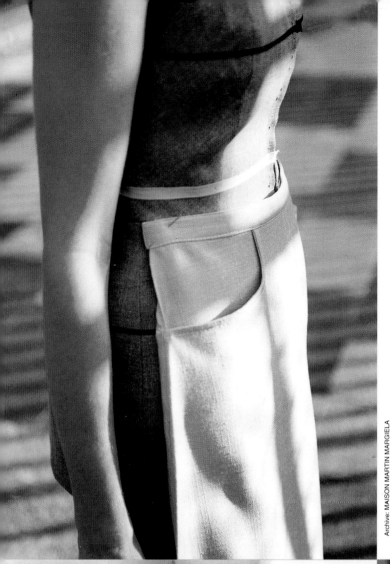

tailors' soft crayons
MADE IN TAIWAN

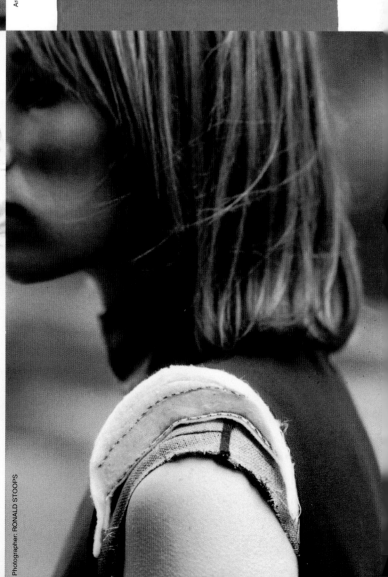

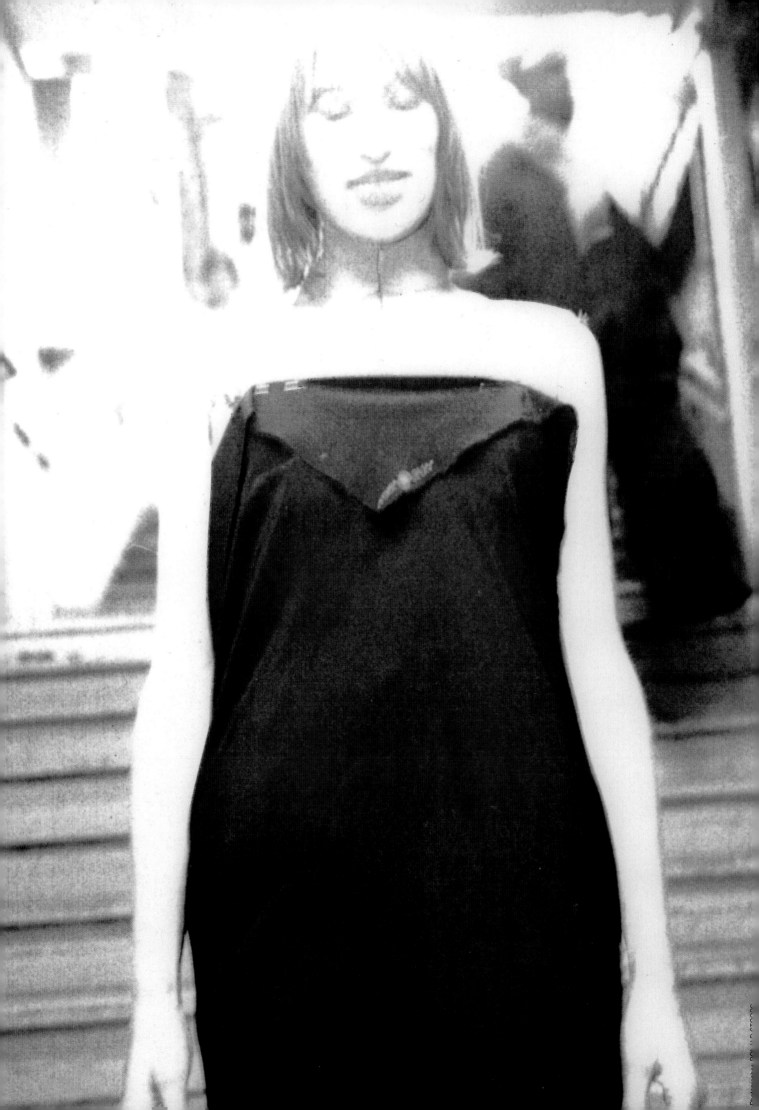

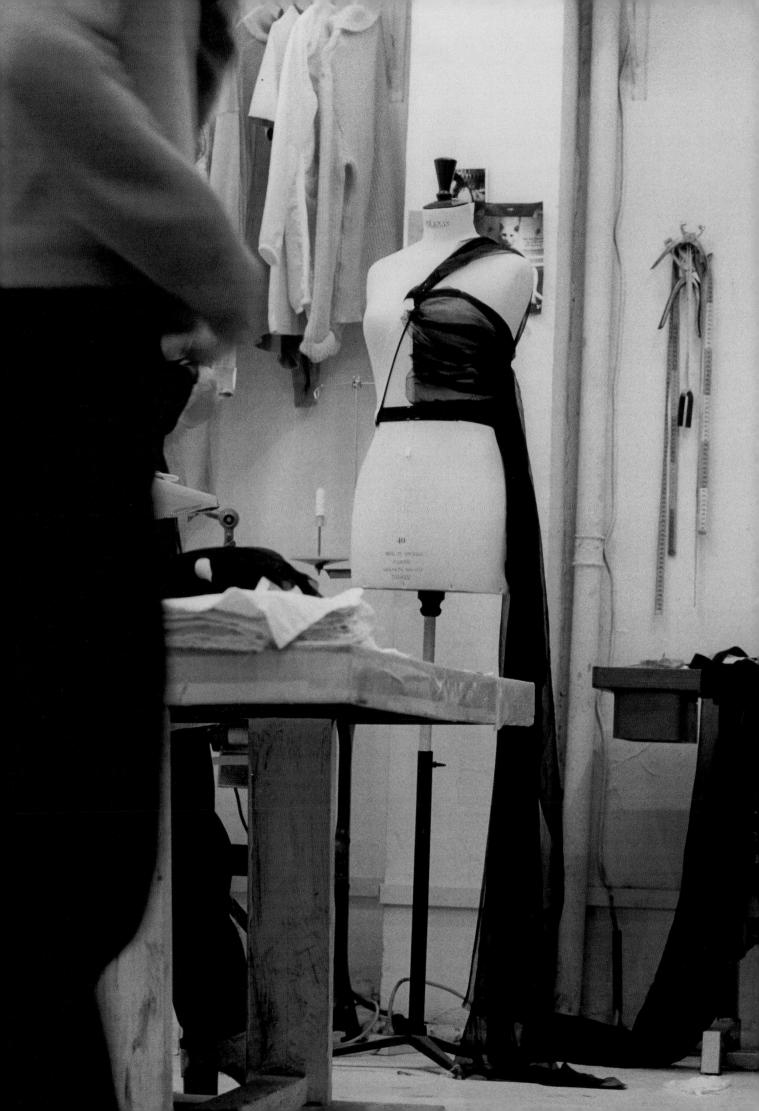

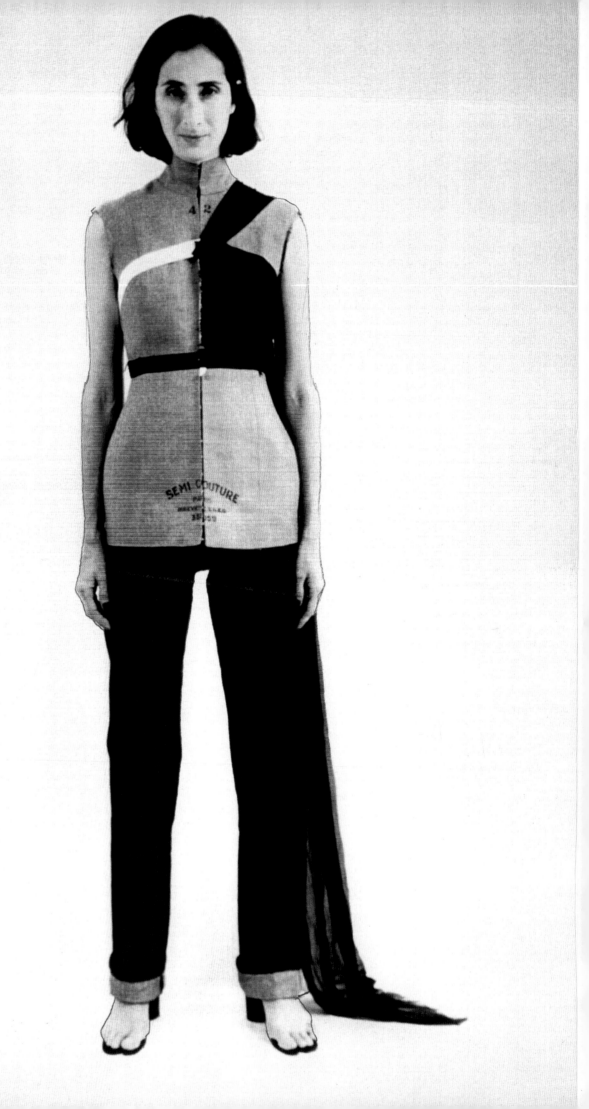

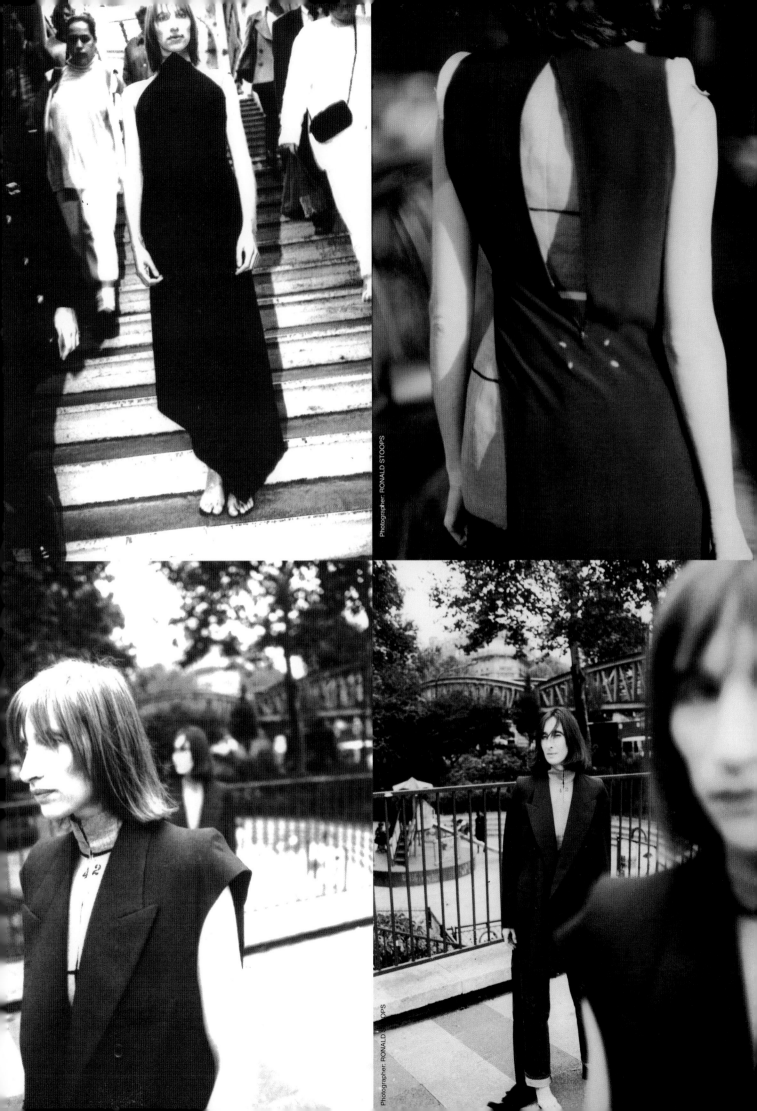

WINTER'97'98

ショールーム

2 bis Passage Ruelle パリ18区

いつもの白を基本としたショールームにマルチカラーのスポットライトをいくつも設置した。

プレゼンテーション

1997年3月

3ヵ所に分けて行なう。
10：30 LA JAVA ベルビル　今は使用されていない屋内マーケット
11：45 LE GIBUS　レペビュリック ガラスの屋根でカバーされている荷物収納場
15：00 LA MENAGERIE DE VERRE　パルモンティエ ダンススクール

いろんなタイプのパリの広告用地図にこの3ヵ所のうち1ヵ所のみスタンプマークされそれが招待状となる。まず、大型バスで朝5：00ブリュッセル（ベルギー）から35名のブラスバンドが出発。パリで35名のモデルが乗っているもう一台の大型バスとおちあう。そして最初の会場JAVAへ向かう。ショー終了後GIBUSへ直行する。ショーの始まりは、ブラスバンドがスローなマーチを演奏し彼らがモデル達を会場の中へと誘う。招待者は群衆の中からバスの到着、演奏、モデルを見る事となる。3番目の会場 LA MENAGERIE DE VERRE はほとんど使わずに、外で待っている人々の間をコレクションの服を着たモデル達が歩くことにした。

コレクション

前回のコレクションよりいろんなバリエーションの服、オブジェを組成する。

1.　テーラー（ドレス）のダミージャケットシリーズ。このオブジェにはセーターまたはメンズサイズTシャツにライニングスカートまたは、メンズパンツを合わせる。立体裁断用ダミーの腕の部分のみもこのシーズン完成させる。
2.　生地耳に生地会社名が入ったままの部分を残しそれを四角形に切ったままのシリーズ。冬物素材に変え、あくまでも四角形に切ったままのものはスカート、ワンピースとなる。ヘムラインは不規則な線を描く。
3.　カラーバリエーションのシリーズ。服の制作課程を見せたもの。したがって仕付けをしたままや、裾の始末等きちんとできていない。
4.　サンプル商品の第一回目の仮縫い状態シリーズ。一回目の仮縫いでおこる状態、例えばダーツ移動、ライン移動等、全てあるままに残した。
5.　工業用パターン（方眼線入りで破れない紙）シリーズ。工業用パターンが工場につりさがっている状態のものを服として作り直した。

コートやジャケットは1997年の春夏物を再検討したものであり、冬物素材に変えられ、ケープとして提案し、袖の部分を中へひっぱり入れた。古着のファーコート、アライグマ、きつね、うさぎ等の素材を集め、一人一人モデルに合わせかつらを作る。このかつらはマルタンマルジェラデザインによるものでベルリンベースのBLESS制作によるもの。

Show-room

2 bis Passage Ruelle, 18th Arrondissement, Paris.

A white decor stands within the main area of the show space which is lit by many multi-coloured spotlights.

Presentation

March 1997

3 different locations at three different times:

10.30hrs	La Java, Belleville	Abandoned covered market.
11.45hrs	LE GIBUS, République	Glass covered loading bay
15.00hrs	LA MENAGERIE DE VERRE, Parmentier	Dance School.

Many various types of free promotional maps of Paris are stamped with indications to any one of the three different locations. A bus carrying a 35-man brass band leaves Brussels for Paris at 5 a.m. to meet another bus carrying the thirty-five models to their first destination, 'Java' before moving on to the second at the 'Gibus'. The brass band played slow marching music at each location. The invited crowd could see the arrival of the buses bringing the music and models. The third location, Le Menagerie de Verre was barely used as, at the last minute, it was decided that the women wearing the collection walk amongst the waiting crowd in the street.

Collection

The collection is composed of various series of garments and objects tracing the stages in the production of a garment:

1　A series of the moulds Tailor's Dummies/ Dress forms:
This object is worn on a sweater or a man's sized T-shirt with a synthetic slip-skirt or a man's trouser. The arms of the Dummy / Dress Form complete the series this season.

2　A series of squares of fabric that show their trademarked edging:
Squares of unfinished winter-weight fabrics become a skirt or dress. The hem-line is irregular.

3　A series of garment studies in various colours:
This series shows the internal structure of a garment. They are unfinished and unlined.

4　A series of first fitting prototypes:
These garments are the rough versions used for a first fitting. All of the faults and instructions for rectification are visible.

5　A series of garment patterns in industrial untearable paper stitched together so that they may be worn.:
The patterns of garments made in industrial untearable paper assembled as garments.

Restudied versions of the coats and jackets presented for Spring/Summer 1997. Proposed in winter weight fabrics they are worn as capes, their arms tucked inside. Old and used fur coats are used to provide the pieces of fur assembled to produce individually fitted wigs for each model. Furs include Racoon, Fox and rabbit. Colours range from black to beige. These wigs, an accessory to the collection, are produced for to the designs of Martin Margiela by BLESS, Berlin.

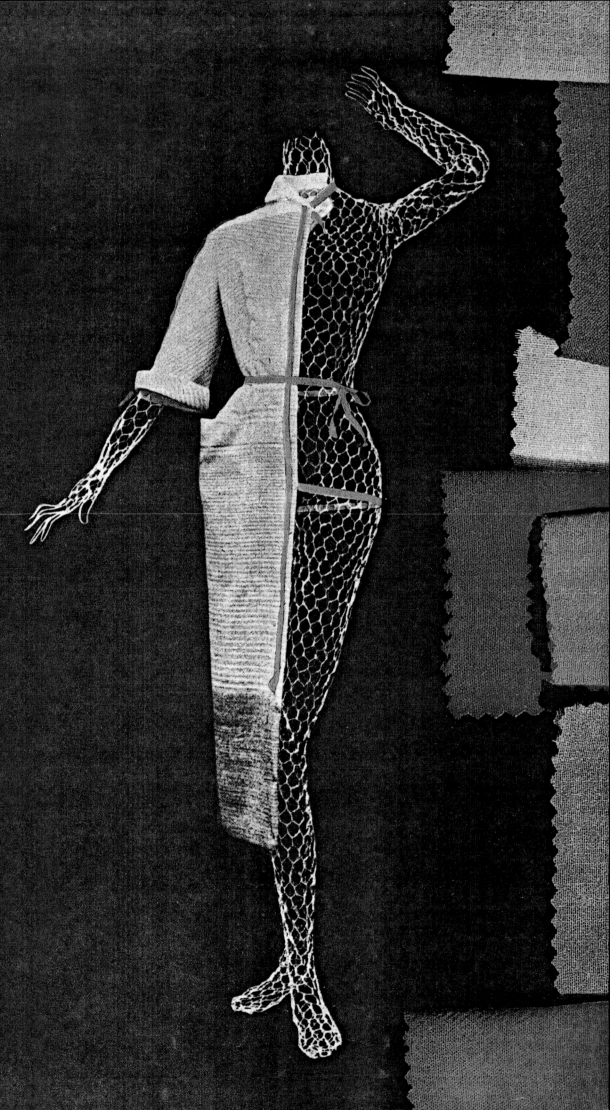

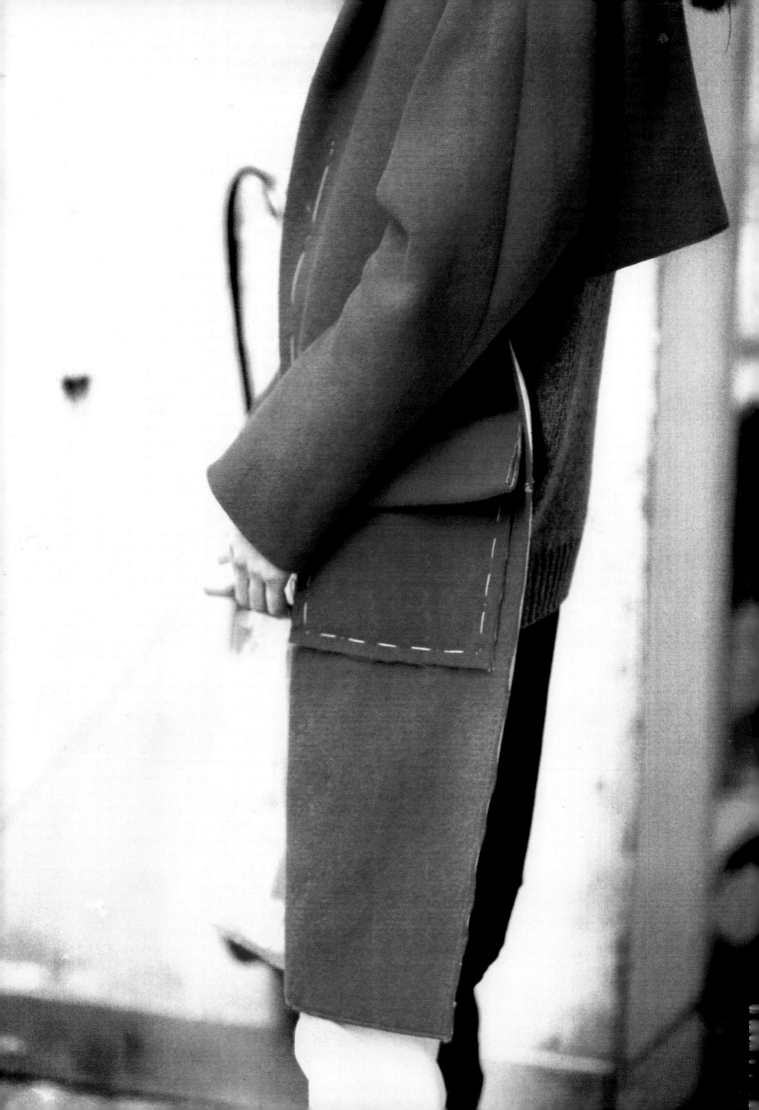

teichen Kostüme und Mänteln

Ist die Einlage nicht als Schnitteil gegeben, so wir[d] in Besatzbreite zugeschnitten.

1

Bei Webeinlage[n] bitte auf den Fadenlauf achte[n]. Er muß mit der vorderen Mitte[l] übereinstimme[n]. Vlieseline hat keinen Fadenla[uf,] sie kann gerade[,] schräg, aber au[ch] quer zugeschnit[ten] werden, so wie'[s] am sparsamste[n.] Die Einlage wir[d] auf die linke Se[ite] des Oberstoffes geheftet, entlan[g] der vorderen Ka[nte,] der Revers- umbruchlinie u[nd.] Die Reverskant[e] bleibt offen, d. hier wird die Einlage nicht fe[st] geheftet.

2

Das Revers

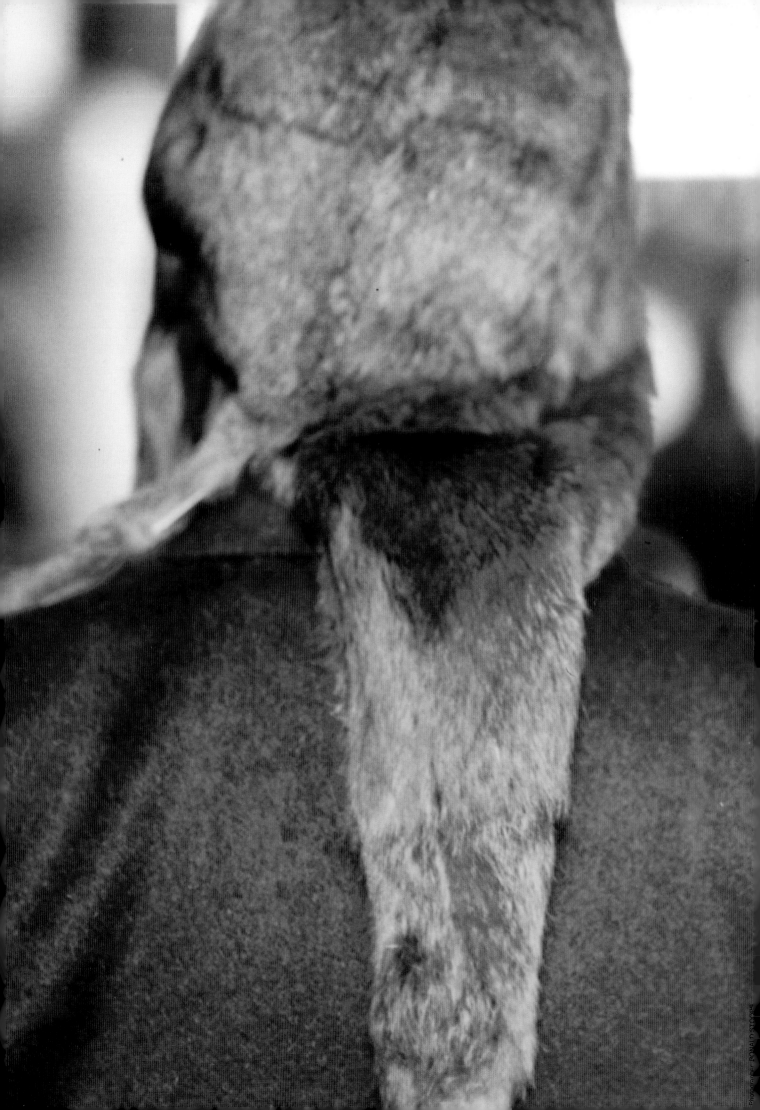

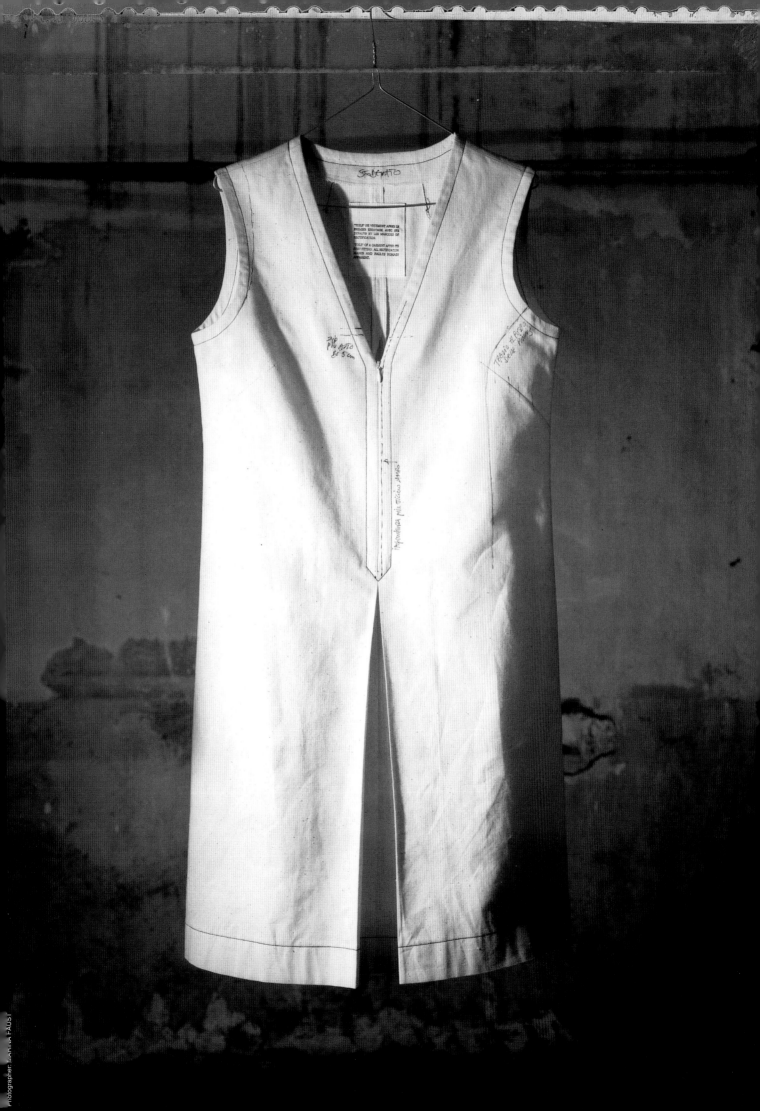

klassieke
NDELJAPON

dit mooie model af. Knippen en passen hebben wij
aan. Het aanbrengen van het linnen in de shawlkraag,
de zakken moet met veel zorg en nauwkeurigheid gedaan
rgeten, dat de kleinigheden meetellen om een succes van

ns GRATIS PATROON X 19, dat beschikbaar is in de
Voor de maten 42-48 · 2.20 m × 1.40 m. Voor de maten

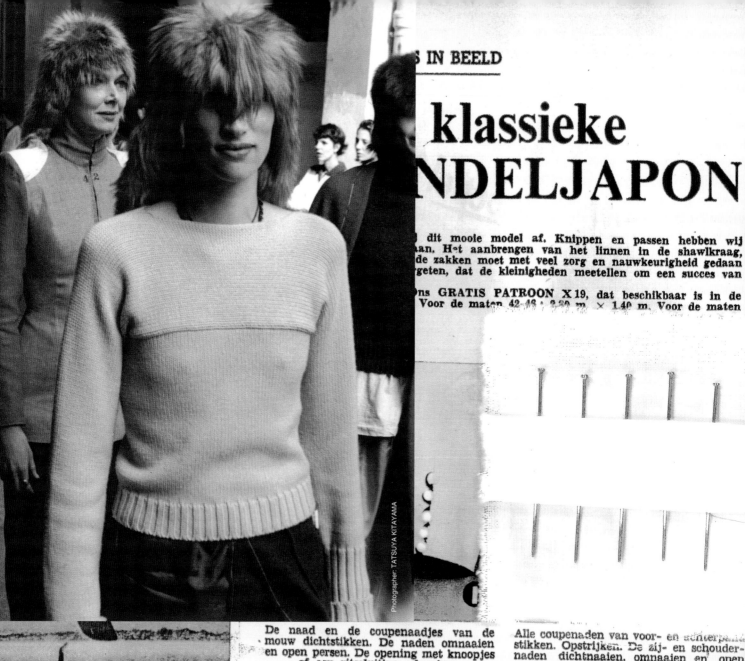

Photographer: TATSUYA KITAYAMA

De naad en de coupenaadjes van de
mouw dichtstikken. De naden omnaaien
en open persen. De opening met knoopjes
of een ritssluiting afwerken.

Alle coupenaden van voor- en achterpand
stikken. Opstrijken. De zij- en schouder-
naden dichtnaaien, omnaaien en open
strijken met behulp van een vochtige

De plooi van de rug vanaf de halsuit-
nijding tot aan de schouderbreedte stik-
en. Even boven het middel tot er onder
e plooi opnieuw dichtstikken. Op deze
anier trekt de plooi niet overdreven ver
open.

De mouwen inzetten. Het linnen op het
voorpand en onder de kraag aanbrengen.
Met behulp van zigzagsteken op de wol-
len stof rijgen, zonder helemaal door te
steken. De kraag naaien.

Op het rechtervoorpand uitgemonsterd
knoopsgaten maken. De bovenkant va
de kraag recht tegen recht van het kle
dingstuk spelden, rijgen en met de ma
chine steken. Naar de binnenkant om
slaan.

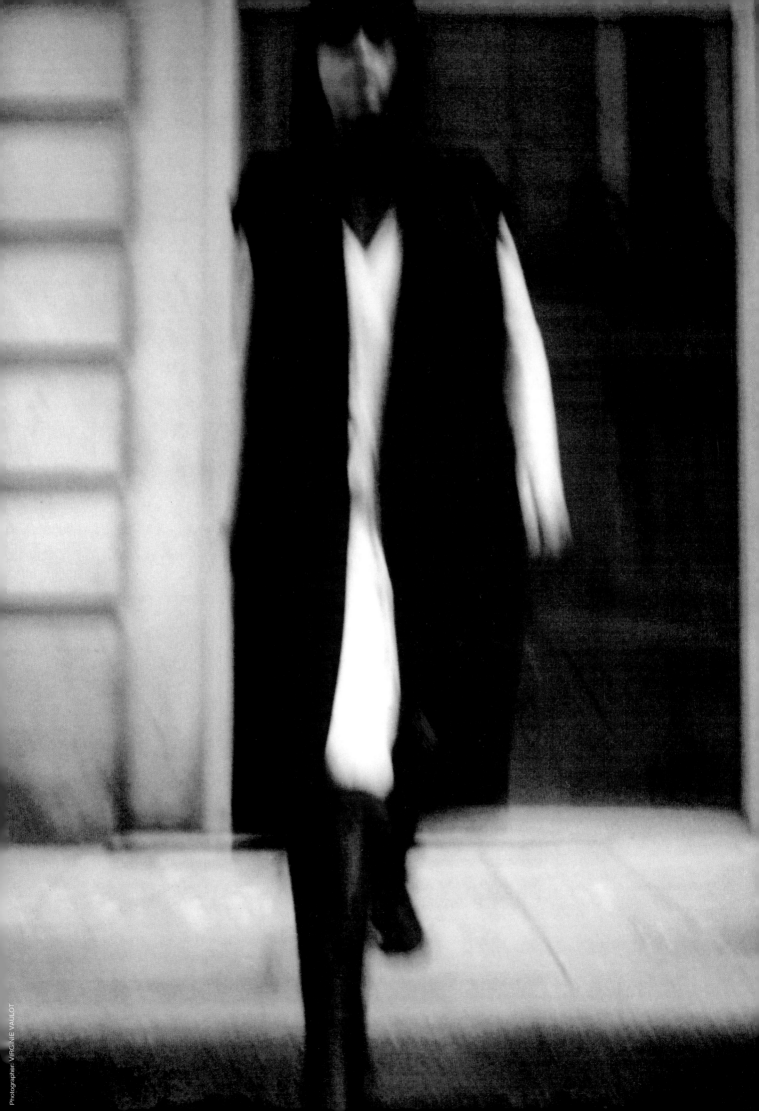

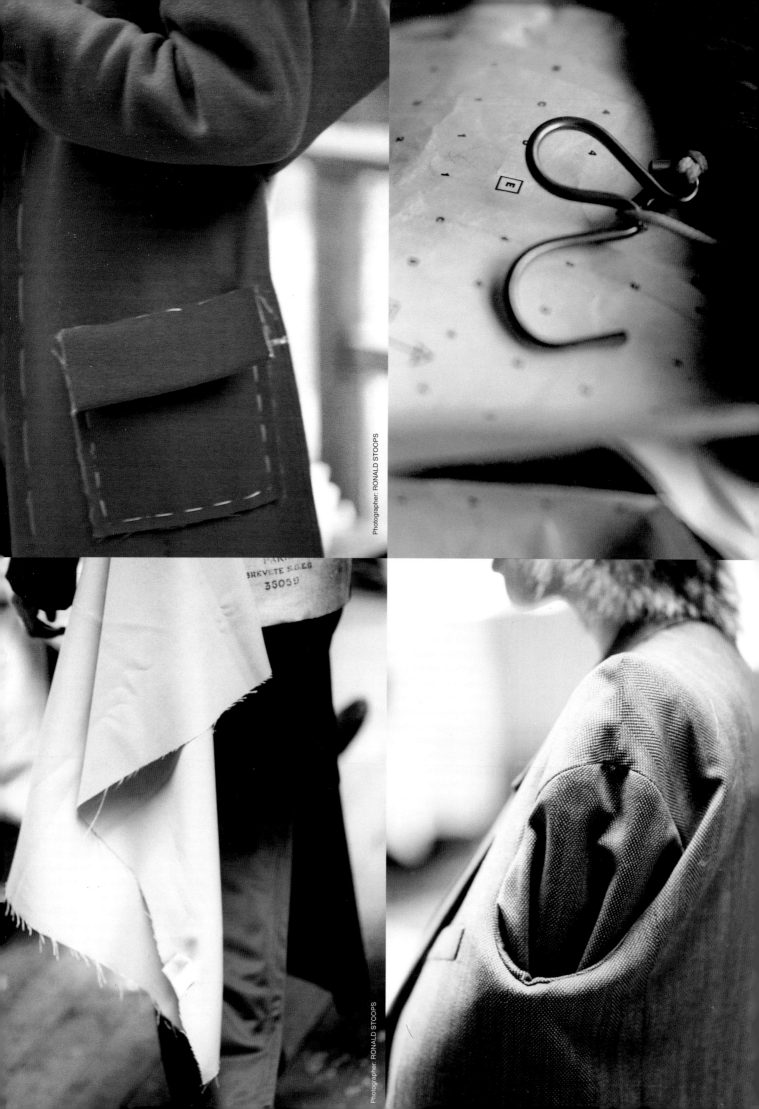

Photographer: RONALD STOOPS

Photographer: RONALD STOOPS

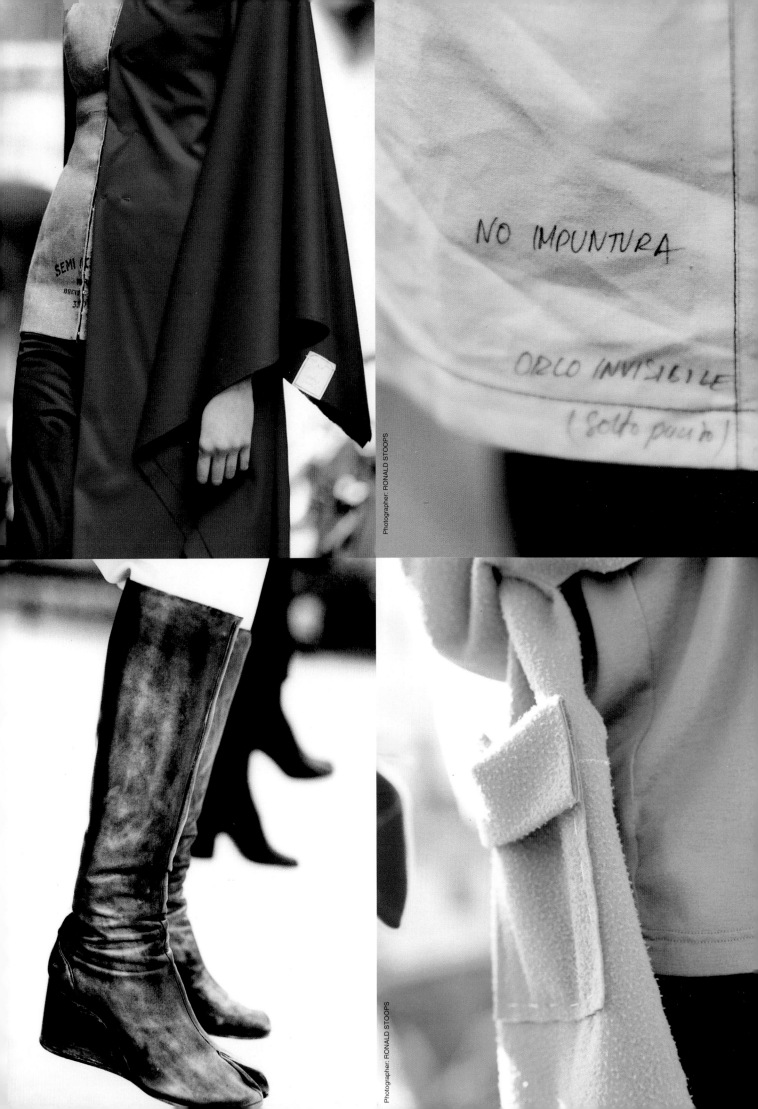

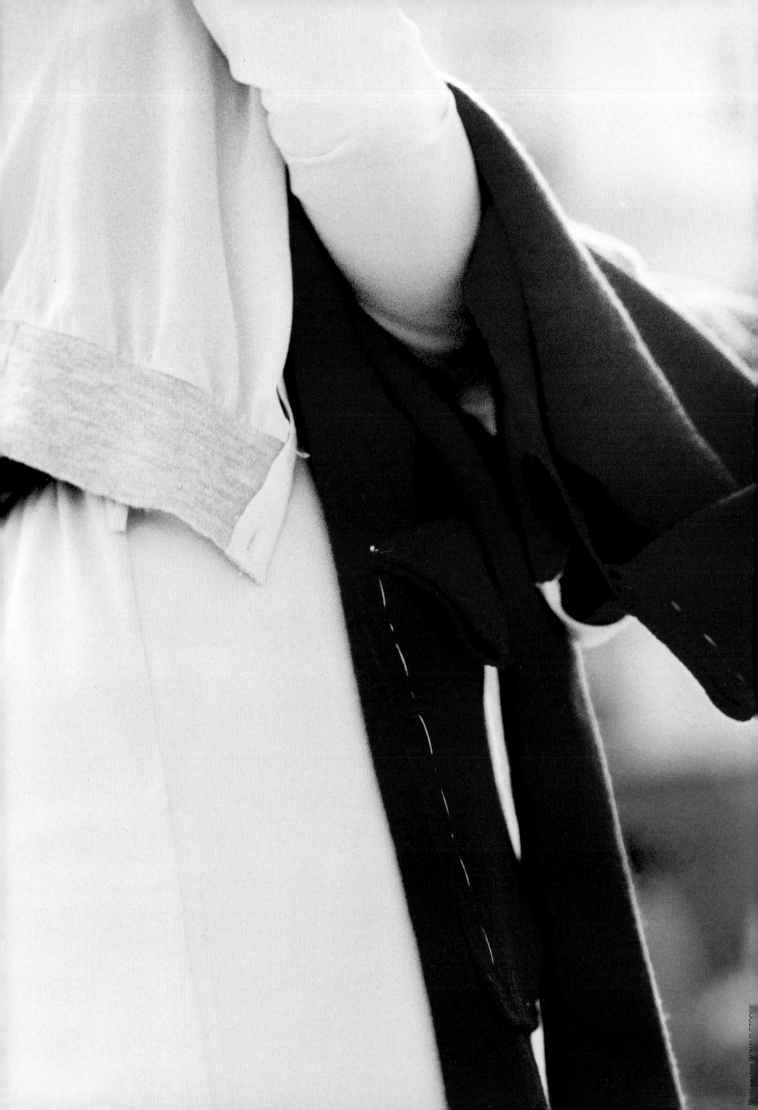

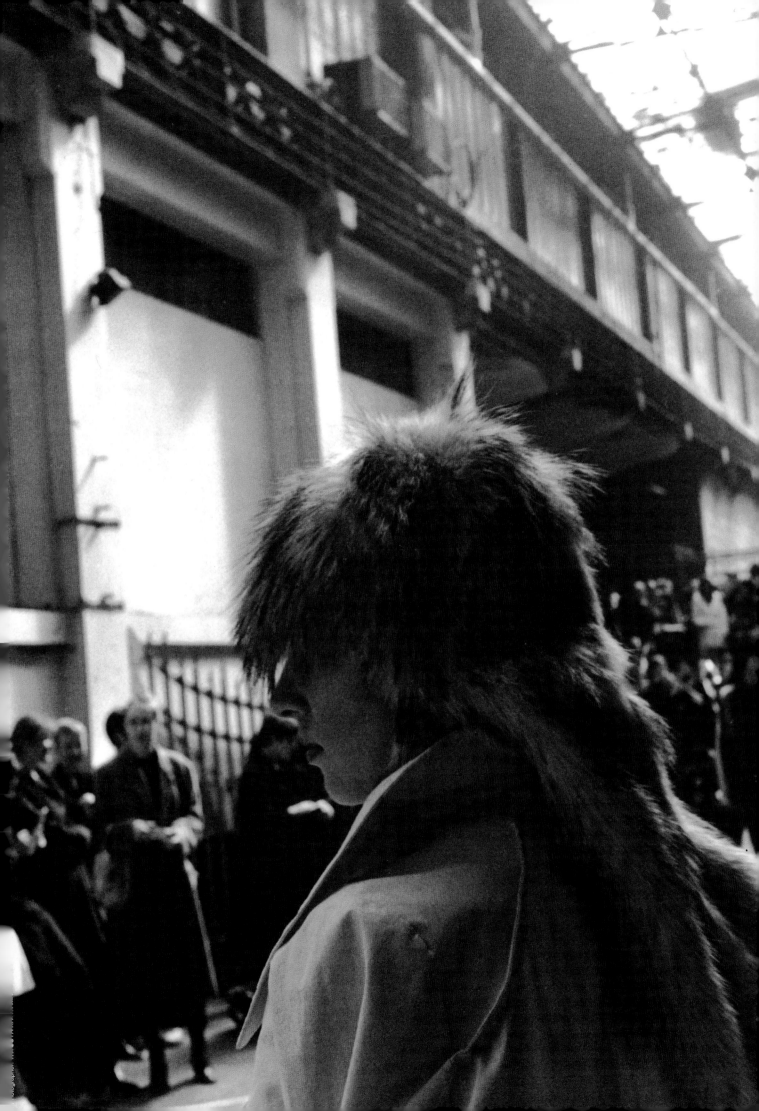

SUMMER'98

ショールーム

2 bis Passage Ruelle パリ18区

ショールームのメインスペースを白を基本としたデコレーションにする。グループ別にされた10体のシルエットを発表し同じものはビデオフィルムでも使用した。

プレゼンテーション

1997年 10月

パリ1区にある'Salle des Gend d'anmes La Conciergerie'（大革命のとき死刑囚を収容したパリ裁判所付属の牢獄）でComme des Garconsと合同で行なう。両社からの招待者は20：00に入場を始めた。インビテーションは1つの封筒に両社のものを入れ送られた。メゾンMARTIN MARGIELAはこのConciergerieのお土産品として売られている記念銅貨を白のカードでカバーしたものを招待状とした。広いスペースを二つに分けそれぞれのショースペースとした。MARTIN MARGIELAは5つの柱を5ｍの長さの白のコットンで覆った。20名の年令層の異なる男性が白いコットンをかぶせた洋服ラックを押し出してきて柱と柱の間に置き始める。ライトが消え投影が始まる。10体の洋服はそれぞれ1分間の10本の映像で紹介される。ミュージックはかん高いボーカル曲から始まってパンクからクラシック曲まで流れる。映像の間に今紹介されたシルエットの説明文が1分30秒間投影される。その説明文の間、ハンガーにかけられたそのシルエットのメインとなる作品を各スクリーン前に立っていた4名の男性によってスポットライトを浴びながら招待者に近づき見せてゆく。その間サウンドシステムからいろんな場所での歓声のノイズ（ロックコンサートからフットボールマッチまで）が流れた。次のシルエットの投影が始まる前に4名の男性は隣のスクリーンへと服ごと移動し、それを2周続け招待者全員が同じ物を最後は見た事となる。全員が10本のフィルムを見た後、最後のグループの服に赤いペンキで'THE END'と書かれる。同時に25ケ所の柱で、異なった言語で。5つのグループの男性達はラックを押してショースペースから出て行く。

コレクション

2つのグループによる服

ーフラット（平面）シリーズ

服の構成を人が着ていない時全くの平面になる様にしたもの。
このグループのテーマの中では：工業用パターンが工場に収納されている状態を着る服として表現したもの、肩線を全く平らな状態になるまで前身側にずらしたもの、特殊なクラッシュ加工によって平面にしたもの。あるものに上から下までファスナーを付けそれを開いた時平面になるもの。以前発表したスーパーマーケットのプラスティック袋、ペーパー作品等の延長となるシリーズ。また、前面に頭の部分が通せるよう垂直に切れ目の様にカットされたネックラインを作ったもの、これらも着ない時は全くの平面な状態となる。

ートラディショナル製作シリーズ

昔からの伝統的なテーラー、女性服をそのままに作り直されたもの。ジャケットは2つのフォームがあり、一つは大人が着るジャケット、もう一つは青年が着るジャケット。

Show-room

2 bis Passage Ruelle, 18th Arrondissement, Paris.

A white decor stands within the main area of the show space. Garments of the collection are grouped to reflect the ten outfits of the video used to present the collection.

Presentation

October 1997

Held at the 'Salle des Gend d'armes, La Conciergerie', 75001 Paris in collaboration with the company Comme des Garcons. The same public is invited to attend at 20h00 to witness the presentation of each company one after the other. Each invitee receives an invitation o the presentation of each collection in one envelope. For Maison Martin Margiela, copper souvenir coins, sold to tourists at the Conciergerie, are placed in white card covers used to protect coins. The room holds the installation of each company at either end. For the Martin Margiela presentation five towers five metres high and covered in white cotton stand within the space. Twenty men of varying ages enter the space pushing five racks of clothes covered in white cotton towards the towers. The lights fall. A projection starts. Ten outfits of the collection are presented by ten segments of film of one minute and ten segments of music, each featuring a high shrill voice, vary in style from punk to classical accompany them. Between each film a text describes the clothes that have just been shown appears on the tower, this time for one and a half minutes. While this text is projected each of the four men standing before the tower bring garments that have appeared in the segment of film close to the public, they are lit by harsh spotlights. The noise of varying crowds (from rock concerts to football matches) comes over the sound system while the text is projected. The garments are on hangers. Just before the next segment of film commences the four men move on to the next screen , where, the film that has just been shown to one public, will be projected for the next. The five groups of men move from tower to tower, encircling the room twice, exchanging the garments they carry mid way, until all of the invited public in front of each of the five towers has seen all of the ten segments of film and all ten groups of garments. Each tower, therefore, presents a different film and group of garments at a different moment. Once everyone has seen all ten films and groups of garments 'The End' is painted in red paint on the five towers (each time in a different language). The five groups of men then push the racks of clothes back out of the space.

Collection

The collection is composed of two groups of garments:

A series of 'flat' garments:
Garments whose structure has been adapted so that when not worn they are totally flat. Amongst the themes of this group: Foldable pieces produced by assembling the panels of industrial garment patterns. Garments whose shoulder line has been displaced onto their front, flattened by way of a special 'crushing' process. Garments that have full length zips along their side that allow them to be opened totally and laid flat. A series of garments based on the varying forms of flat paper and plastic carrier bags. Neck openings that appear as a vertical slit on their front panel that, when not worn lay totally flat.

A series of traditionally structured garments:

A simple wardrobe of masculine and feminine elements whose cut, structure and finish evoke the methods of classic tailoring. Jackets are in two forms, those of an adult man and those of an adolescent man.

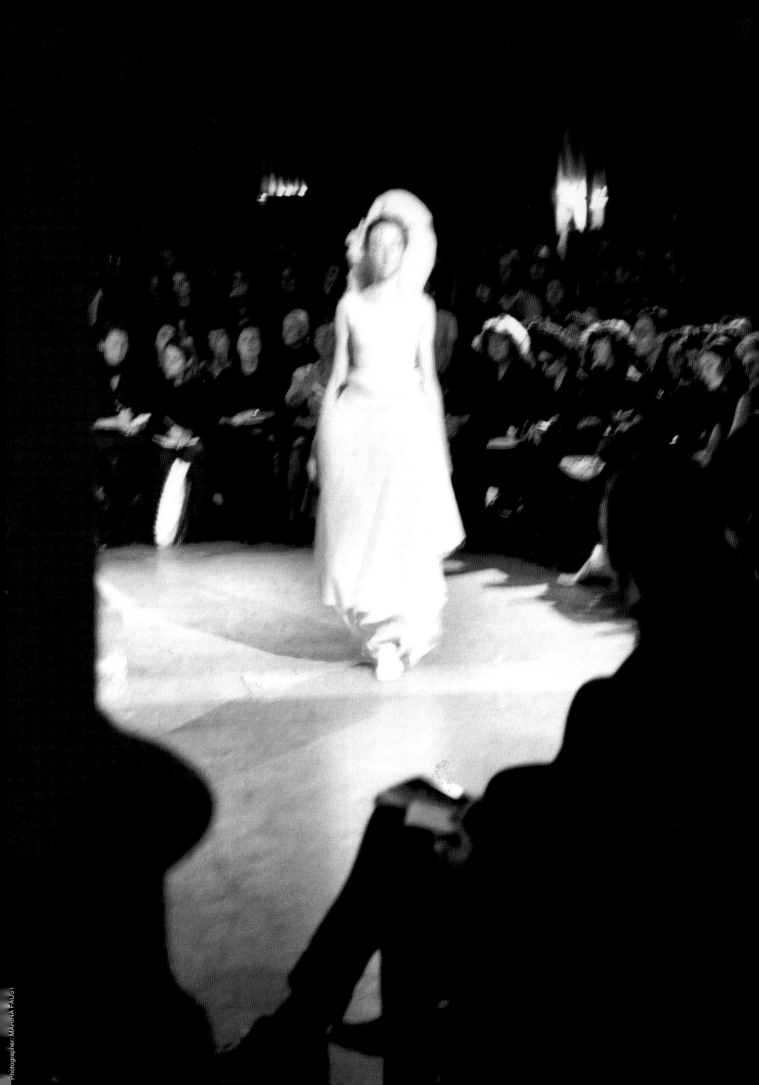

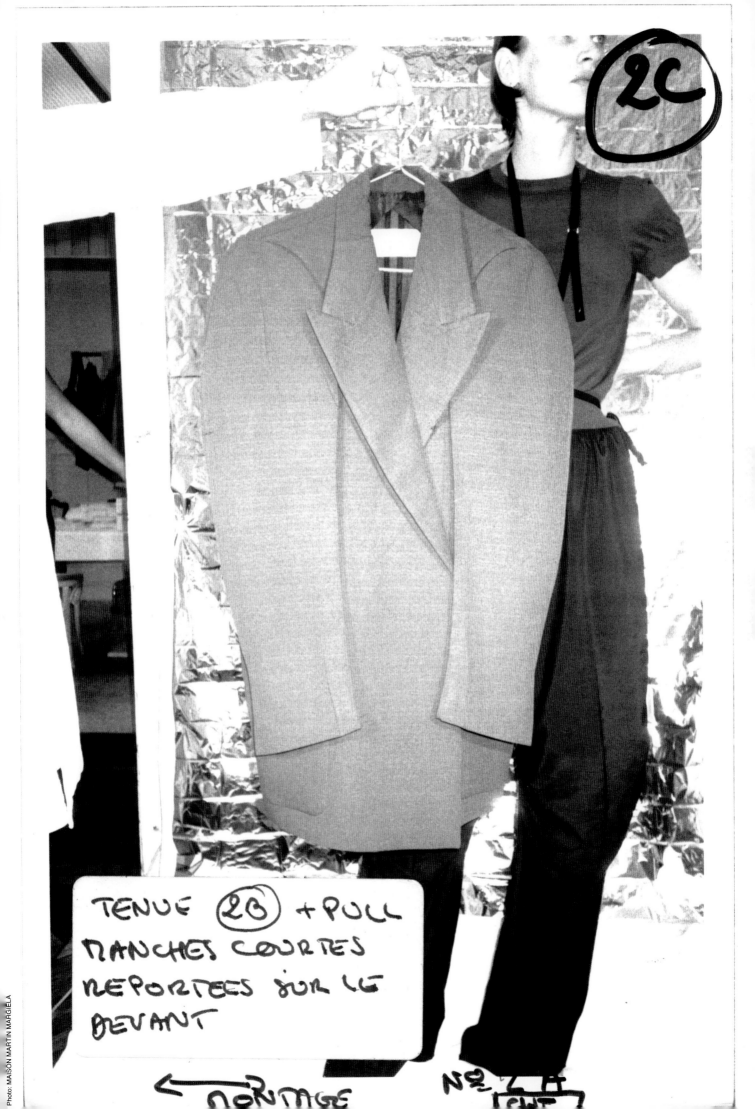

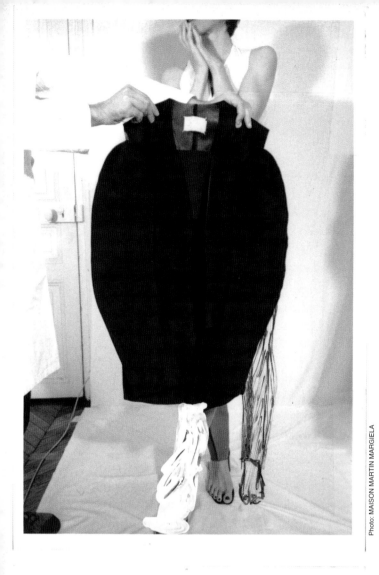

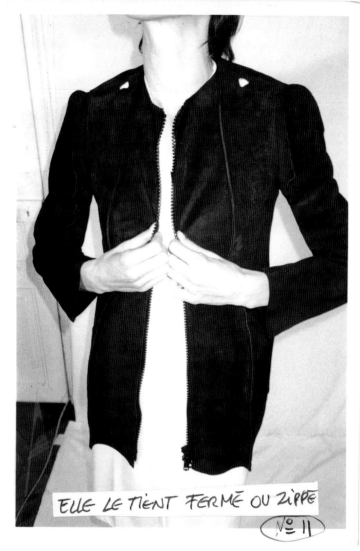

ELLE LE TIENT FERMÉ OU ZIPPÉ

N° 11

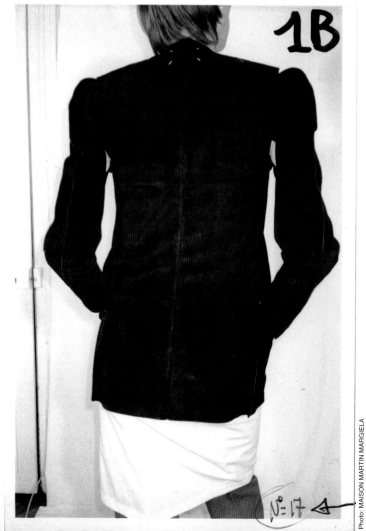

1B

N° 17

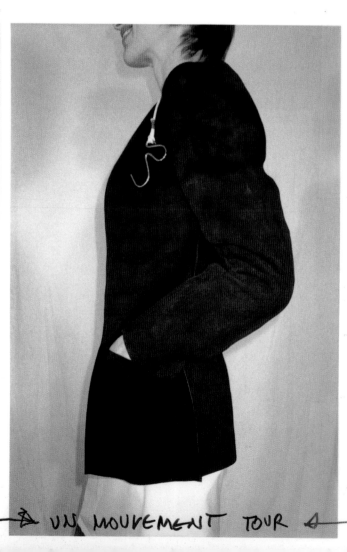

UN MOUVEMENT TOUR

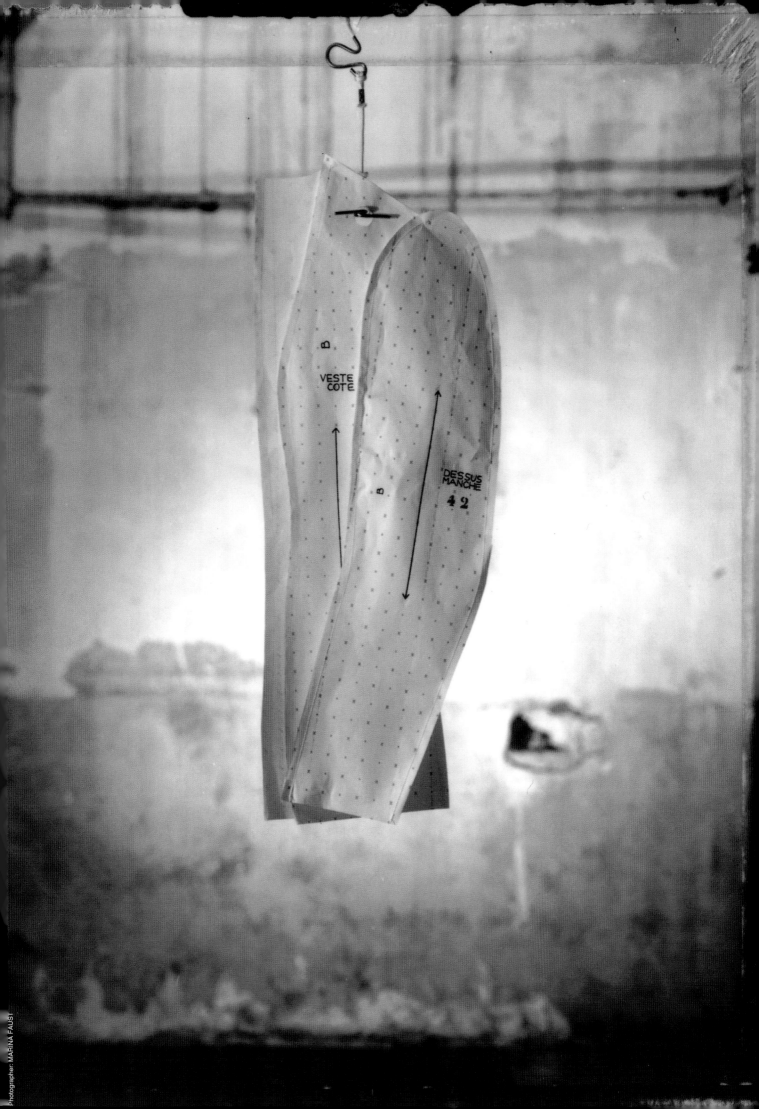

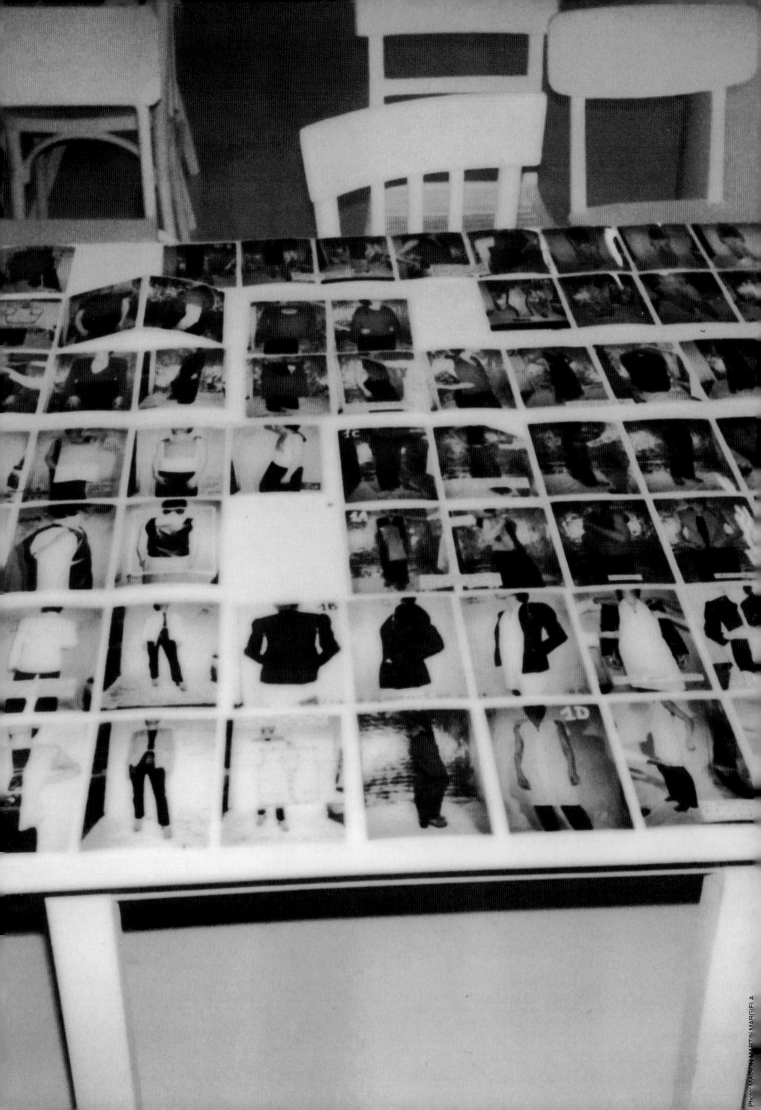

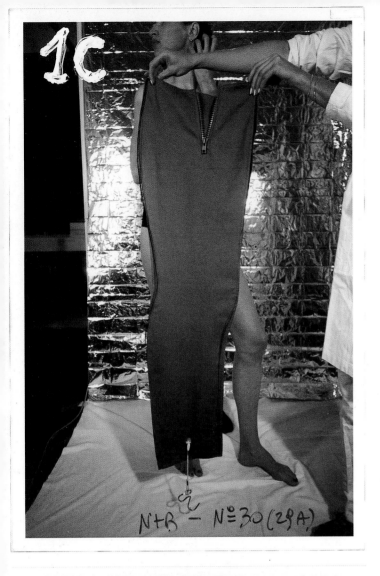

1C

N+B — N° 30 (29A)

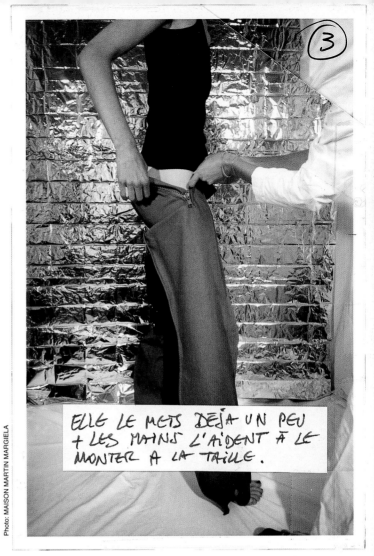

ELLE LE METS DÉJA UN PEU
+ LES MAINS L'AÏDENT À LE
MONTER A LA TAILLE.

③

VU D'EN HAUT

COL 36A

DÉTAIL TROUS.

N° 16

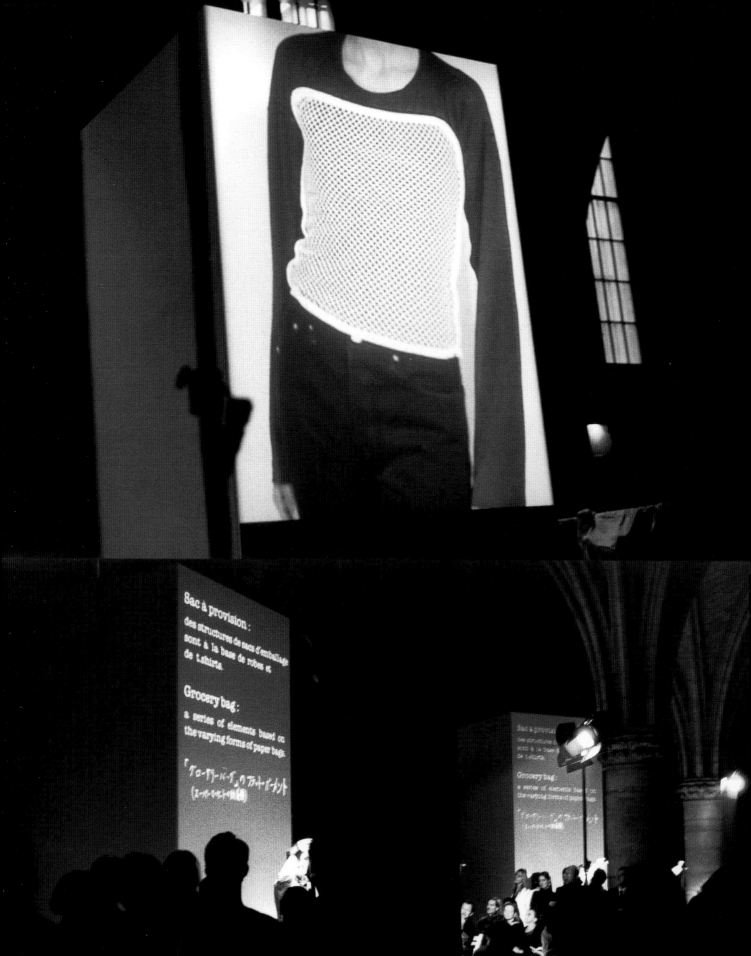

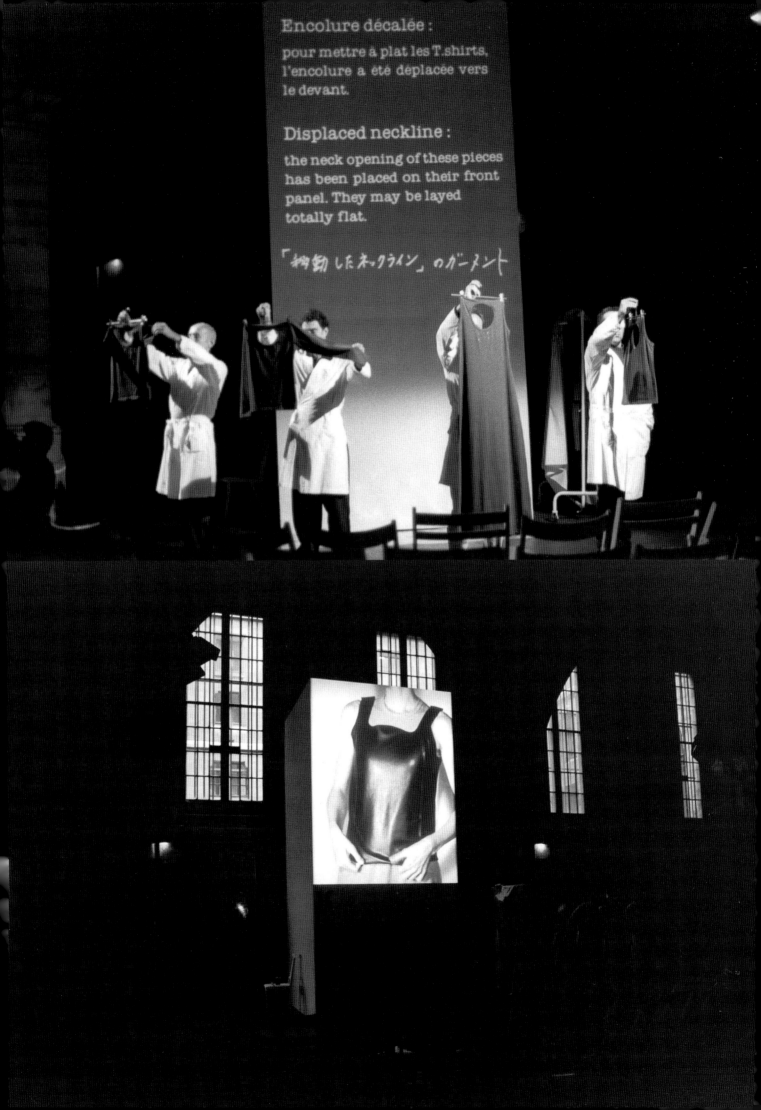

Encolure décalée :
pour mettre à plat les T.shirts,
l'encolure a été déplacée vers
le devant.

Displaced neckline :
the neck opening of these pieces
has been placed on their front
panel. They may be layed
totally flat.

「移動したネックライン」のガーメント

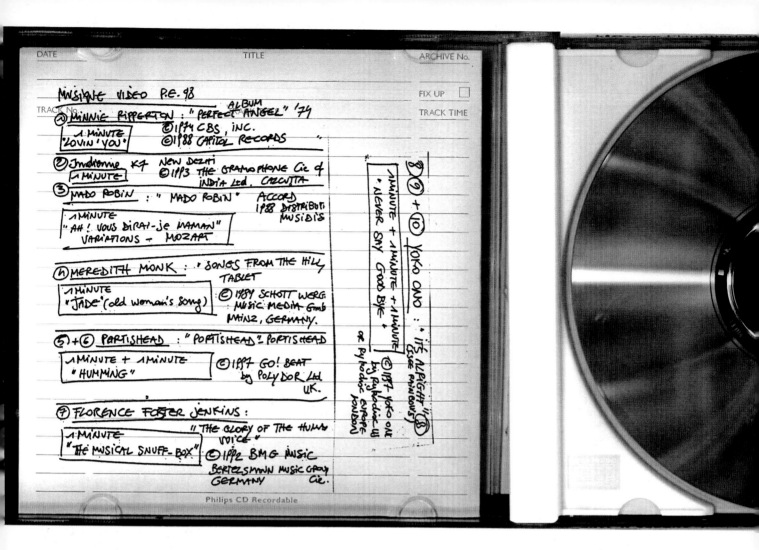

DATE **TITLE** **ARCHIVE No.**

MUSIQUE VIDEO P.E. 98 **FIX UP** ☐

TRACK No. ALBUM **TRACK TIME**

① MINNIE RIPPERTON : "PERFECT ANGEL" '74

1 MINUTE ©1974 CBS, INC.
"LOVIN' YOU" ©1988 CAPITOL RECORDS "

② Indienne K7 NEW DELHI
1 MINUTE ©1993 THE GRAMOPHONE Cie of
 INDIA Ltd. CALCUTTA

③ MADO ROBIN : "MADO ROBIN" ACCORD
 1988 DISTRIBUTI
1 MINUTE MUSIDIS
"AH! VOUS DIRAI-JE MAMAN"
 VARIATIONS + MOZART

④ MEREDITH MONK : "SONGS FROM THE HILL
 TABLET
1 MINUTE
"JADE" (old woman's song) ©1989 SCHOTT WERG.
 MUSIC MEDIA GmbH
 MAINZ, GERMANY.

⑤+⑥ PORTISHEAD : "PORTISHEAD" PORTISHEAD
1 MINUTE + 1 MINUTE ©1997 GO! BEAT
"HUMMING" by POLYDOR Ltd
 UK.

⑦ FLORENCE FOSTER JENKINS :
1 MINUTE "THE GLORY OF THE HUMAN
 VOICE "
"THE MUSICAL SNUFF-BOX" ©1992 BMG MUSIC
 BERTELSMANN MUSIC GROUP
 GERMANY Cie.

⑧⑨ + ⑩ YOKO ONO : "IT'S ALRIGHT" ℗
1 MINUTE + 1 MINUTE + 1 MINUTE (CESSE RAINBOWS)
"NEVER SAY GOOD BYE" ©1997 YOKO ONO
by Rykodisc UK
 Rykodisc EUROPE
LONDON)

Philips CD Recordable

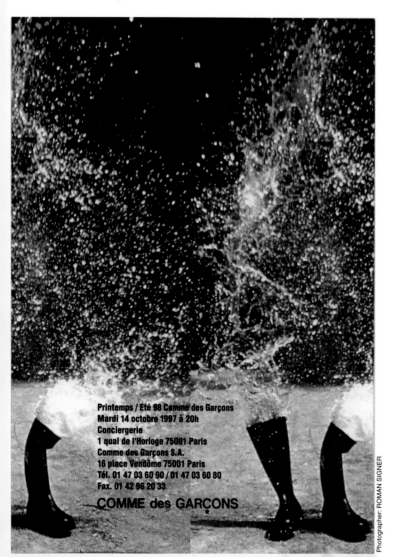

Printemps / Eté 98 Comme des Garçons
Mardi 14 octobre 1997 à 20h
Conciergerie
1 quai de l'Horloge 75001 Paris
Comme des Garçons S.A.
16 place Vendôme 75001 Paris
Tél. 01 47 03 60 90 / 01 47 03 60 80
Fax. 01 42 96 20 33

COMME des GARÇONS

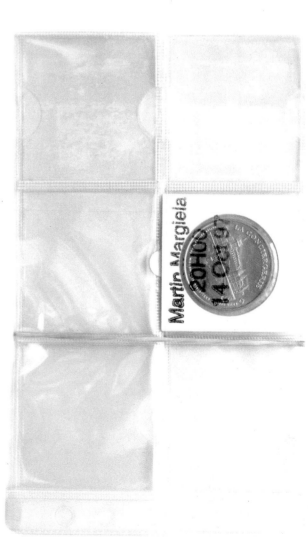

Martin Margiela

20H00
14 OCT 97

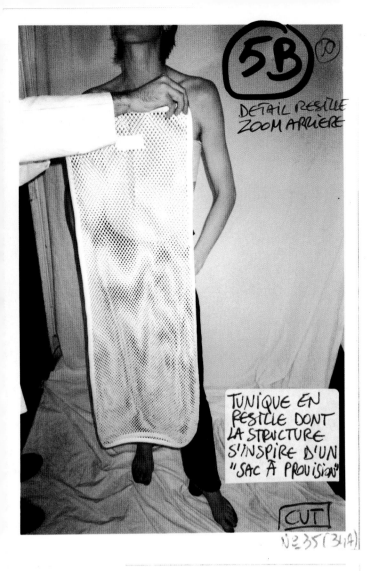

5B ⑩

DETAIL RESILLE
ZOOM ARRIÈRE

TUNIQUE EN
RESILLE DONT
LA STRUCTURE
S'INSPIRE D'UN
"SAC À PROVISION"

CUT

N° 35 (3/4)

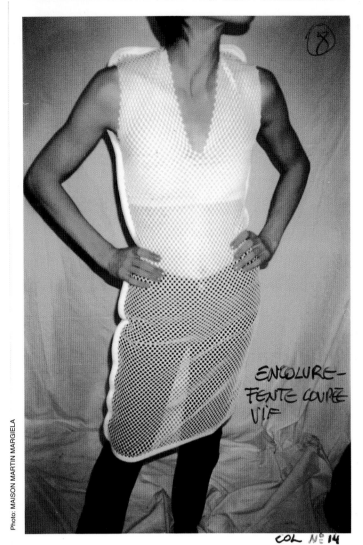

⑧

ENCOLURE-
FENTE COUPÉE
VIF

COL N° 14

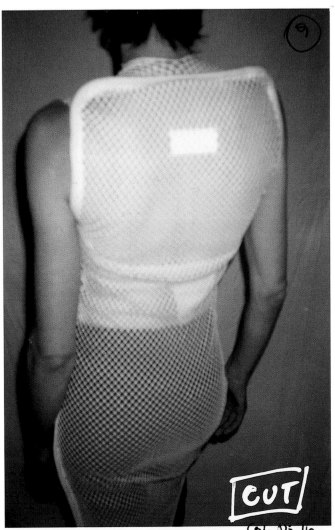

⑨

CUT

COL N° 16

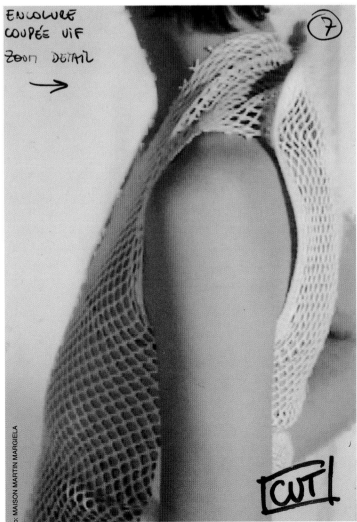

ENCOLURE
COUPÉE VIF
ZOOM DÉTAIL

→

⑦

CUT

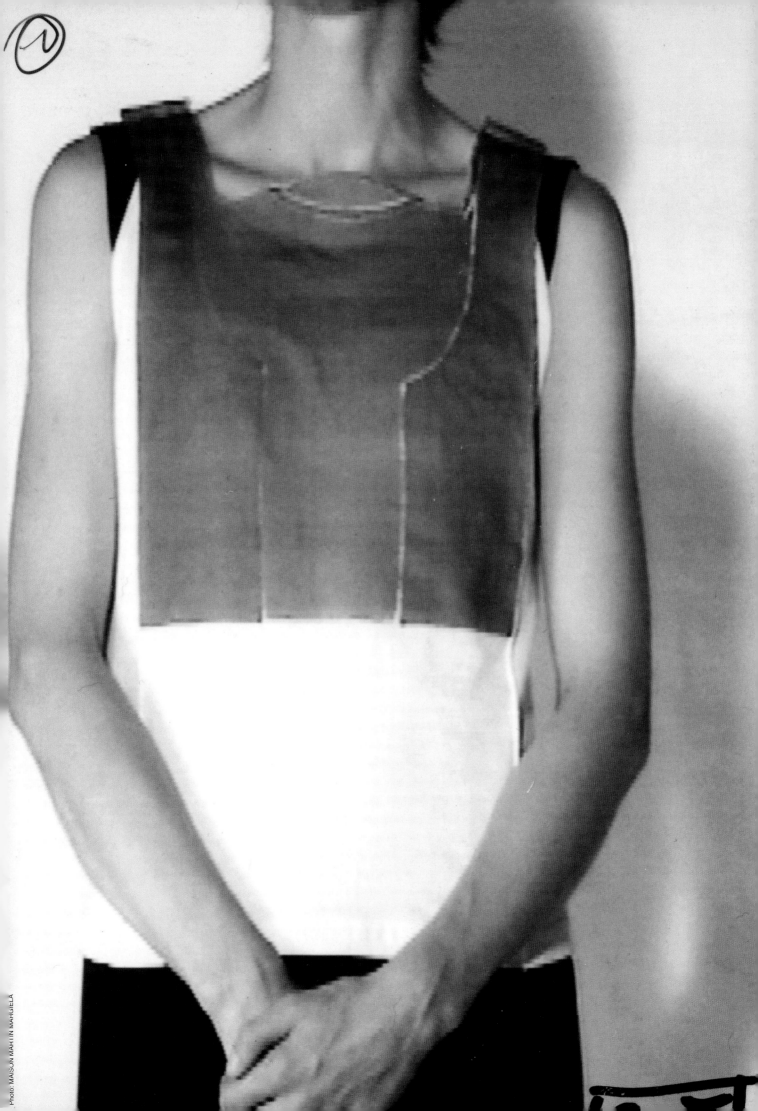

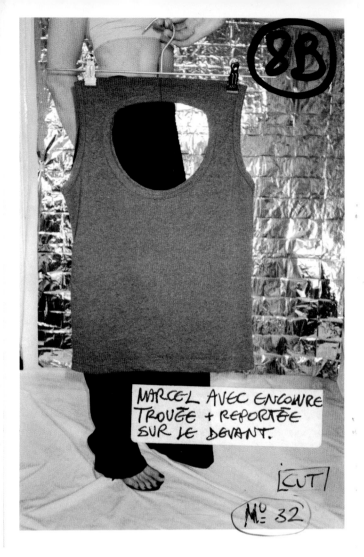

8B

MARCEL AVEC ENCOLURE
TROUÉE + REPORTÉE
SUR LE DEVANT.

CUT

Nᵒ 32

Photo: MAISON MARTIN MARGIELA

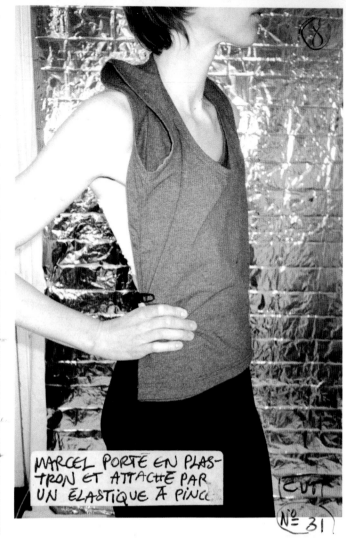

MARCEL PORTÉ EN PLAS-
TRON ET ATTACHÉ PAR
UN ÉLASTIQUE À PINCE

CUT

Nᵒ 31

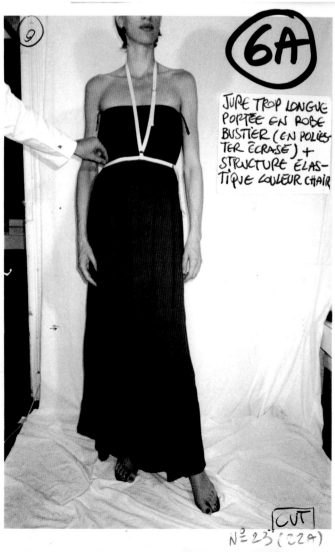

6A

JUPE TROP LONGUE
PORTÉE EN ROBE
BUSTIER (EN POLIÈS-
TER ÉCRASÉ) +
STRUCTURE ÉLAS-
TIQUE COULEUR CHAIR

CUT

Nᵒ 23 (22A)

Photo: MAISON MARTIN MARGIELA

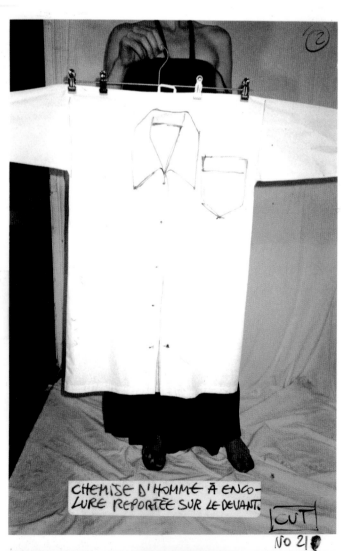

CHEMISE D'HOMME À ENCO-
LURE REPORTÉE SUR LE DEVANT

CUT

Nᵒ 21

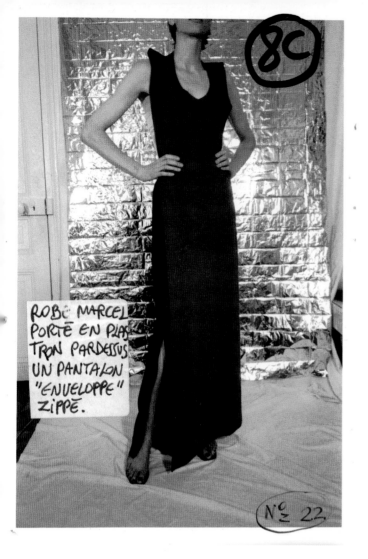

ROBE MARCEL PORTÉ EN PLAS TRON PARDESSUS UN PANTALON "ENVELOPPE" ZIPPE.

N° 22

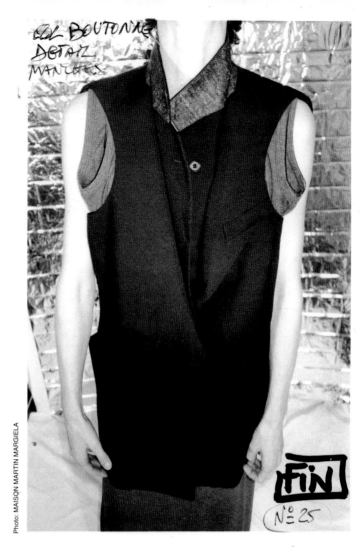

COL BOUTONNÉ DÉTAIL MANCHES

FIN

N° 25

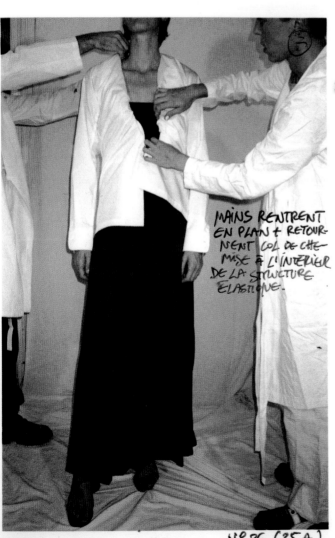

MAINS RENTRENT EN PLAN + RETOURNENT COL DE CHEMISE À L'INTÉRIEUR DE LA STRUCTURE ELASTIQUE.

N° 26 (25A)

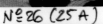

COL DE CHEMISE RENTRE DANS LA STRUCTURE ELASTIQUE ET PORTÉ EN "U" DRAPÉ.

CUT

N° 28 (27A)

WINTER'98'99

ショールーム

2 bis Passage Ruelle パリ18区

白に塗られた木造舞台をショールームのメインに設置する。

プレゼンテーション

1998年3月

パリ郊外にある新凱旋門の下の"Le Foyer de L'Arche"で行なう。3名それぞれ違うカテゴリーでの人達から見たコレクションをプレゼンテーションする。ニューヨークをベースにする写真家MARK BORTHWICK、ロンドンをベースにするスタイリストJAEN HOW、パリをベースにするライターSYDNEY PICASSO、MARK BORTHWICKのプロジェクトは1998年3月の初めニューヨークで撮影したフィルムの上映と、'2000-1'という本だった。そのフィルムは秋冬コレクションの服を着た3名の女性間の言葉の相互作用。本は、ビデオ撮影の間に撮った写真で作られ、1998年秋に出版された。JEAN HOWは彼女のスタイリングによるものを人間実物大のマリオネットに着せ発表する。

このマリオネットはこのプレゼンテーションのためにイギリスで人形師が製作したもので、2人のプロフェッショナルによってあやつられた。SYDNEY PICASSOは白のコットンリボンを制作、そのリボンに切れ目がなく連続した文章の一節をプリントした。その文章は"ENDLESS THREADS"（終わりのない糸）という小冊子にした。そのコットンリボンは招待者全員の手首に結ばれた。3名それぞれのプレゼンテーションの間、白衣を着た30名のMARTIN MARGIELAのスタッフが招待者に赤ワインをサービスした。MARK BORTHWICKの映像のサウンドトラックはとても大きな音で流された。

コレクション

2シーズン同テーマによるコレクションの2シーズン目。メインのコレクションは5つのシリーズからなるフラットガーメンツで、ネックラインまたはショルダーラインをずらし全くの平面状態にして見せたもので、肩と、首を通すスリットが前面にある。工業用パターンの作品は工業用パターンの作品はブラックモーターバイクレザー、シープスキンを使ってコート、ジャケットを組み立てる。スーパーマーケットのプラスティック袋のシリーズはストレッチのフランネル素材、ウールのヘリンボーンで作る。"封筒"シリーズは、上から下までジッパーをつけた、スカート、パンツ、セーター。それらは着ない状態の時全くのフラット状態となる。

アーミーのバリエーションとして、アーミーパンツを表裏逆にひっくり返し新しいパンツにしたものや、アーミーシャツの肩ラインをずらしたもの等を作る。またアクセサリーとして皮手袋にがま口を付けペンダントとして首からかけられるもの、これは盗難防止のさいふともなる。

Show-room

2 bis Passage Ruelle, 18th Arrondissement, Paris.

A white decor stands within the main area of the show space.

Presentation

March 1998

Le Foyer de L'Arche, La Grande Arche de la Défence, Paris. A subterranean Space under the Arch de la Defence. Three people are chosen to each represent their professional discipline in presenting their vision on the collection: New York based photographer Mark Borthwick, London based stylist Jane How and Paris based writer Sydney Picasso. Mark Borthwick's project included the projection of a video in two parts shot in New York in early March 1998 and a book entitled '2000-1'. The video features a verbal interaction between three women wearing garments of the collection. The book features photographs taken during the shooting of the video and is published in the Autumn of 1998. For Jane How's project fifteen life-size puppets are each dressed in an outfit of the collection styled by Jane. Each puppet, specially made in UK, is manipulated by two professional puppeteers. Sydney Picasso decided to produce a white cotton ribbon, on which a continuous text is printed, as well as a pamphlet entitled 'Endless Threads'. The tract is distributed and the ribbon is tied to everyone's wrist as they enter the space. Thirty members of the Maison Martin Margiela staff, in blouses blanches (white coats) serve red wine to the crowed while the three visions on the collection are being expressed. A soundtrack by Mark Borthwick plays loudly.

Collection

The second part of a collection in two parts. The principal group of the collection is made up of five series of `flat' garments with displaced shoulders or necklines. Their sleeves or their neck opening lies on their front. The panels of industrial garment patterns in black motorbike leather and sheepskin are assembled to form coats and jackets. Flat 'Grocery Bag' garments in stretch flannels and woollen herring bone. A series of 'Envelope' garments have full length zips that allow skirts, trousers and sweaters to be opened and laid flat. Various used military garments have been transformed into army trousers (worn inside out), army shirts with a displaced shoulder line. Amongst accessories are leather gloves transformed into pendant wallets and 'Anti-Theft' wallets in leather, worn as bags.

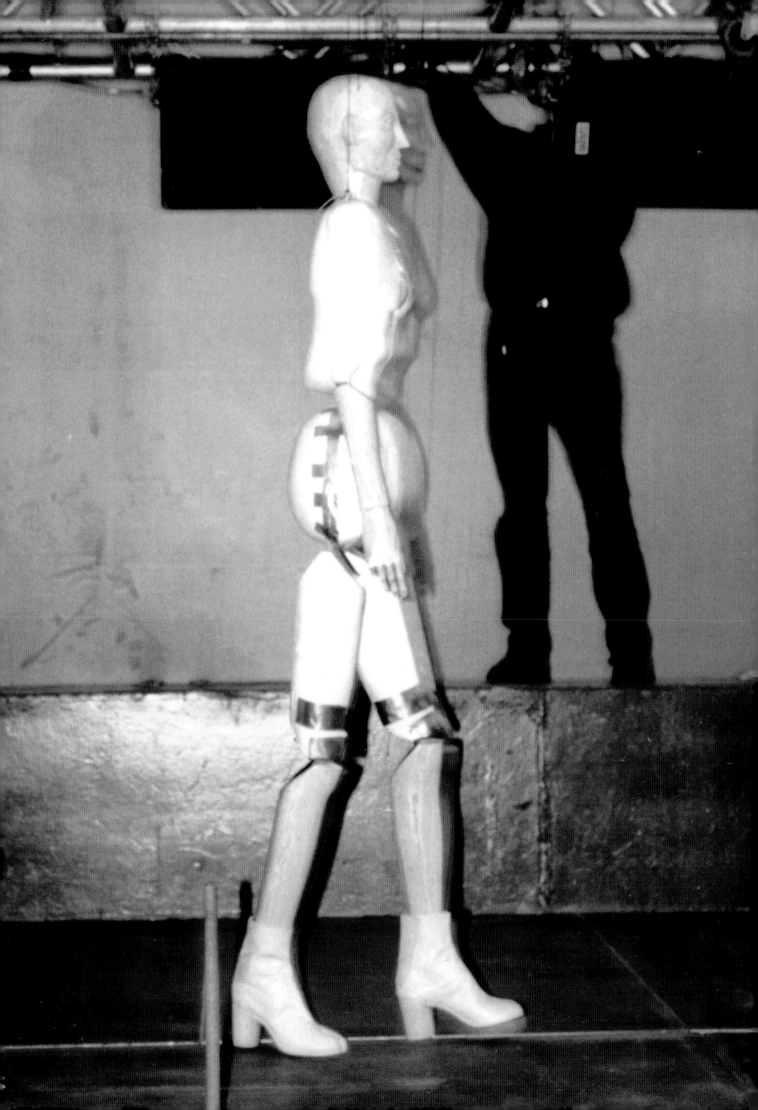

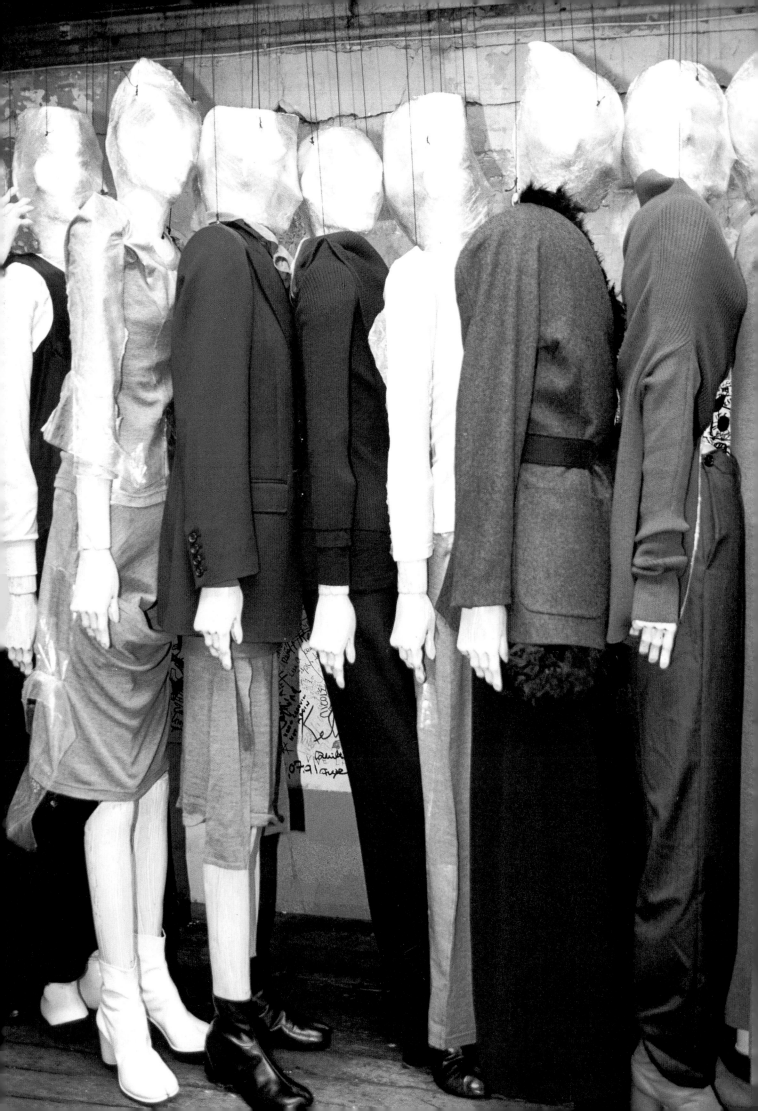

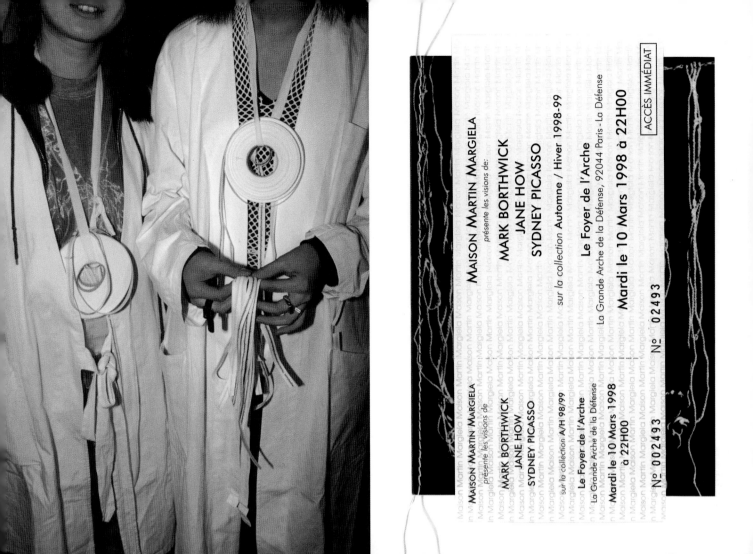

MAISON MARTIN MARGIELA

présente les visions de:

MARK BORTHWICK
JANE HOW
SYDNEY PICASSO

sur la collection Automne / Hiver 1998-99

Le Foyer de l'Arche

La Grande Arche de la Défense, 92044 Paris - La Défense

Mardi le 10 Mars 1998 à 22H00

N° 02493

ACCÈS IMMÉDIAT

MAISON MARTIN MARGIELA

présente les visions de

MARK BORTHWICK
JANE HOW
SYDNEY PICASSO

sur la collection A/H 98/99

Le Foyer de l'Arche

La Grande Arche de la Défense

Mardi le 10 Mars 1998
à 22H00

N° 002493

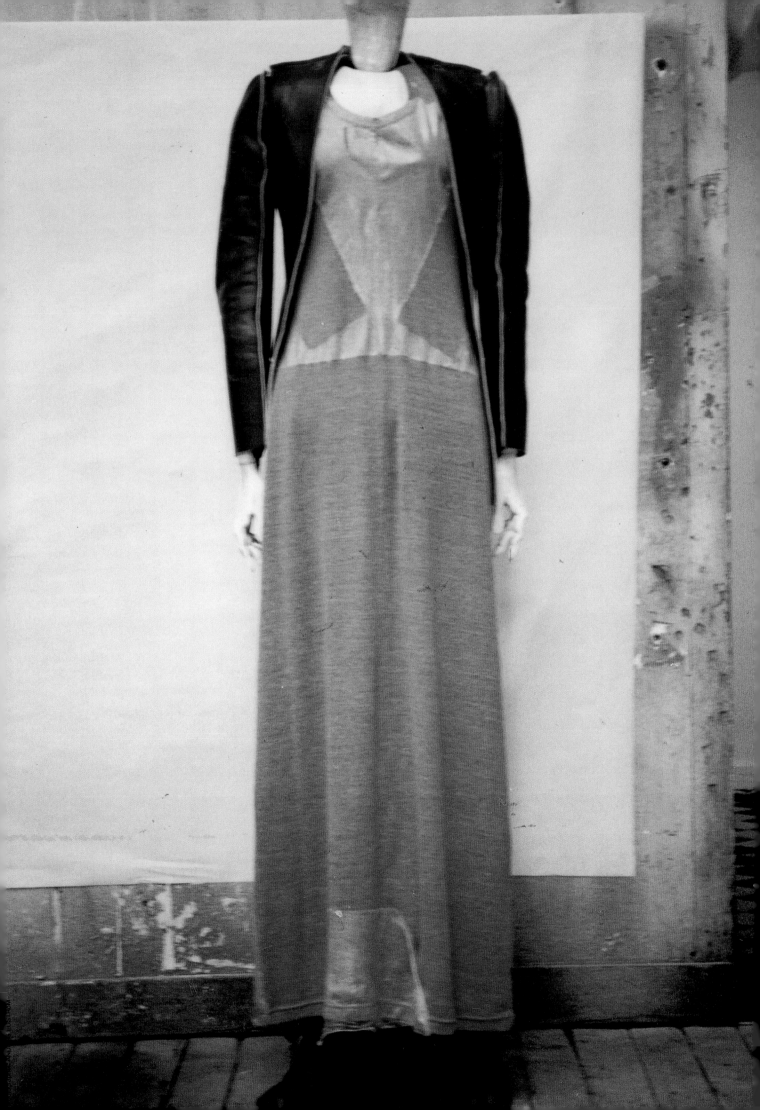

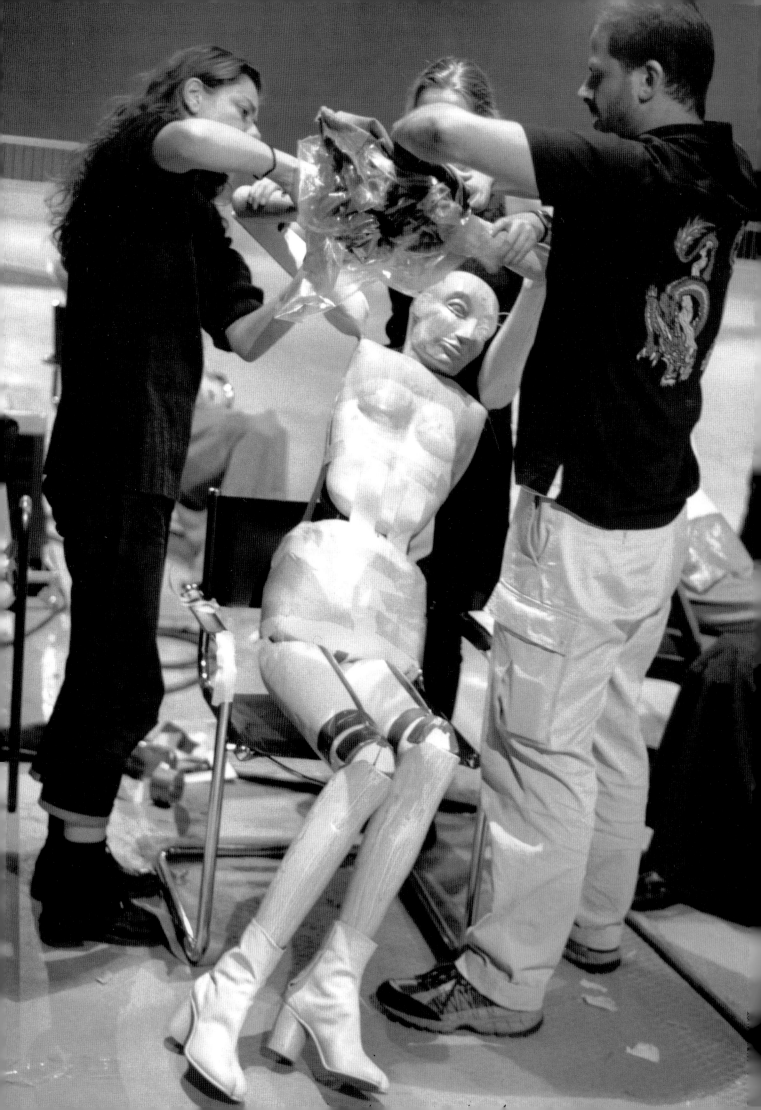

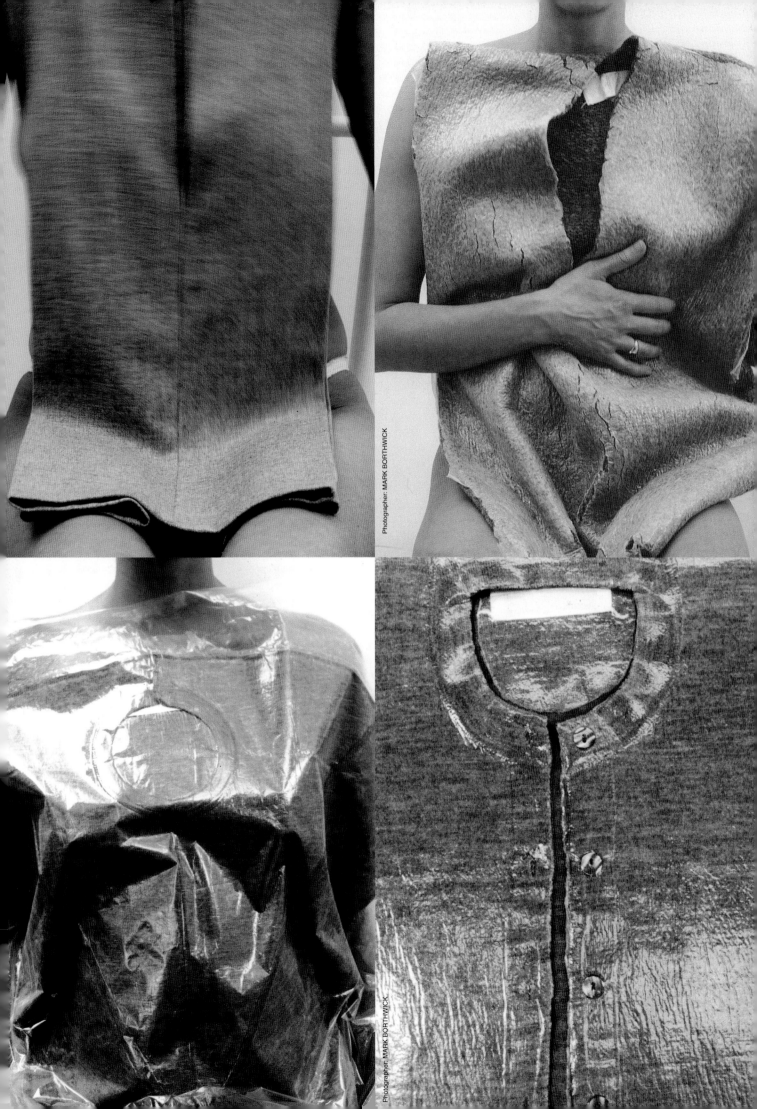

Photographer: MARK BORTHWICK

Photographer: MARK BORTHWICK

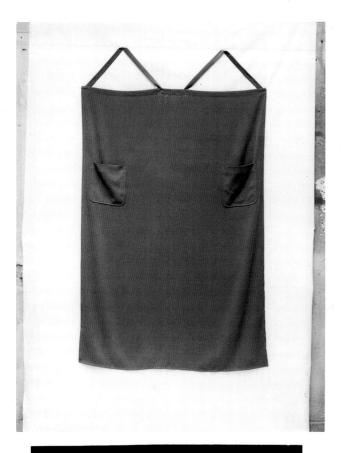

'ENVELOPE' GARMENTS:

Squares of fabric with straps become 'apron skirts' or dresses.

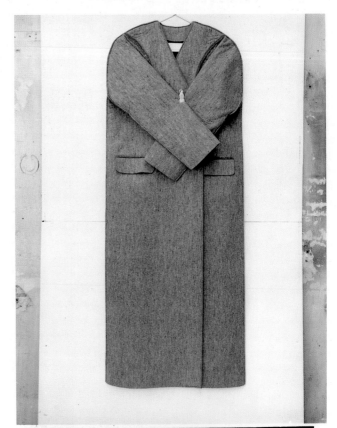

GARMENTS WITH 'DISPLACED SHOULDERS':

The shoulder line of these garments has been brought forward on to their front. When not worn, these pieces become flat objects. Large vests with oversized arm openings and coats with exaggerated sleeves (vents).

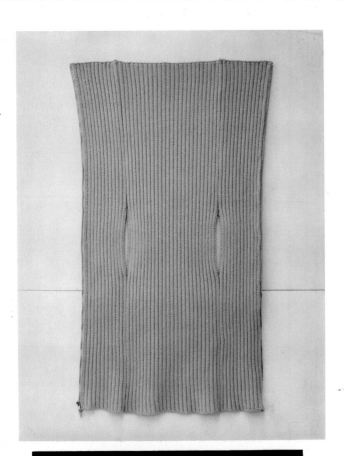

'ENVELOPE' GARMENTS:

Knitted squares in different weights have two slits as armholes. Long zips, once closed, allow that these squares become close fitting sweaters, with large collars.

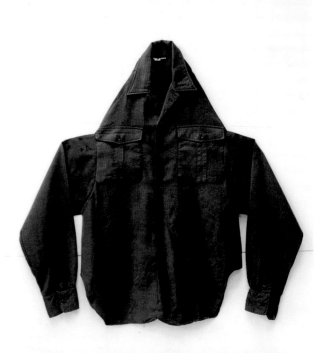

'ARTISANAL PRODUCTION':

Various military garments have been transformed. The shoulder line of different army shirts has been displaced towards the waist.

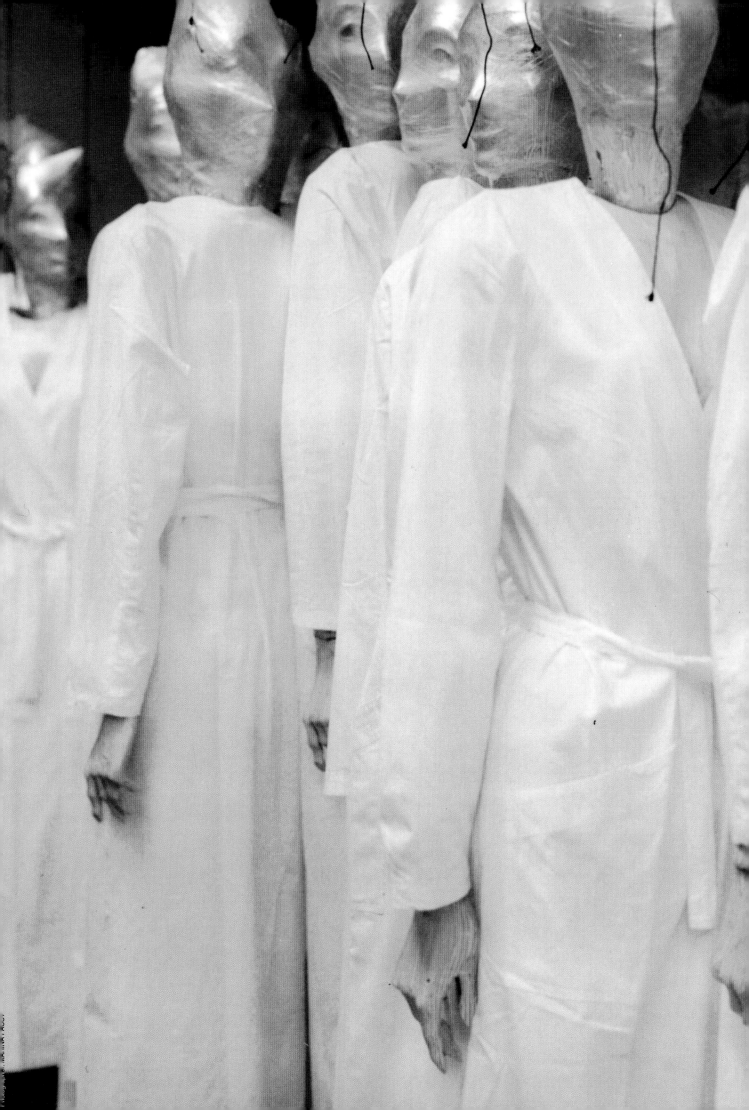

SUMMER '99

ショールーム

2 bis Passage Ruelle パリ18区

20回目のMARTIN MARGIELAのコレクションは、１つもの白の木造舞台をショールームのメインに設置し、"0"と"1"のコレクションを真一列に、"6"のコレクションはコの字形に小さなブティックの様に置かれる。

プレゼンテーション

1998年10月

パリ6区にあるサンシュプリス広場のそば6rue Ferouにある巨大な廃墟となったプライベートハウスで行なう。フランス、オートクチュールプレタポルテ協会公認で普通ジャーナリスト達に送られるパリファッションウィークのスケジュール表に会場の住所をスタンプされたものを招待状として送る。4階あるフロアの内、1.2階を招待客が埋める。全てのシャッター、カーテンは閉められ外からの関わりが断ち切られた。各部屋の天井からワイヤーで吊り下げられていた裸電球をそのまま使う。2階の招待者達の話し声は1階へ、1階の招待者たちの話し声は2階へと放送した。そして、ショーの開始を待っている招待者の中へ白衣を着た男性がポスター状の看板を首から下げサンドイッチマンのように練り歩き始めた。その看板には"6"コレクションの拡大写真を貼った。その後を15名の男性が"10"コレクション（メンズ）を着て歩く。白衣の男性を含め全員25名の男性達が全ての部屋を歩き終わった時、全ての照明は消え招待者は真っ暗な中に立たされる事となる。40名の女性が一人一人間をあけながら全ての部屋を歩き始める。彼女達が歩き始めるとスポットライトを持った44名の男性によってスポットライトをあてられる。全ての女性はパッチョウリオイルの香りに包まれていた。ヘビーロックミュージックがサウンドシステムから流れる。1989年のファーストコレクションのファイナルのように、そしてその後の多くのショーのファイナルのように、白衣を着た40名の女性が群集の中を歩いた。

コレクション

グループ別に作られたコレクションの内容は、"0"セカンドハンドものを作り直したレディス用、"0/10"セカンドハンドを作い直したメンズ用、"1"レディスのメインコレクション、"6"ティーンエイジから女性までのライン、"10"メンズコレクション、"13"出版物―オブジェ、"22"レディス用靴。"1"以外のコレクション―すものには0から23までの通し番号をネームの部分にプリントされ、そのコレクションに該当する数字を丸で囲む。"1"現在から過去10コレクションのアイデアを集約したコレクション。しばしば、あるコレクションのテクニックを他のコレクションの服に使った。例えば1997年春夏に発表したテーラーダミーのアイデアは、1996年春夏で発表したフォトプリントトランスフォームされた。その他、コルセット、平ゴムを使った'studies in draping'。スパンコールドレスのフォトプリントは、ネガ、ポジ両方のテクニックでソフトなジャージー素材にプリントされ直した。セカンドハンドのスカート、パンツを前身後身で切り離しコロン状にしたものをウエストに結いた。1枚のハンド状のニット、ジャージー素材をコイル状にジッパーで体に巻きつけるようにしたセーター、Tシャツを作ったり、着せ替え人形のシリーズは前回同様人形、あるディテール、サイズをそのまま人間大に拡大して作り直した。コート、ジャケット、ドレス、シャツ、パンツ、スカートの衿、ポケット等のディテールをそのまま縫い付けて、ミニマルな服に変えた。また足袋から発想したブーツはいつものヒールのものと、フラットなヒールのもの、スコッチテープ（透明ガムテープ）で靴底を足に巻き付けるもの

Show-room

2 bis Passage Ruelle, 18th Arrondissement, Paris.

For the twentieth Martin Margiela collection a white decor stands within the main area of the show space in which garments of '0' and '1' hang in a line. Across the showroom, garments of '6' hang in the formation of a mini boutique.

Presentation

October 1999

6 rue Ferou, a large abandoned private house at Place St Suplice in the 6th arrondissment of Paris. The invited public fill the first two of the four floors of the house. All shutters on the windows and curtains are shut to the outside world. Only the already existing light bulbs, hanging on a wire from each ceiling, light each room. The sound and conversations of the public on the first floor are broadcast to the public on the ground floor and vice versa. While the public waits for the show to begin, men in white coats, wearing sandwich boards, walk in procession through the rooms. Poster size photographs of garments from '6' are printed on each sandwich board. They are followed by fifteen men wearing garments from '10'. When all twenty-five men leave the space, the lights go out, and the invited public stands in darkness. Forty women wearing the collection begin their procession, one at a time, through each room. As each women enters a room they are lit by small lights hand-held by a team of fifty-four men spread throughout the house. As they move through the room their light follows them and goes out as they leave the room. Each woman smells of patchouli oil. A soundtrack of heavy rock music plays over the sound system. Like for the finale of the first Martin Margiela show for Spring Summer 1989, and many shows since, all of the forty women, wearing white coats, pass through the crowd in a group at the end of the show.

Collection

The collection is now made up of groups: 0: Reworked garments for women; 0/10 : Reworked garments for men ; 1 : A collection for women; 6 : Garments for girls & women, 10 : A wardrobe for men, 13 : Publications - objects and 22 : Shoes for women. All groups other than '1' carry a label on which the numbers 0 to 23 are printed. In each case the relevant number for that piece is encircled on its label.

'1': A summary of our favorite ideas from the past ten collections. Often the techniques of one season are used on a garment from another, for example, The Tailor's Dummy from Spring/Summer 1997 is transformed into a photo print(technique Spring/Summer 1996). Some of the other favorite ideas: 'Studies in draping' of elastic and corset bones A negative and positive of a photo print of sequinned evening dress is applied to a dress in fluid jersey; the front and back panels of used skirts and trousers are tied to the waist; Strips of knit and jersey coil around the body by zips to form sweaters and T-shirts; Garments from a Doll's wardrobe are enlarged to human size in a way that their every detail and disproportion are respected; A series of coats, jackets, dresses, shirts, trousers and skirts have their collars pockets and styling details stitched flat transforming them into minimal garments. The 'Tabi' inspired boot is with its usual heel, a flat heel and with its sole attached to the feet with 'Scotch tape'.

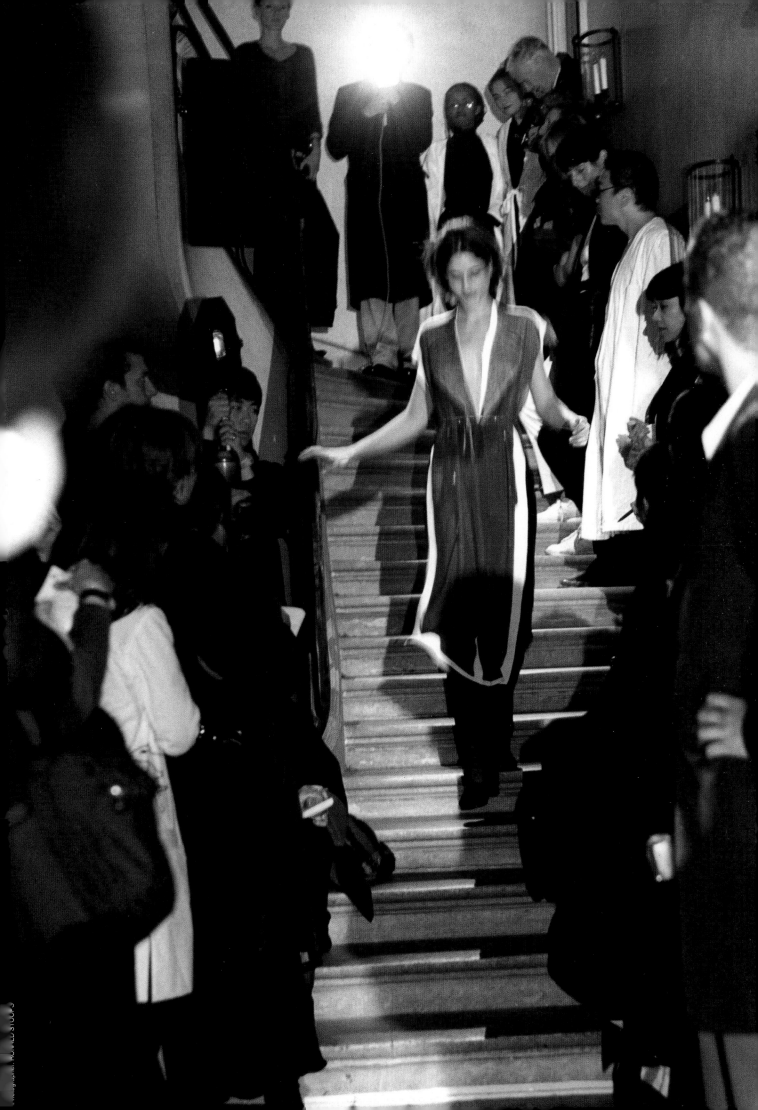

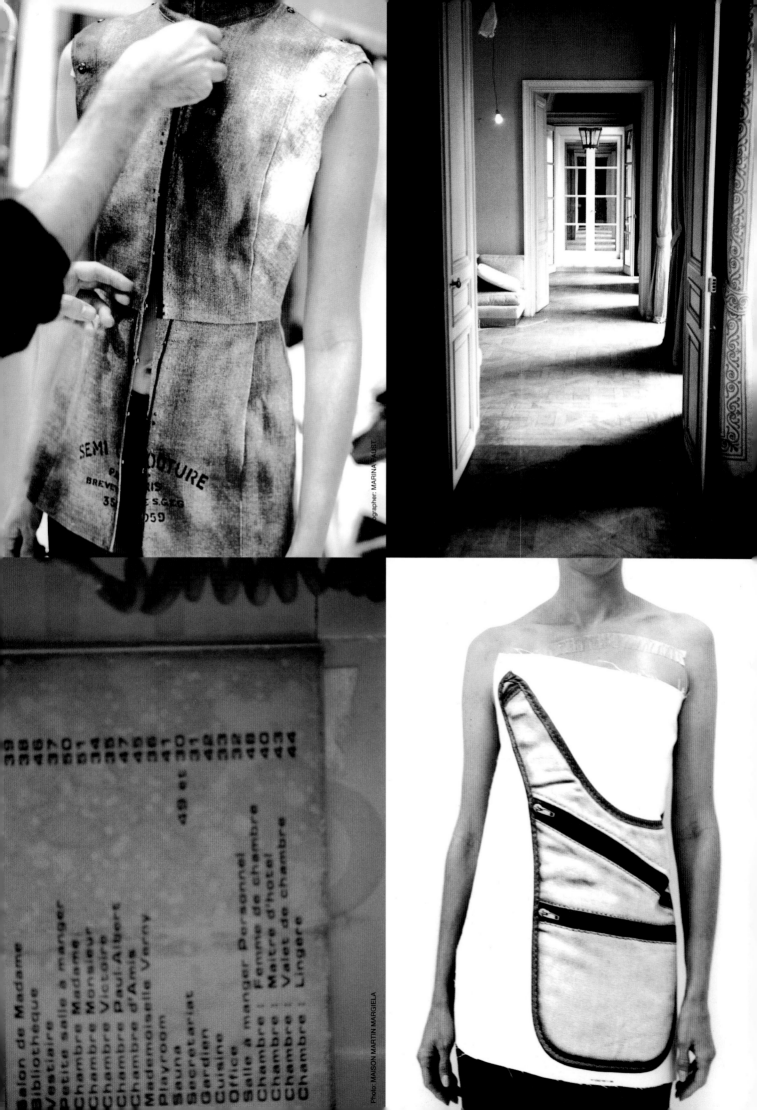

SEMI ~~DE~~ COUTURE
BREVET~~E~~ PARIS
35 ~~RUE~~ S.G.E.G
~~1~~059

Salon de Madame
Bibliotheque
Vestiaire
Petite salle à manger
Chambre Madame
Chambre Monsieur
Chambre Victoire
Chambre Paul Albert
Chambre d'Amis
Mademoiselle Verry
Playroom
Sauna
Secrétariat
Gardien
Cuisine
Office
Salle à manger Personnel
Chambre : Femme de chambre
Chambre : Maître d'hôtel
Chambre : Valet de chambre
Chambre : Lingère

39
38
37
36
35
34
33
32
31
30
29
28
27
26
25
24
23
22
41
40
43
44
49 et 50

0 1 2 3 4 5 6 7 8 9
10 11 12 13 14 15 16
17 18 19 20 21 22 23

Pièces artisanales pour femmes
Pièces artisanales pour hommes
Collection pour femme *
Vêtements pour filles & femmes
Garde-Robe pour hommes
Editions — objets
Chaussures pour femmes
* Etiquette blanche

Maison Martin Margiela

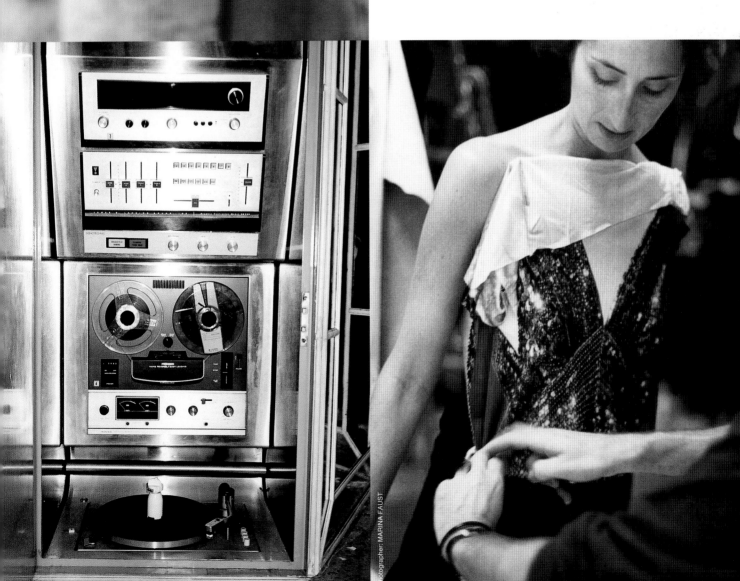

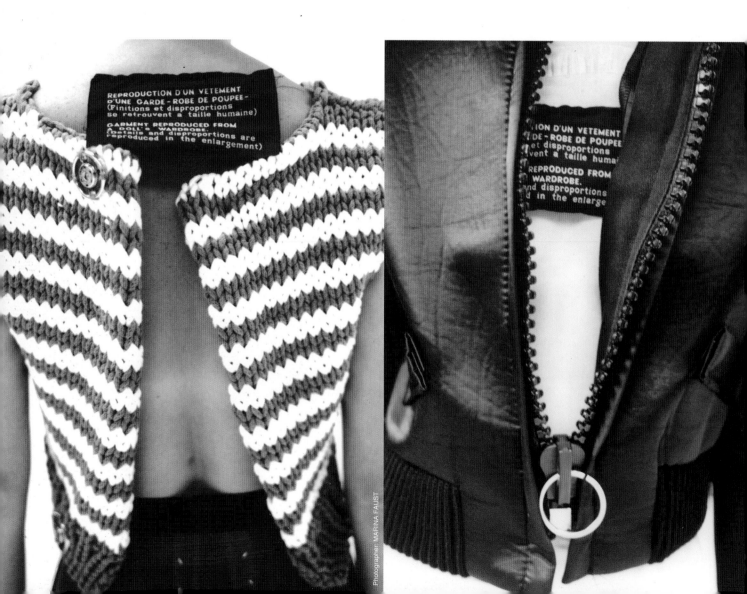

REPRODUCTION D'UN VETEMENT
D'UNE GARDE-ROBE DE POUPEE-
(Finitions et disproportions
se retrouvent a taille humaine)

GARMENT REPRODUCED FROM
A DOLL'S WARDROBE.
(Details and disproportions are
reproduced in the enlargement)

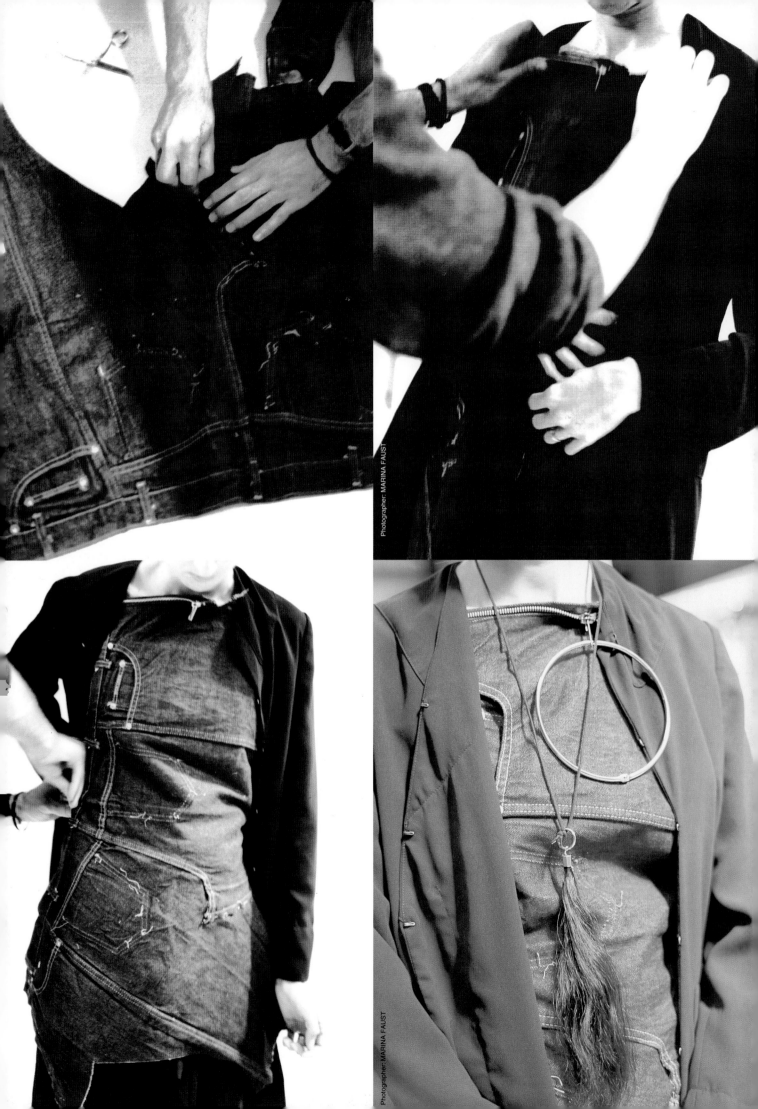

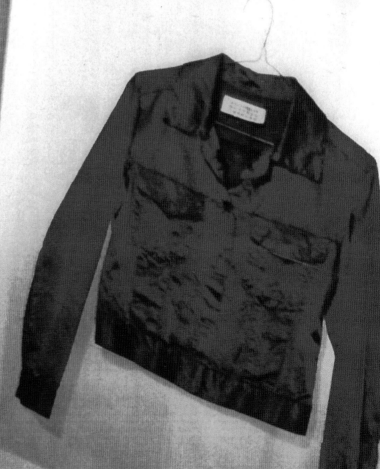

LIGNE

SERIE A2

SERIE B1 62 cotton 38 rayon

62%COTON 32K014 38%RAY

SERIE A2　100 cotton　　LIGNE

6

REF. 83631 / 10　REF. 83631 / 90

32N011

100%COTON

0 1 2 3 4 5 6 7 8 9
10 11 12 13 14 15 16
17 18 19 20 21 22 23

(22) (13) (10) 6 → (0) (0)
　　　　　　　　　(10)

Reworked garments for women,

Reworked garments for men

A collection for women *

Garments for girls & women

A wardrobe for men

Publications; objects

Shoes for women

* White label

Maison Martin Margiela

THAT SUIT
IS YOU SIR

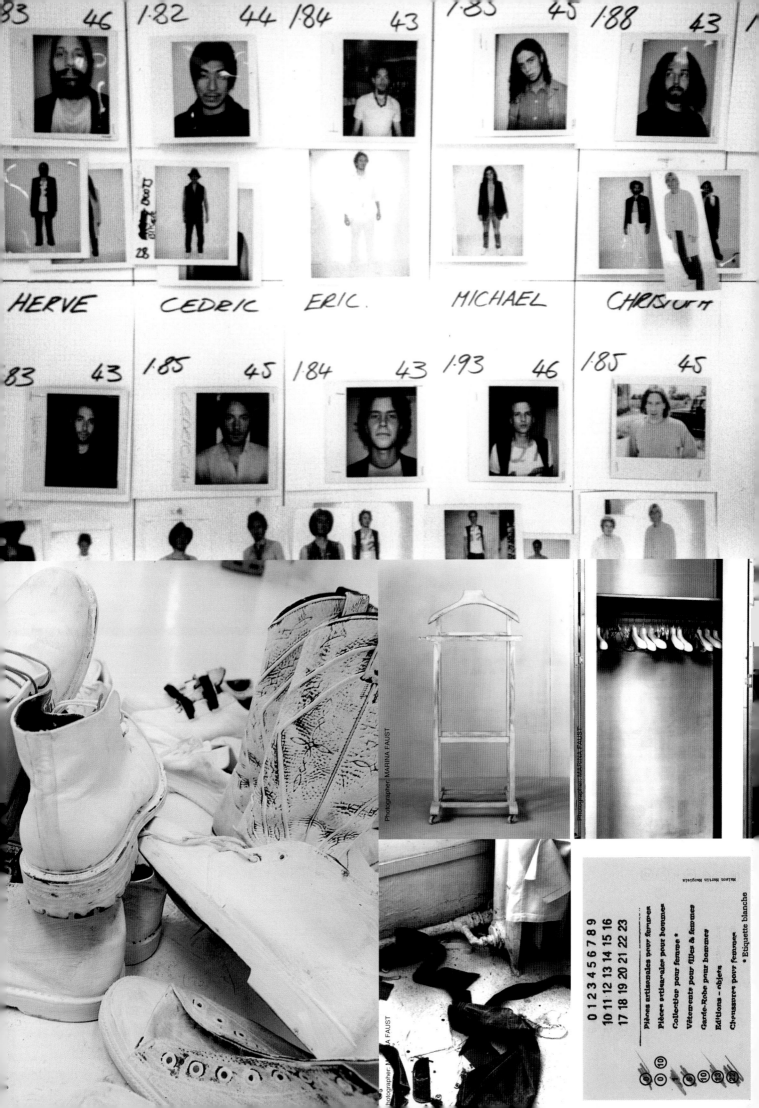

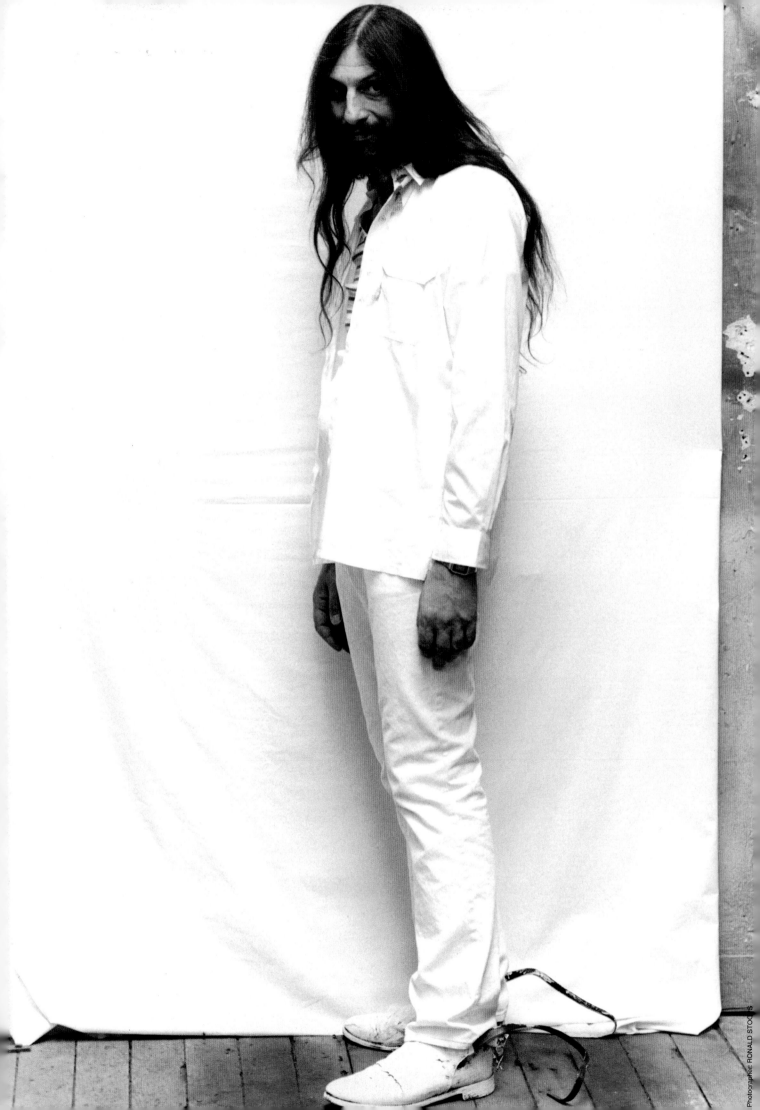

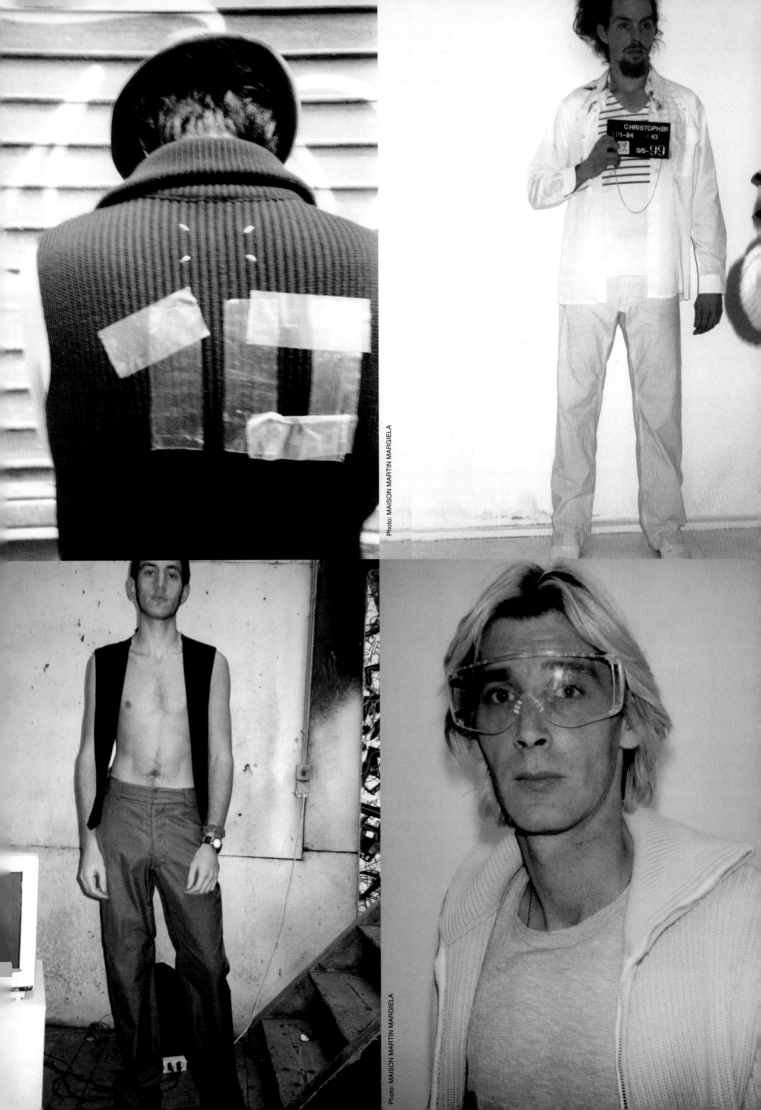

ERIC
H:1-84 S: 43
023
s/s-99

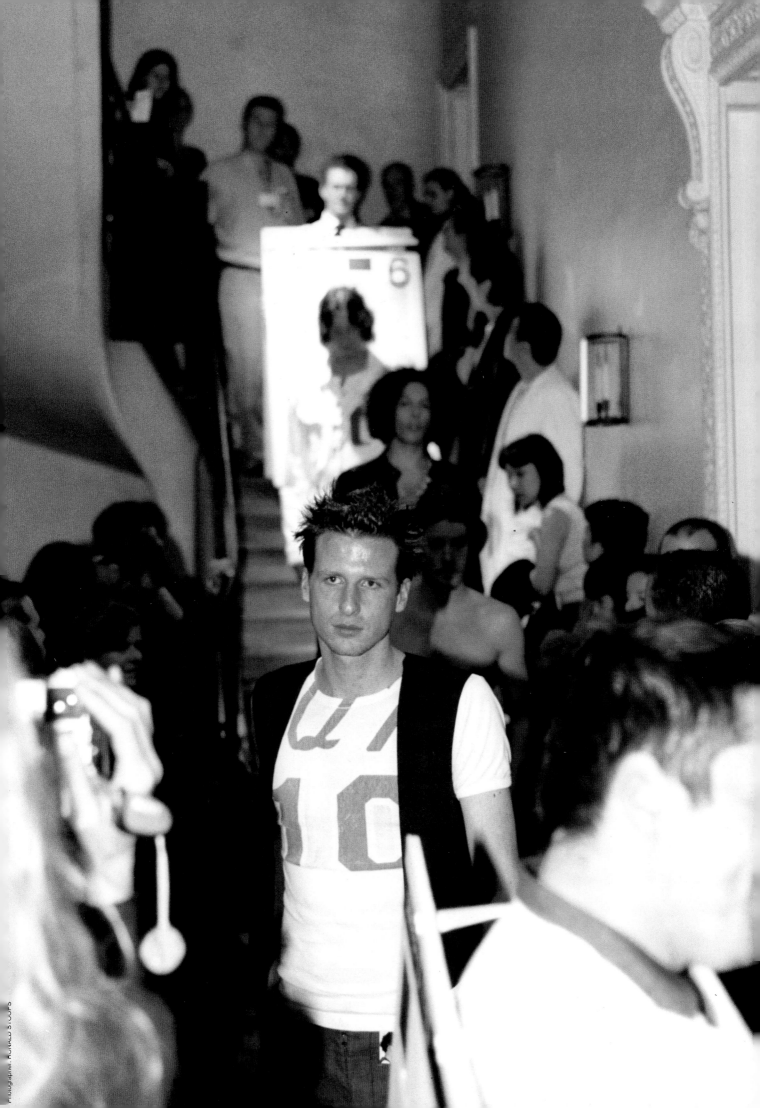

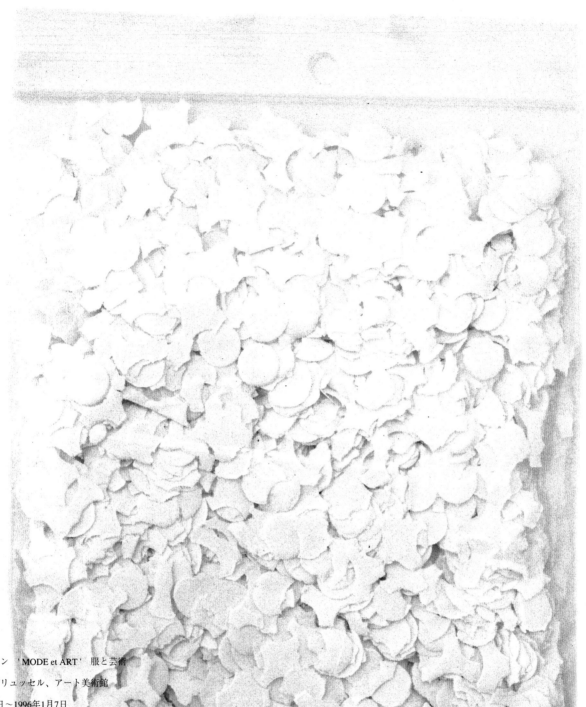

エキシビション　'MODE et ART'　服と芸術

ベルギー、ブリュッセル、アート美術館

1995年9月28日～1996年1月7日

白い壁には白のスポットライトが当てられる。このエキシビションの、MARTIN MARGIELAのプロジェクトについて書いてあるページを破って壁にスコッチテープで貼った。私達のスペースに白のコンフェッティ（細かく切った紙）をまるで厚みのあるカーペットのようにまき散らした。1989年～1995年までのMARTIN MARGIELAのデザイン35体を様々な素材、様々な白で作り直した。それらはオープニングの夜に白のベールで顔を覆った女性達が着た。群集の中を移動する彼女達はビデオで撮影された。彼女達が私達のスペースから出て歩いて行く度、白のコンフェッティは他の場所へと広がり散っていた。翌朝、フィルムは編集され、午後からは'TRACE'（足跡）と題されたエキシビションオープニングの夜の白黒ビデオが、この期間中放映された。エキシビションが終わった時には、白のコンフェッティは美術館の外の道まで達していた。

Exhibition ' MODE et ART'/ 'MODE en KUNST 1960-1990'.
'FASHION and ART 1960-1990'

Palais des Beaux-Arts, Brussels, Belgium.
28/09/1995 - 07/01/1996.

A white wall is lit by white projector light. The page describing the Martin Margiela project is torn from
the catalogue of the exhibition and stuck to the wall with scotch tape. A thick carpet of white confetti
covers the floor of our space. Thirty five outfits designed by Martin Margiela between 1989 and 1995, remade
in fabrics in various degrees of white, are worn on the evening of the opening of the exhibition by women
with faces veiled in white. The women are filmed on video as they move through the crowd, their feet carrying
the white confetti from the space throughout the exhibition. The next morning the video images are edited
and, from that afternoon, for the duration of the exhibition, the projection of this black and white video
provides a 'trace' of that first night and our participation. When the exhibition closes the white confetti
has reached the street outside the museum.

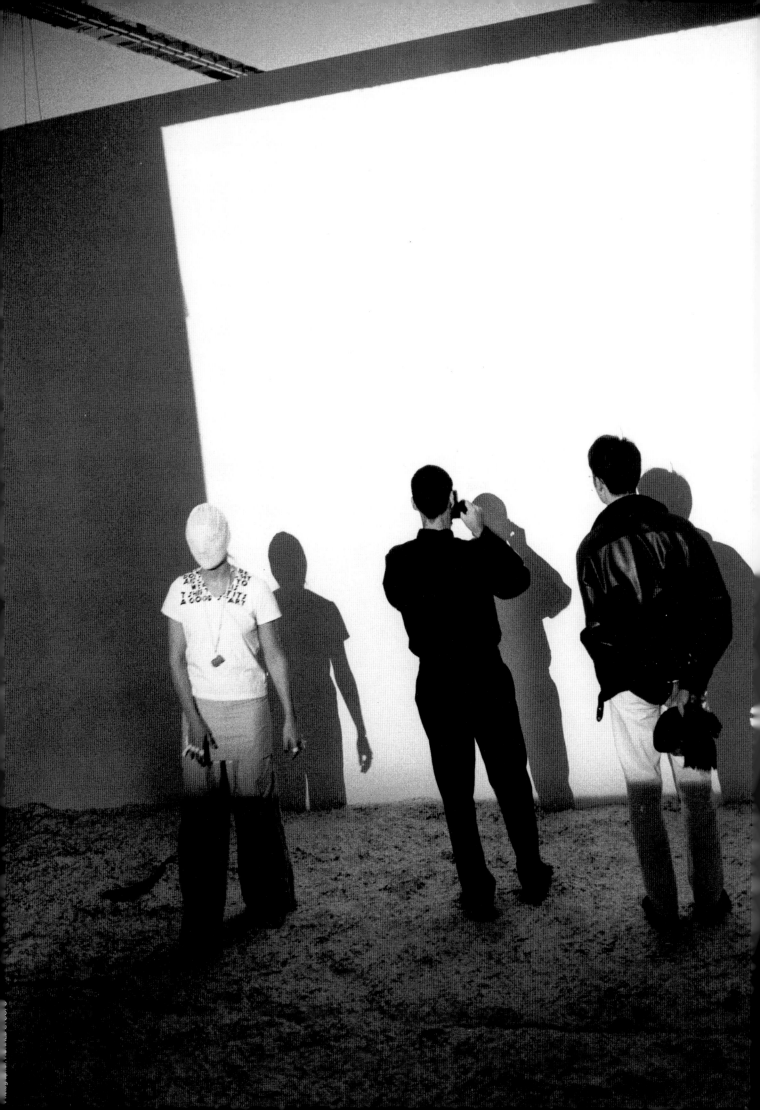

«spontané», c'est-à-dire produit dans certaines conditions sociales, qui fait qu'il lui suffit de «suivre son goût» pour répondre au goût d'une nouvelle bourgeoisie qui abandonne une certaine étiquette, qui abandonne la mode de Balmain, décrite comme mode pour vieilles femmes. Il abandonne cette mode pour une mode qui montre le corps, qui le laisse voir et qui suppose donc qu'il soit bronzé et sportif.
Courrèges fait une révolution spécifique dans un champ spécifique parce que la logique des distinctions internes l'a amené à rencontrer quelque chose qui existait déjà au-dehors.
La lutte permanente à l'intérieur du champ est le moteur du champ. On voit au passage qu'il n'y a aucune antinomie entre structure et histoire et que ce qui définit la structure du champ telle que je la vois est aussi le principe de sa dynamique. Ceux qui luttent pour la domination font que le champ se transforme, qu'il se restructure constamment. L'opposition entre la droite et la gauche, l'arrière-garde et l'avant-garde, le consacré et l'hérétique, l'orthodoxie et l'hétérodoxie, change constamment de contenu substantiel mais elle reste structuralement identique. Les nouveaux entrants ne peuvent faire dépérir les anciens que parce que la loi implicite du champ est la distinction dans tous les sens du terme: la mode est la dernière mode, la dernière différence. Un emblème de la classe (dans tous les sens du terme) dépérit lorsqu'il perd son pouvoir distinctif, c'est-à-dire lorsqu'il est divulgué. Quand la mini-jupe est arrivée aux corons de Béthune, on repart à zéro.
La dialectique de la prétention et de la distinction qui est au principe des transformations du champ de production se retrouve dans l'espace des consommations: elle caractérise ce que

Martin Margiela

35 modèles blancs créés par Martin Margiela de 1989 à 1995, dont certains réalisés spécialement pour l'exposition, sont portés le soir du vernissage par des mannequins voilés, filmés en vidéo évoluant sur un tapis de confettis blancs au milieu des visiteurs.
Dès le lendemain, cette vidéo est projetée sur grand écran et constitue la «trace» de la performance.
Vidéo réalisée par Alice in Wonderland. Collection Martin Margiela.

1991 – Atelier

1989年から1995年までのMARTIN MARGIELAのデザイン35体をこのエキシビションのために白の素材で作り直した。それらはオープニングの夜に白のベールで顔を覆った女性達が着た。群集の中を白のコンフェッティ（細かく切った紙）のカーペットの上を移動する彼女達はビデオで撮影された。翌朝から、編集されたビデオが大きな白い壁に映写され、'TRACE'（足跡）と題されたパフォーマンスの構成要素になる。VIdeo produced by 'Alice in Wonderland' Collection MArtin Margiela.

35 outfits designed by Martin Margiela between 1989 and 1995, specially recreated in white for this exhibition, are worn on the evening of the opening by veiled models, who are filmed as they walk on a a carpet of white confetti amongst the visitors. From the following morning an edited version of this video is projected on a large white wall and constitutes a 'Trace' of the performance. Video produced by 'Alice in Wonderland'. Collection Martin Margiela.

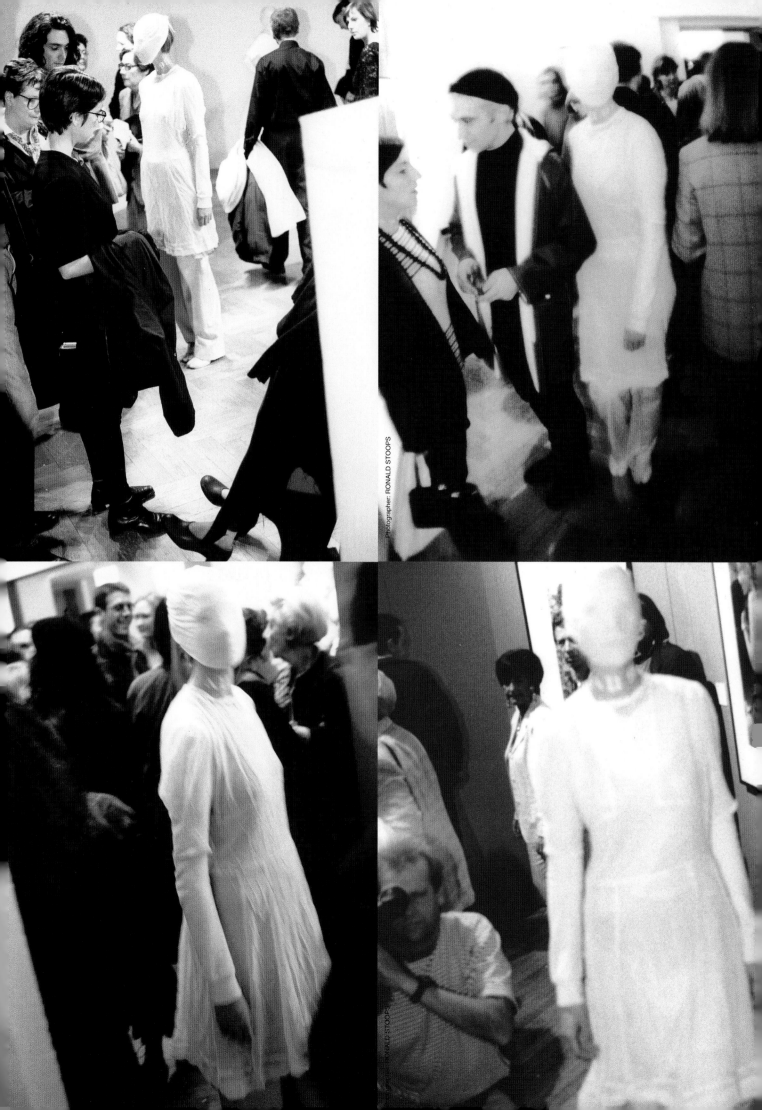

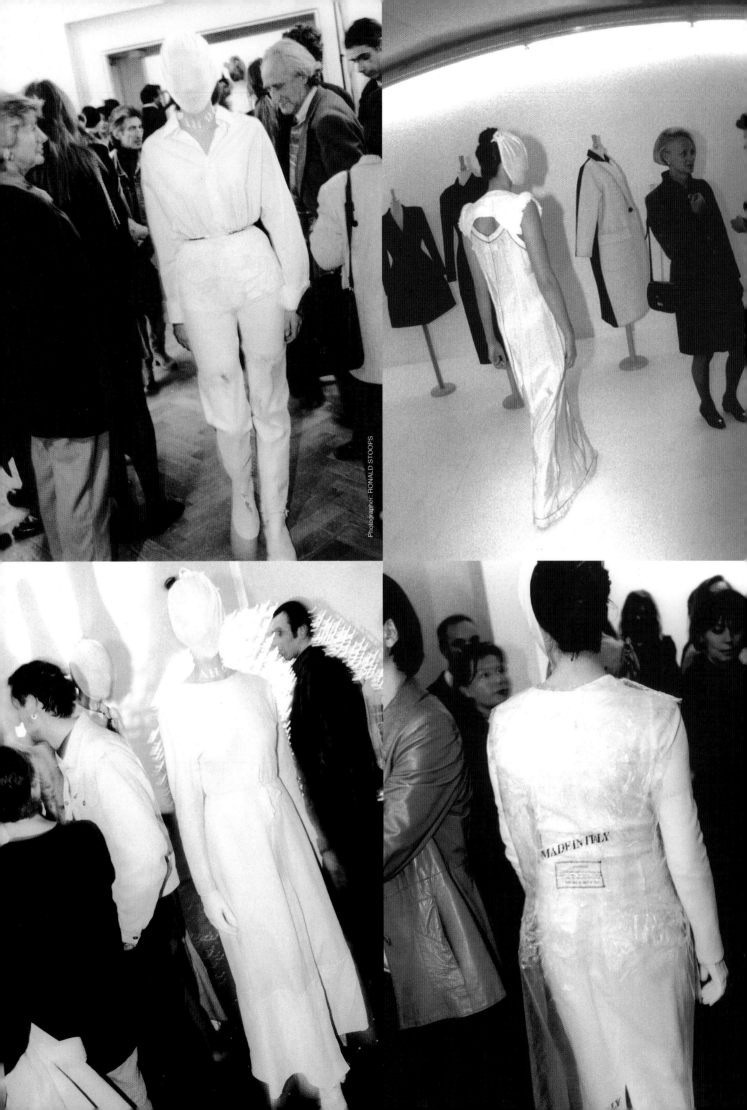

Photographer: RONALD STOOPS

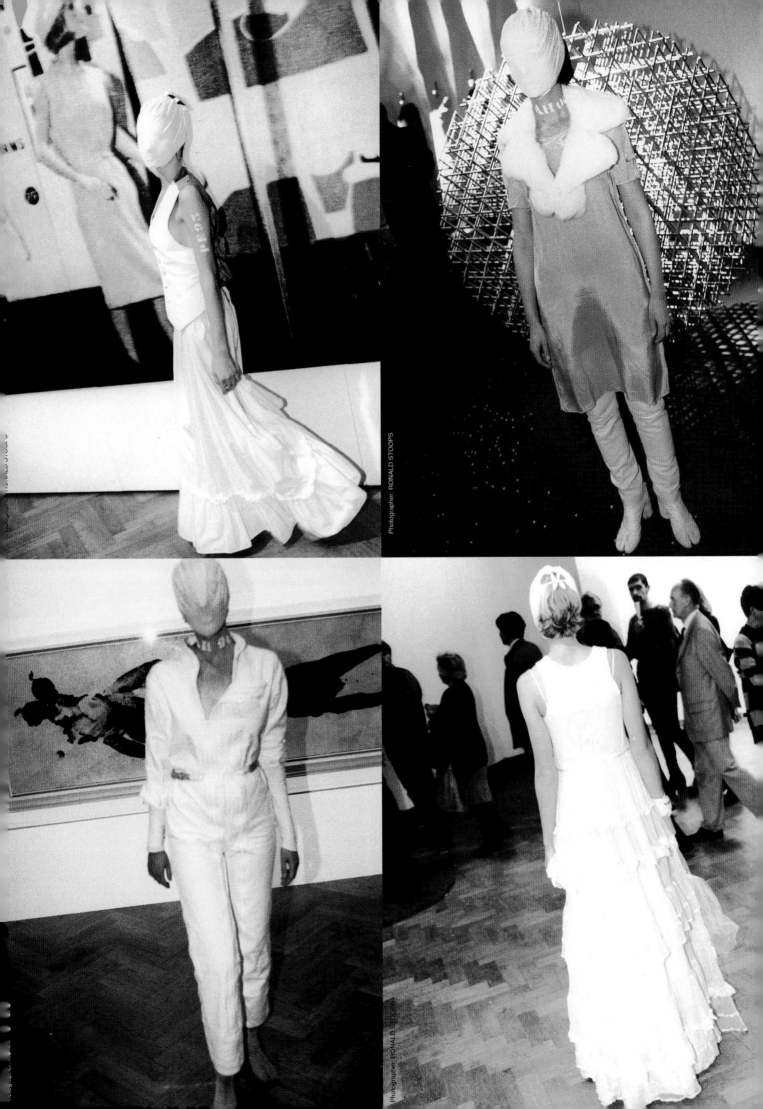

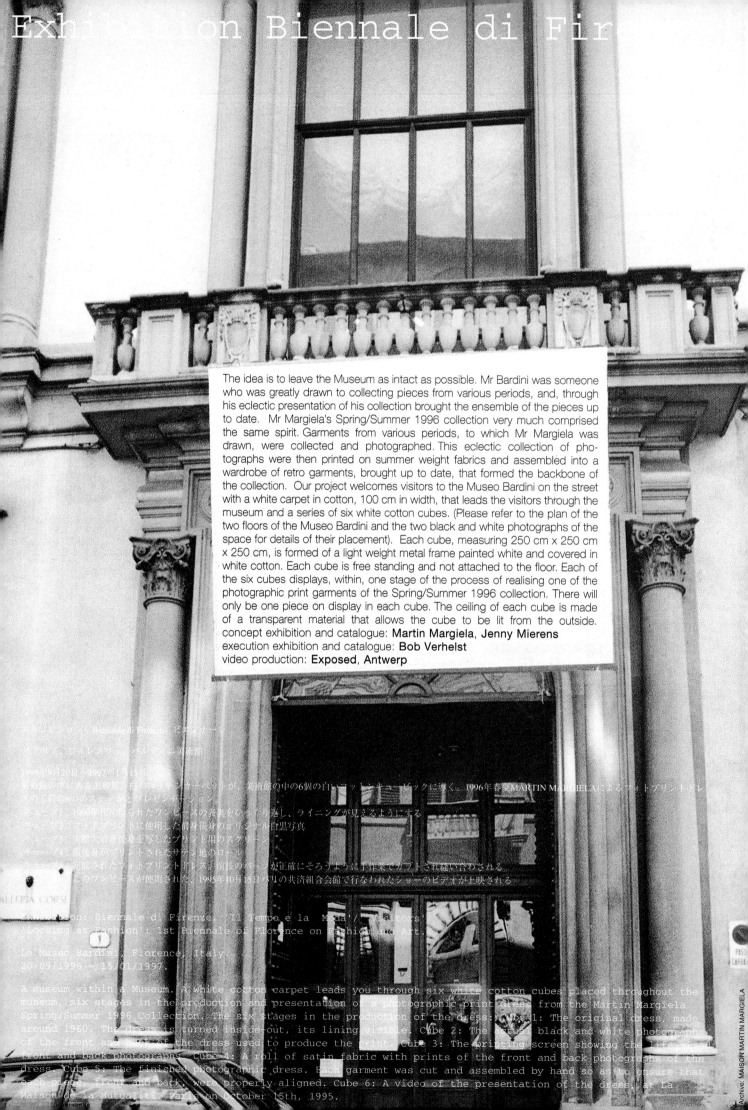

The idea is to leave the Museum as intact as possible. Mr Bardini was someone who was greatly drawn to collecting pieces from various periods, and, through his eclectic presentation of his collection brought the ensemble of the pieces up to date. Mr Margiela's Spring/Summer 1996 collection very much comprised the same spirit. Garments from various periods, to which Mr Margiela was drawn, were collected and photographed. This eclectic collection of photographs were then printed on summer weight fabrics and assembled into a wardrobe of retro garments, brought up to date, that formed the backbone of the collection. Our project welcomes visitors to the Museo Bardini on the street with a white carpet in cotton, 100 cm in width, that leads the visitors through the museum and a series of six white cotton cubes. (Please refer to the plan of the two floors of the Museo Bardini and the two black and white photographs of the space for details of their placement). Each cube, measuring 250 cm x 250 cm x 250 cm, is formed of a light weight metal frame painted white and covered in white cotton. Each cube is free standing and not attached to the floor. Each of the six cubes displays, within, one stage of the process of realising one of the photographic print garments of the Spring/Summer 1996 collection. There will only be one piece on display in each cube. The ceiling of each cube is made of a transparent material that allows the cube to be lit from the outside.
concept exhibition and catalogue: **Martin Margiela, Jenny Mierens**
execution exhibition and catalogue: **Bob Verhelst**
video production: **Exposed**, Antwerp

エキシビション　Biennale di Firenze　ビエンナーレ

・フロア、フィレンツェ、バルディーニ美術館

1996年9月20日〜1997年1月15日

美術館の中にある美術館。白いコットンカーペットが、美術館の中の6個の白いコットンキュービックに導く。1996年春夏MARTIN MARGIELAによるフォトプリントドレ
スの工程の6つのステージとプレゼンテーション。
キューブ1：1960年代に作られたワンピースの裏表をひっくり返し、ライニングが見えるようにする
キューブ2：プリントに使用した前身後身のオリジナル白黒写真
キューブ3：実物大前身後身を写したプリント用のスクリーン
キューブ4：前後身がプリントされたサテン地のロール
キューブ5：完成されたフォトプリントドレス。前後のパーツが正確にそろうように手作業でカットされ縫い合わされる
キューブ6：このワンピースが使用された、1995年10月15日パリの共済組合会館で行なわれたショーのビデオが上映される

Exhibition: Biennale di Firenze, 'Il Tempo e la Moda'/ 'Visitors'/
'Looking at Fashion': 1st Biennale of Florence on Fashion and Art.
La Museo Bardini, Florence, Italy.
20/09/1996 ~ 15/01/1997.

A museum within a Museum. A white cotton carpet leads you through six white cotton cubes placed throughout the museum, six stages in the production and presentation of a photographic print dress from the Martin Margiela Spring/Summer 1996 Collection. The six stages in the production of the dress: Cube 1: The original dress, made around 1960. The dress is turned inside-out, its lining visible. Cube 2: The actual black and white photographs of the front and back of the dress used to produce the print. Cube 3: The printing screen showing the life-sized front and back photographs. Cube 4: A roll of satin fabric with prints of the front and back photographs of the dress. Cube 5: The finished photographic dress. Each garment was cut and assembled by hand so as to ensure that each piece, front and back, were properly aligned. Cube 6: A video of the presentation of the dress at La Maison de la Mutualité, Paris on October 15th, 1995.

Archive: MAISON MARTIN MARGIELA

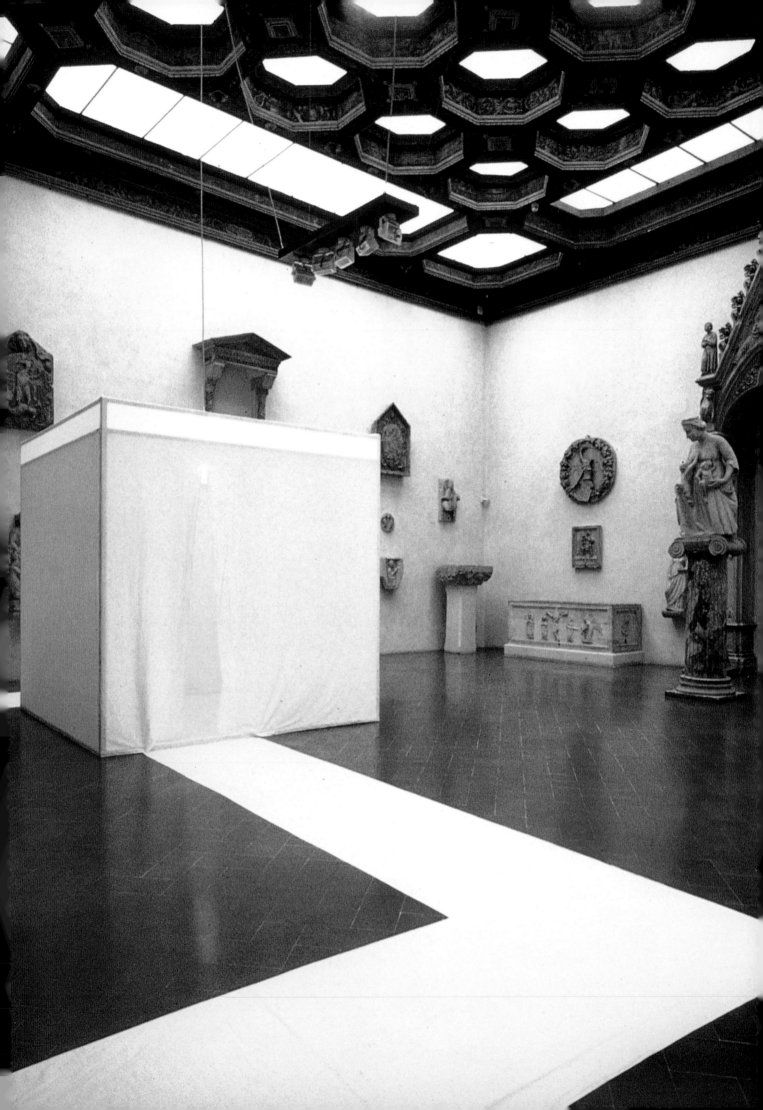

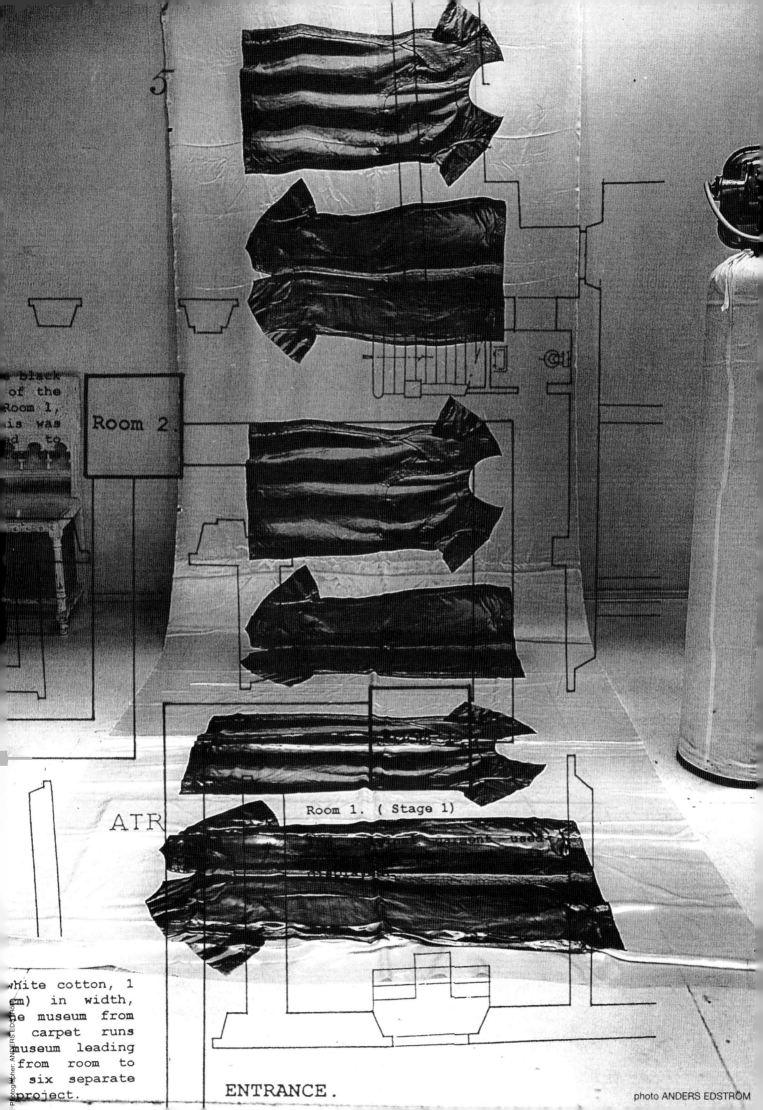

5

Room 2

black
of the
Room 1,
is was
to

ATR

Room 1. (Stage 1)

white cotton, 1
cm) in width,
he museum from
carpet runs
museum leading
from room to
six separate
project.

ENTRANCE.

エキシビション　9/4/1615

オランダ、ロッテルダム、ボイヤアン ヴァン ビュンインゲン美術館

メゾンMARTIN MARGIELA初めての単独でのエキシビション。ローズガーデンとデコラティブな池に隣接した1980年建築のグラスパビリオンで行なった。ダミー人形が着用した18体の作品はMARTIN MARGIELAの1989年春夏から1997/8年秋冬までのコレクションを代表している。各シーズンから選ばれた服は白、クリーム、グレー色で作り直された。このエキシビションはオランダ、ワレンインゲン市にある農業大学の微生物学者Dr.A.W.S.M Van Egeraatとのコラボレーションで行なった。（Dr.Vann Egeraatは豆類の根から浸出した液とその根粒バクテリアに対する効果の研究を専門とされている。）それぞれの服には異なるバクテリア、イースト、カビを付着させ、それぞれ空気から隔離し、培養することにより、色とテクスチャーを変化させた。最初5日間でバクテリア等の組織が生地の上で発育されその後懐胎期に入ると服の様相、色が変わり出す。全て18体のシルエットはグラスパビリオンの外に立てられ、入場者はパビリオンの中からガラス越しに見る事となる。ハンドブックが出版されこれにはこれらの内容が詳しく説明された。このハンドブックは白のコットンでカバーされ、3章から成る。

　（a）MARTIN MARGIELAの代表作
　（b）どの様にしてこれらの服とバクテリアを取り扱ったか
　（c）バクテリアと微生物の参照文

Exhibition: (9/4/1615),

Museum Boijmans van Beuningen, Rotterdam, The Netherlands.
11/06/1997 - 17/08/1997.

The first solo exhibition by Maison Martin Margiela. The exhibition is held in the 'glass pavilion' of the museum, built in the 1980's, that adjoins a rose garden and a large decorative pond. Eighteen dressed dummies represent all previous Martin Margiela collections (Spring/Summer 1989 up to Autumn Winter 1997/8). Garments chosen from each season are specially reproduced in whites, creams and greys. A collaboration with a prominent Dutch Microbiologist, Dr A.W.S.M van Egeraat, Professor at the Wareningen Agricultural University, The Netherlands. (Dr Van Egeraat's previous specialisation, the bacteria and their effect upon root-nodule bacteria). Each outfit is treated with different bacteria, isolated from the air and nurtured to provide varying colours and textures. Over the first five days of the exhibition these organisms develop on the clothes and, once their gestation period is complete, change the colour and aspect of the garments. All eighteen silhouettes remain on the exterior of the pavilion and may only be viewed from the inside through its glass structure. A handbook is published to assist those viewing the exhibition. This handbook, covered in white cotton contains three books: Book (a) represents the Maison Martin Margiela, (b) the garments and their treatment and (c) is a reference book on bacteria and micro biology.

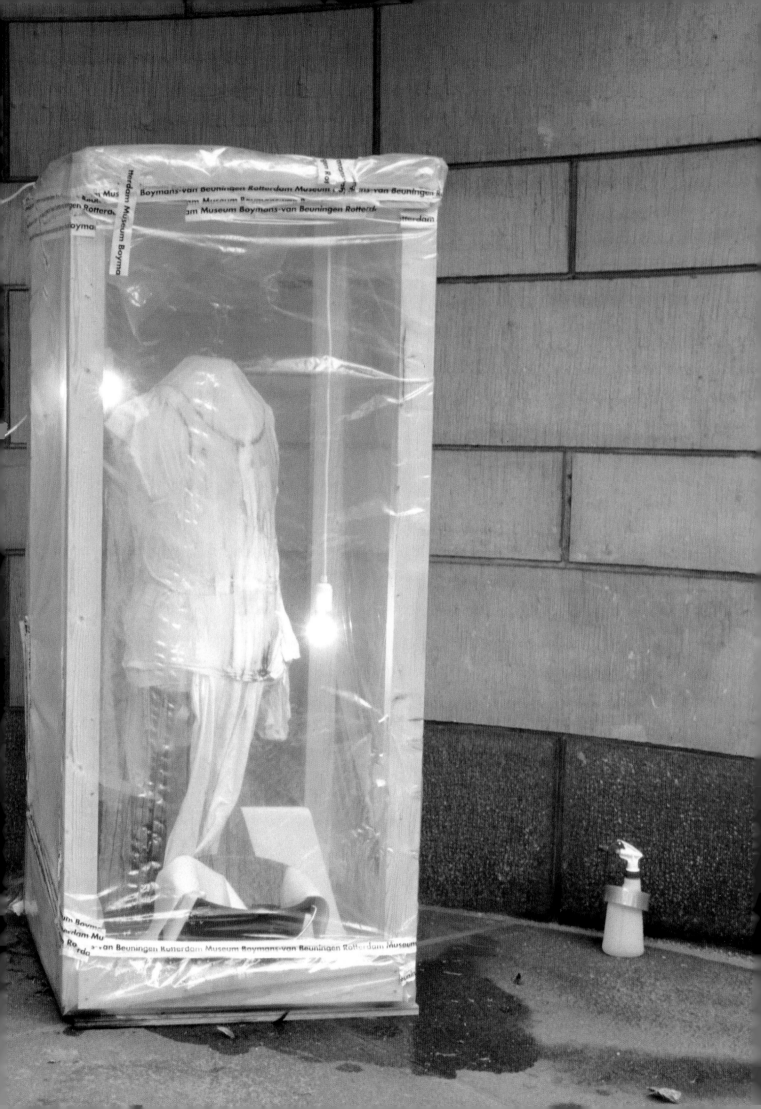

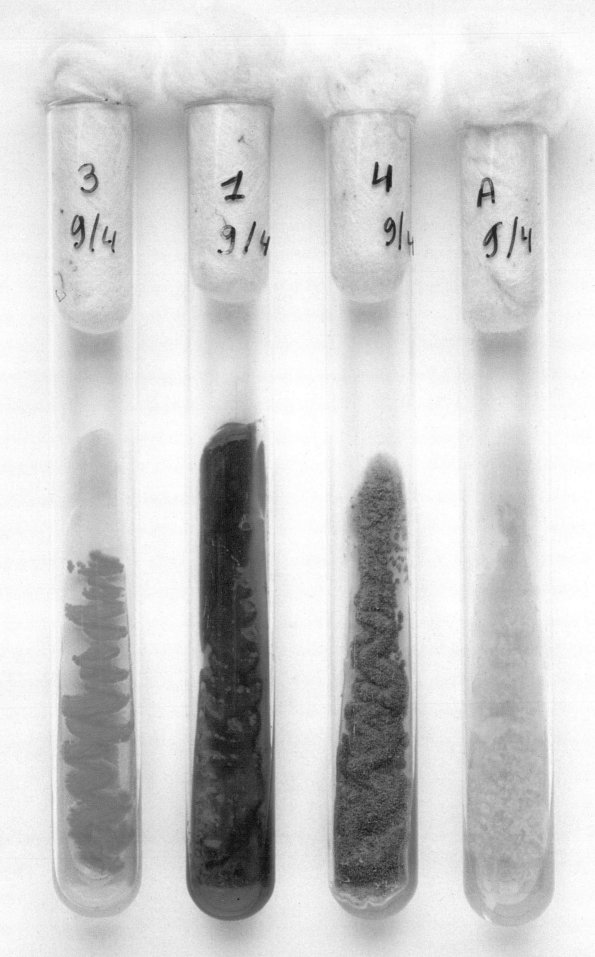

PURE CULTURES OF BACTERIA AND MOULDS, GROWN 9 APRIL 1997

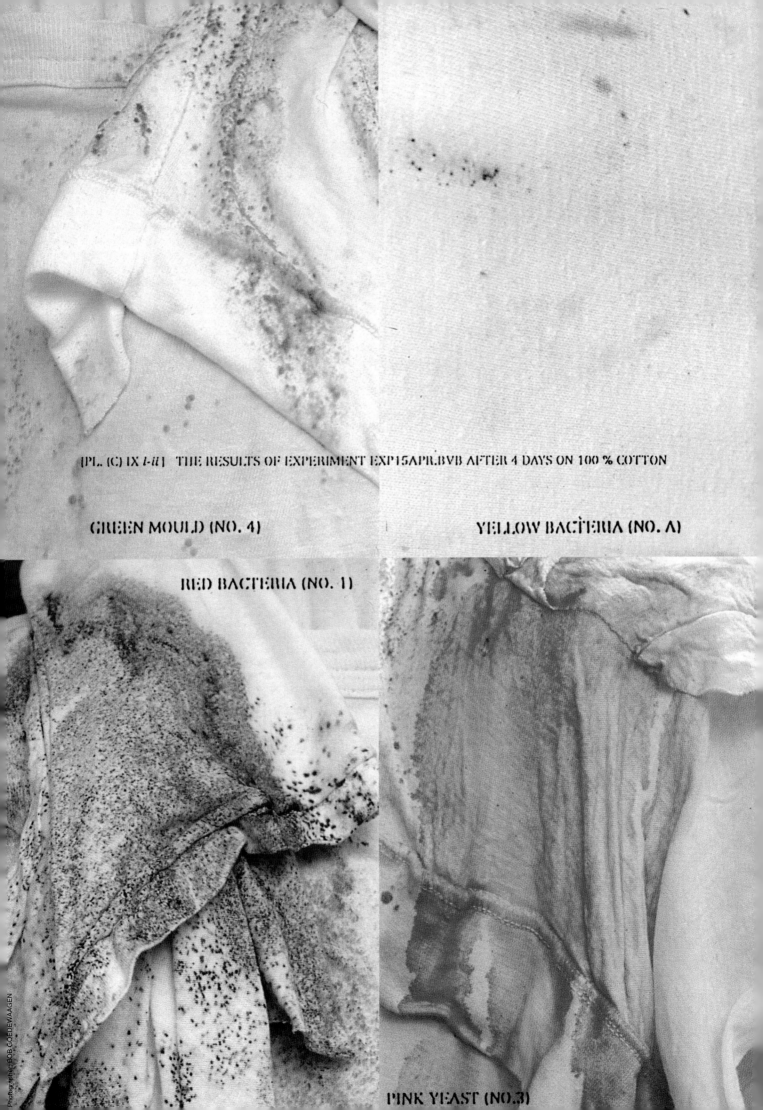

[PL. (C) IX *i-ii*] THE RESULTS OF EXPERIMENT EXP15APR.BVB AFTER 4 DAYS ON 100 % COTTON

GREEN MOULD (NO. 4)

YELLOW BACTERIA (NO. A)

RED BACTERIA (NO. 1)

PINK YEAST (NO. 3)

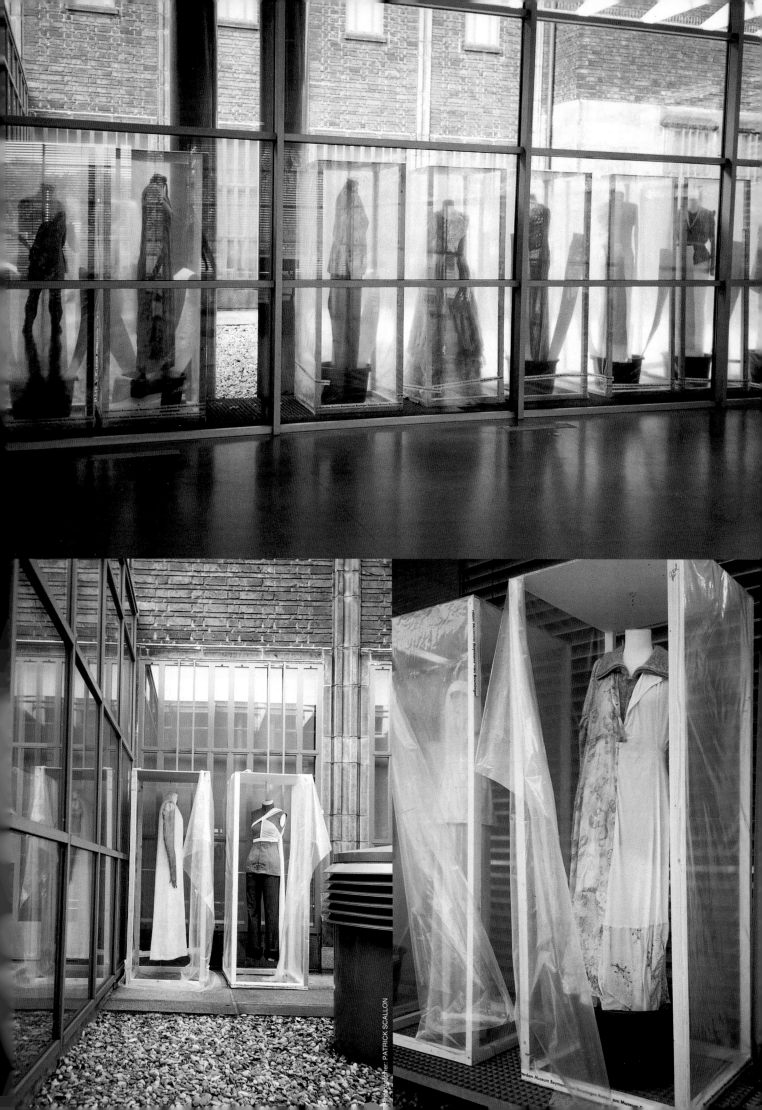

invitation/uitnodiging/invitation
opening/opening/ouverture

11/06/1997 17.00

Mar´tin Mar·gie´la, Born, Belgium. 1977-80, Antwerp, Belgium, Royal Academy of Fine Art, Fashion Department.

La Mai´son Mar´tin Mar·gie´la, Founded: Martin Margiela & Jenny Meirens, 1988. First collection Spring/Summer 1989. Collections for women twice a year. Handmade/Recycled/One off garments, Various exhibitions, 15 team members, 18 collections over 9 years to date.

Ad van E´ge·raat, dr. A.W.S.M. Van Egeraat, Born 1937. Ass. Professor Wageningen Agricultural University (WAU). Thesis: *Pea-root exudates and their effect upon root-nodule bacteria*, Veenman & Zn., Wageningen 1972.

çlōth´ing, *n*. [ME. *clothing,* from AS. *clath,* cloth.]

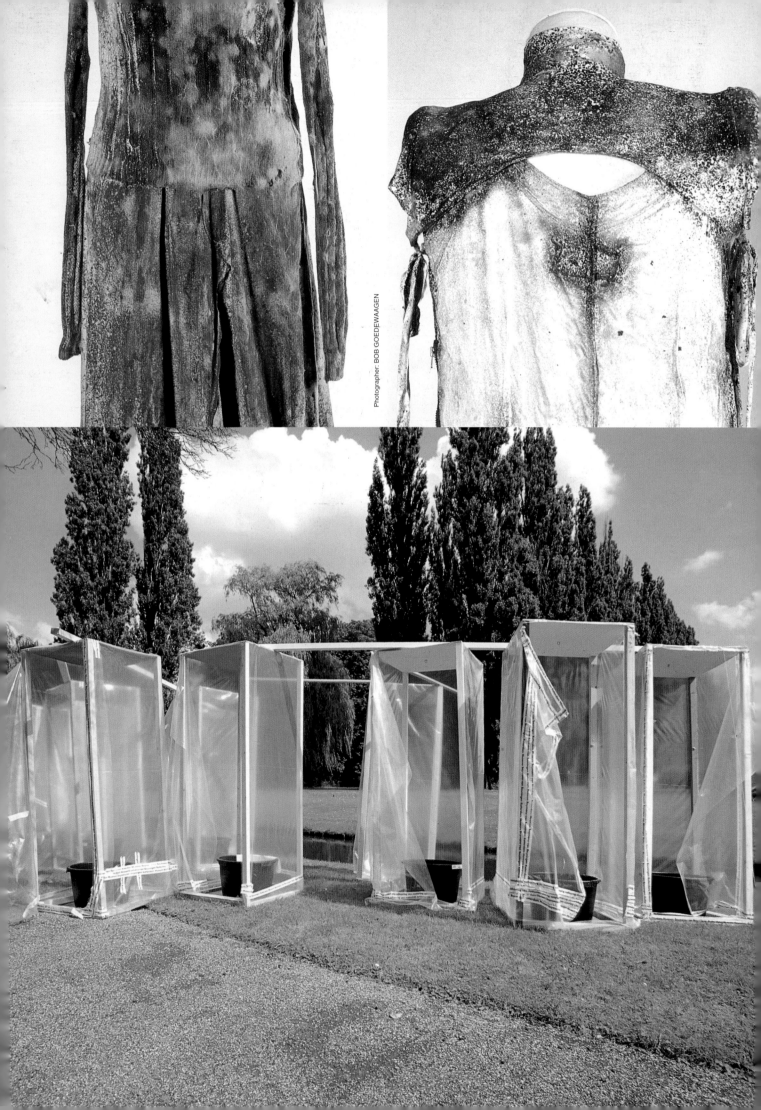